The
chicago
77

★ ★ ★ ★

A COMMUNITY AREA
HANDBOOK

MARY
ZANGS

Charleston London

THE
History
PRESS

Published by The History Press
Charleston, SC 29403
www.historypress.net

Maps created by Shannon Zangs.

First published 2014

Manufactured in the United States

ISBN 978.1.62619.612.4

Library of Congress CIP data applied for.

To Jim, Beth, Shannon and Matt.

"[History shows us] *the whole essence of Chicago—*
its great creative impromptu spirit."
—Tim Samuelson,
Chicago cultural historian

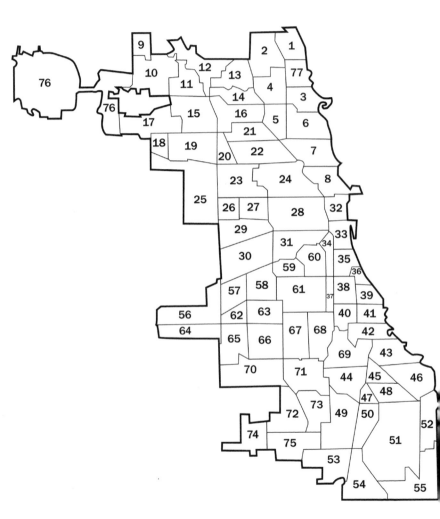

CONTENTS

Preface	9	16. Irving Park	88
		17. Dunning	93
1. Rogers Park	11	18. Montclare	98
2. West Ridge	16	19. Belmont Cragin	103
3. Uptown	21	20. Hermosa	108
4. Lincoln Square	26	21. Avondale	113
5. North Center	31	22. Logan Square	119
6. Lake View	36	23. Humboldt Park	125
7. Lincoln Park	41	24. West Town	130
8. Near North Side	47	25. Austin	135
9. Edison Park	53	26. West Garfield Park	140
10. Norwood Park	58	27. East Garfield Park	145
11. Jefferson Park	63	28. Near West Side	150
12. Forest Glen	68	29. North Lawndale	155
13. North Park	73	30. South Lawndale	160
14. Albany Park	78	31. Lower West Side	165
15. Portage Park	83	32. Loop	170

Contents

33. Near South Side	181	61. New City	314	
34. Armour Square	186	62. West Elsdon	319	
35. Douglas	190	63. Gage Park	324	
36. Oakland	195	64. Clearing	329	
37. Fuller Park	200	65. West Lawn	334	
38. Grand Boulevard	204	66. Chicago Lawn	339	
39. Kenwood	209	67. West Englewood	345	
40. Washington Park	214	68. Englewood	350	
41. Hyde Park	219	69. Greater Grand Crossing	355	
42. Woodlawn	223	70. Ashburn	360	
43. South Shore	228	71. Auburn Gresham	364	
44. Chatham	232	72. Beverly	368	
45. Avalon Park	237	73. Washington Heights	373	
46. South Chicago	242	74. Mount Greenwood	378	
47. Burnside	247	75. Morgan Park	382	
48. Calumet Heights	252	76. O'Hare	386	
49. Roseland	257	77. Edgewater	391	
50. Pullman	262			
51. South Deering	267	Resources	397	
52. East Side	272	About the Author	400	
53. West Pullman	276			
54. Riverdale	280			
55. Hegewisch	285			
56. Garfield Ridge	290			
57. Archer Heights	295			
58. Brighton Park	300			
59. McKinley Park	305			
60. Bridgeport	309			

PREFACE

I love this city! Chicago has grown from a wet and wild prairie to the "most American of American cities." How does one keep track of all those changes? In the 1920s, sociologists at the University of Chicago established the boundaries of the seventy-five "Community Areas of Chicago." The area of O'Hare was formed in 1956, and the Edgewater area was separated from Uptown in 1980. These borders of these seventy-seven community areas have remained unchanged. This stability has provided consistent statistics used by social service agencies, the Chicago Department of Public Health, the Census Bureau and other civic programs or organizations.

Chicago is a "city of neighborhoods." The neighborhood boundaries and names come and go; they are subjective and changeable. Chicago has more than two hundred sub-neighborhoods within these community areas. Some of the neighborhoods span more than two community areas.

Many of the community areas took the name of the most prominent neighborhood within their boundaries. This book is intended to be a lighthearted but factual look at these seventy-seven community areas.

Special thanks to Ben Gibson and Ryan Finn at The History Press and all of the helpful Chicago librarians I encountered along the way.

1. Rogers Park

BOUNDARIES
N—Howard/Juneway
S—Devon Avenue
E—Lake Michigan
W—Ridge Avenue

NEIGHBORHOODS
Rogers Park
Loyola
East Rogers Park
North Howard

HOW IT GOT ITS NAME
Phillip McGregor Rogers was one of the first settlers in the area. He was an Irish immigrant who came to Chicago in 1836. He bought up lots of land and called it Rogers Ridge. His son-in-law, Patrick Touhy, formed a land company with John Farwell, Luther Greenleaf, Stephen Lunt, Charles Morse and George Estes—now we know how those streets got their names. They called the village Rogers Park.

DID YOU KNOW?
* In 1809, there were only American Indians, a few farmers, traders and Fort Dearborn soldiers in the whole territory.

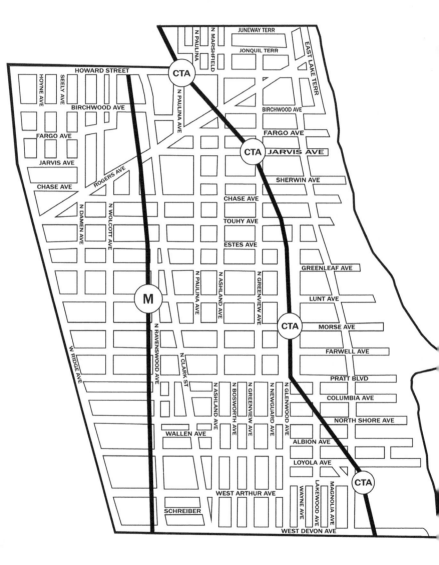

The Karthauser Inn was a stagecoach stop and tavern located in the area that is now Rogers Park.

* In 1845, farmers from Luxembourg and Germany settled in the area around Ridge and Devon. In 1873, the railroad arrived and soon had a stop near Lunt and Ravenswood (then called Market Street). The population grew to several hundred, and the first post office was established in 1873. The village was incorporated in 1878.

* Cornelius Ceperly came home after the Civil War and built most of the first houses in "The Park." When he built his own house on Morse Avenue in 1874, there was only wilderness from his home east to Lake Michigan and only farms to the west.

* The Great Fire of Rogers Park occurred in 1894. The fire started at the Gerson Mill and destroyed the entire block of the Clark Street business district. Rogers Park had been annexed to Chicago one year earlier but had been without city water all that time. The fire department was located in the old town hall only one block away but had to depend on neighboring fire stations for assistance.

* Birchwood Country Club was located along the lake from 1906 to 1942. The property was sold to the North Shore School. The Birchwood neighborhood was near the Jarvis "L" stop.

* Loyola University was established in Rogers Park by the Jesuits in 1912. It was built on the swampy acreage of land called Cape Hayes. St. Ignatius College had been located on Taylor Street, and its name was changed to Loyola in 1909 before moving to the lakeshore campus. It now has a total enrollment of 15,900 students. In 1991, Loyola merged with neighboring Mundelein College.

* Mundelein College was started in 1930 by the Sisters of Charity of the Blessed Virgin Mary. The "skyscraper college" was built in the Art Deco style, with two guardian angels adorning the main entrance. In 1934, the college purchased two neighboring lakeside mansions. Mundelein was the last Catholic women's college in Illinois.

* In 1915, the panhandle area north of Howard was annexed. It was known as Germania because of the German settlers there. It was isolated by the "L" tracks and seceded from Evanston. The small area east of Sheridan was called Fisher's Grove.

* Developed in 1931, Pottawattomie Park honors the American Indians who lived in northern Illinois from 1765 until 1835. There is a large painting in the fieldhouse that depicts a meeting between the Indians and whites.

* Movies became very popular as an escape from the Prohibition era from 1920 to 1933 and the Great

Depression of 1929. Rogers Park was once home to about a dozen grand movie palaces. They stood for decades until most were demolished in the 1960s. The Regent Theater opened on Sheridan in 1914 and has evolved into the New 400 Theater.

FAVORITE THING ABOUT ROGERS PARK

My favorite thing about Rogers Park is that it is such a diverse community that works so well together.

Anthony Boatman
A Just Harvest

PLACE OF INTEREST

Emil Bach House
7415 North Sheridan Road

This home was designed by Frank Lloyd Wright in 1915 for Emil Bach and his wife, Anna. Mr. Bach was the owner of the Bach Brick Company on Irving Park Road near the river. The house became a Chicago Landmark in 1977. It was bought by Jennifer Pritzker in 2010 and is carefully being restored to be opened to the public.

2. West Ridge

BOUNDARIES
N—Howard Street
S—Peterson/Bryn Mawr
E—Ridge Avenue
W—Kedzie/North Shore Channel

NEIGHBORHOODS

West Rogers Park	Arcadia Terrace
Nortown	Rogers Park Manor
Rosehill	Golden Ghetto

HOW IT GOT ITS NAME
Yes, you guessed it: it is west of Ridge Avenue. Once part of Rogers Park, it split from the village during a dispute over the formation of Indian Boundary Park. A politician from the elite lakefront area had the nerve to call the farmers, who lived to the west, "cabbageheads"! The farmers won the "Cabbage War" to get the park and a new name for the village in 1890.

DID YOU KNOW?
* The first settler here was an Irish immigrant, John O'Leary. He bought farm property in 1837. The area was part of Gross Point Territory in 1812 and was then called Ridgeville from 1850 until 1878.

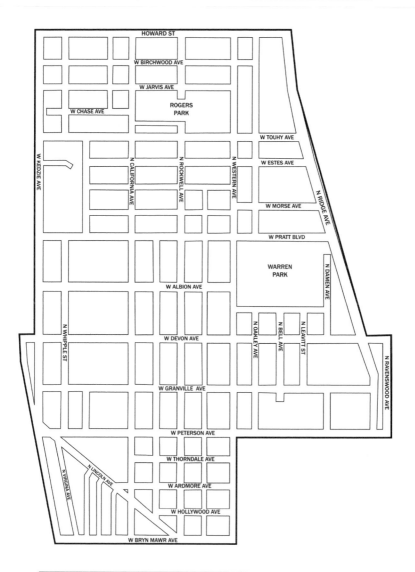

* Ridge Avenue (and Clark Street to the south) was originally called Green Bay Trail, used by the Pottawattamie and other tribes. The treaties in 1816 and 1829 moved the American Indians north of the Indian Boundary Line.

* Mather High School is named after Stephen Mather, the first director of the National Park Service. Its team nickname is the "Rangers." Seems fitting.

* The Golden Ghetto neighborhood was named for the Jewish community that settled here in the 1930s to 1970s. Many came around the time of World War II to escape the war and persecution.

* The North Shore Channel was created in 1910 as a drainage canal from Evanston to the Chicago River North Branch at Lawrence. There are many parks and a lovely paved trail along its banks.

* Devon Avenue is often called "Little India" and is home to Indian and Pakistani communities. The Indian section is nicknamed "Gandhi Marg," and the Pakistani section is called "Jinnah Road." Devon Avenue was named by early settlers who had come from Devonshire, England.

* The old Angel Guardian Orphanage was at Ridge and Devon. It was founded in 1865, and many children had harrowing experiences there. Misericordia's Heart

of Mercy Village took over the grounds in 1976 and developed a village environment. Misericordia provides a homelike setting for the developmentally delayed, centered on education and independence. On the campus, you can find the Greenhouse Restaurant and the Heartstrings Gift Shop, run by volunteers and residents.

* The Edgewater Golf Club was established in 1896 and moved to Ridge and Pratt in 1910. Developers wanted to buy it in 1965, but local organizations fought to save the open space. Governor Richard Ogilvie made it a state park in 1965, and it was named Warren Park. It was transferred to the park district in 1975. The golf course became the Robert A. Black Course, and the clubhouse was demolished. The large homes that were built nearby reflect the wealth of the club members.

* Rogers Park Manor Historic District is located from Western to California and from Lunt to Farwell. The area saw initial development in 1918, with various architects providing diverse bungalow styles.

* Mel Thillens opened North Towns Check Cashing Service in 1932 in West Ridge. He conceived the idea to send specially designed armored vans to companies on payday to cash employees' checks. It was later called Thillens Checashiers and still serves Chicago companies. He organized youth baseball and had Thillens Stadium

constructed on Devon near the North Shore Channel in 1938. A giant painted baseball was installed and greeted fans until 2013.

FAVORITE THING ABOUT WEST RIDGE

The neighborhood has made a comeback over the last fifteen years. There are architects who have moved into the area and have influenced the designation of the Talman Historical District. More families with children have settled here, and it is a safe, friendly community. Neighbors look out for each other in West Ridge.

Carol Veome
Rogers Park West Ridge Historical Society

PLACE OF INTEREST

Indian Boundary Fieldhouse
2500 West Lunt

Built in 1929, the fieldhouse was created by Clarence Hatzfeld, who designed many of the Chicago Park District fieldhouses, public schools, commercial buildings and private residences.

3. Uptown

BOUNDARIES
N—Foster Avenue
S—Montrose/Irving Park
E—Lake Michigan
W—Ravenswood/Clark

NEIGHBORHOODS

Uptown	Margate Park
Buena Park	New Chinatown
Sheridan Park	Clarendon Park
Little Vietnam	

HOW IT GOT ITS NAME
There are several possibilities. Most say that it was named because the first northbound train stopped here, heading "uptown" from the Loop. Others say that it was named after the Uptown department store that opened in 1905. Then there is the adjective usage of "uptown" meaning sophisticated and classy. In its heyday, Uptown was the glamor spot of the city.

DID YOU KNOW?
* In the Roaring Twenties and 1930s, Uptown was the entertainment district. Some of the grand destinations

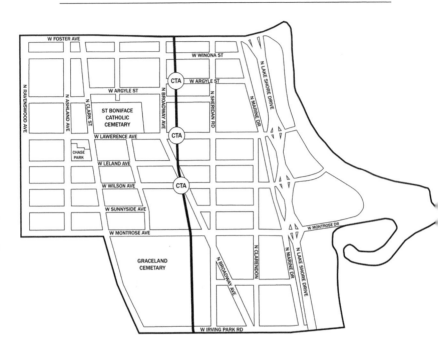

included the Aragon Ballroom, the Uptown Theatre, the Riviera Theatre and the Green Mill. The sounds of popular performers and bands filled the air. Al Capone frequented these hotspots. A tunnel under the Green Mill was originally used to deliver coal. It is said that Al and his gang escaped from police raids through this handy route.

* After the Great Depression and the Industrial Revolution, coal mining companies phased out three-fourths of the

miners' jobs. Many of the miners from West Virginia and Kentucky migrated to this area looking for work. Uptown was given the nickname "Little Appalachia."

* The American Indian Center of Chicago is located on Wilson. It was organized in 1953 to serve newcomers to Chicago. When the federal government relocated Native Americans off reservations and into the cities in 1950, many made Uptown their home.

* Graceland Cemetery, established in 1860, is located in Uptown. It is the burial site of many amazing people. Several architects are interred here, among them Louis Sullivan, John Root, Daniel Burnham, Ludwig Mies van der Rohe and Mary Mahoney Griffin. Jack Johnson, the first black boxer to become the world champ, is also buried here. Other notables include Dr. Daniel Hale Williams, John Kinzie, Melville Fuller, George Pullman, Marshall Field, Alan Pinkerton, Cyrus McCormick, Phillip Armour and many politicians. Splendid memorial markers abound in this peaceful setting.

* The Wilson Yard opened in 1900 on Broadway between Montrose and Wilson. It was the chief maintenance facility and storage yard for the Northwestern Elevated RR (Red Line "L"). It was closed in 1993 when a new facility opened at Howard. The Wilson Yard Redevelopment Project 2010 brought an apartment

complex and retail building—including the ever popular Target—to the site.

* Schlitz Brewing Company opened a tavern known as Winona Gardens at Winona and Broadway in 1904. Now known as the South East Asia Center, it became a Chicago Landmark in 2011.

* Essanay Studios was located at 1345 West Argyle from 1908 to 1917. George Spoor and Gilbert Anderson ("S" and "A"—get it?) started the company in 1907. St. Augustine College, which became the first bilingual institution of higher learning in Illinois in 1980, is now located at the site. But you can still find the Essanay name and Indian head logo on the old entrance to the studio.

* "Old-timers" remember Ma Skinner's Diner; Lieberman Drug Store; the 5100 comedy club, where Danny Thomas was discovered; the Rainbo Arena on Clark Street, where the Blackhawks sometimes practiced; Arcadia Ballroom, which also served as a roller rink and boxing ring; and Motor Row car showrooms on Broadway.

FAVORITE THING ABOUT UPTOWN

Two things stand out about the uniqueness of Uptown. One is the diversity of the residents, many who come from around the world to live here. It's that diversity that binds our community together. Second is the strong commitment of residents to improve

the Uptown neighborhood. I think it's a great place to live, own a business and raise a family, and I really believe that Uptown is moving in a positive direction.

Harry Osterman, alderman

The most interesting thing about Uptown is the incredible cultural diversity.

Sister Jean Hughes, resident

PLACE OF INTEREST

Uptown Theatre
4816 North Broadway

The theater was built in 1925 as a massive, ornate movie palace known as "an acre of seats." Many theater historians consider it to be the finest theater ever built. It was closed in 1981, but there are hopes and plans to restore it to its former splendor. It was designated a Chicago Landmark in 1991.

4. Lincoln Square

BOUNDARIES

N—Peterson/Bryn Mawr
S—Montrose Avenue
E—Ravenswood Avenue
W—Chicago River North Branch

NEIGHBORHOODS

Lincoln Square	Bowmanville
Ravenswood	Ravenswood Gardens
Budlong Woods	Welles Park
Rockwell Crossing	Summerdale

HOW IT GOT ITS NAME

In 1925, the Chicago City Council declared that the intersection of Lincoln, Western and Lawrence would be called Lincoln Square. The statue of Abe Lincoln wasn't dedicated at the site until 1956.

DID YOU KNOW?

* The prairie here was settled in the 1840s by mostly German farmers. Brothers Lyman and Joseph Budlong arrived in 1857 and built a pickle factory near Lincoln and Berwyn. They later erected Budlong's Greenhouse to provide flowers for Rosehill Cemetery.

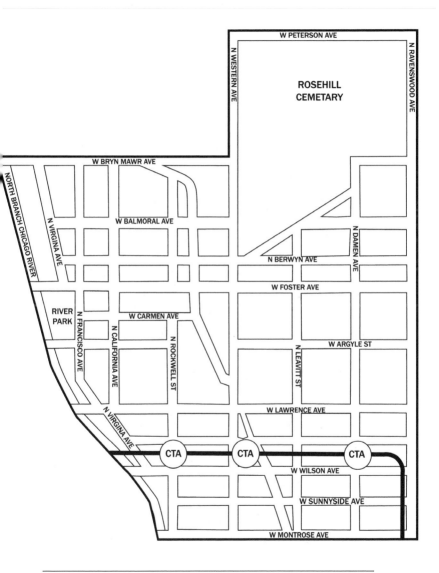

* In 1889, the settlements of Bowmanville, Summerdale and Ravenswood were annexed to the city of Chicago. Portions of these three villages formed Lincoln Square.

* Bowmanville was settled in 1850, when Jesse Bowman, who owned a local tavern, sold plots of land. But there was a catch: he didn't actually own the land. He skipped town soon after it was discovered.

* Sunnyside Inn was opened in 1859 on Clark near Montrose. It was a bordello and casino run by "Gentle Annie" Safford. It later became a respectable hotel where Abraham Lincoln and Stephen Douglas stayed.

* Merz Apothecary was opened in 1875 and still remains open today. Local physician and pharmacist Wallace Abbott started Abbott Laboratories here in 1888. Electric streetcars arrived in 1890, and the "L" line followed in 1907 to spur growth in the area.

* Lincoln Square Mall at the intersection of Lawrence, Lincoln and Western is the commercial heart of the community. Here you will find the Gidding Square fountain and the Lombard Lamp, both of which were gifts from the mayor of Hamburg, Germany.

* Lincoln Square was historically heavily populated by German immigrants. It is evident in monuments, restaurants

and organizations around the neighborhood. There is a thirty-foot maypole at Leland and Lincoln to celebrate the German tradition of welcoming spring. There is a Berlin Wall monument in the Brown Line Western station. The Dank Haus German American Cultural Center is located on Western near Lawrence. There are two huge festivals held every year to honor the German roots of the community. Don't miss the Chicago Brauhaus.

* The Conrad Sulzer Library is named after a Swiss immigrant who was the first settler in the area. In 1836, Sulzer bought property at Montrose and Clark that extended into Lake View and started a truck farm. He drove his produce in a cart down Little Fort trail to the markets in Chicago. He was very active in the township and gave many years of public service to the community. Montrose Avenue used to be called Sulzer Road.

* The Old Town School of Music is located on Lincoln Avenue. It is the largest school of its kind. It originally opened in 1957 in Old Town (of course) and moved to the site of the old public library in 1998.

* Rosehill Cemetery occupies 20 percent of Lincoln Square. Opened in 1864, it is the largest and oldest non-religious cemetery in Chicago. It is also the largest burial ground of Civil War soldiers in the Midwest. There are twelve Chicago mayors, four Illinois governors and

twelve Civil War generals buried here. Notable grave sites include those of baseball broadcaster Jack Brickhouse, International Olympic Committee president Avery Brundage, businessman A. Montgomery Ward, U.S. Vice President Charles Dawes and architect George Maher. The property was originally called Roe's Hill and was owned by local tavernkeeper Hiram Roe.

FAVORITE THING ABOUT LINCOLN SQUARE

It is like living in a small town but in the middle of a world-class city. It's the best of both worlds.

Lincoln Square Chamber of Commerce

PLACE OF INTEREST

Krause Music Store
4611 North Lincoln Avenue

This was the last building designed by Louis Sullivan in 1922. It was registered as a Chicago Landmark in 1977. The ornate terra-cotta façade was restored, and the interior was renovated in 2006 by Studio V Design.

5. North Center

BOUNDARIES

N—Montrose Avenue
S—Diversey Avenue
E—Ravenswood Avenue
W—Chicago River North Branch

NEIGHBORHOODS

North Center
St. Ben's
Roscoe Village
Hamlin Park

HOW IT GOT ITS NAME

The shopping district at the intersection of Irving Park, Lincoln and Damen took on the name of North Center in 1921 at the suggestion of local businessman Henry Moberg. This community area is practically in the center of the north side of Chicago.

DID YOU KNOW?

* In the 1840s, most of the land here was owned by John Kinzie and William Ogden (more street names!). Ogden was the first mayor of Chicago in 1837. The area was settled by German, Irish, Swedish and English farmers.

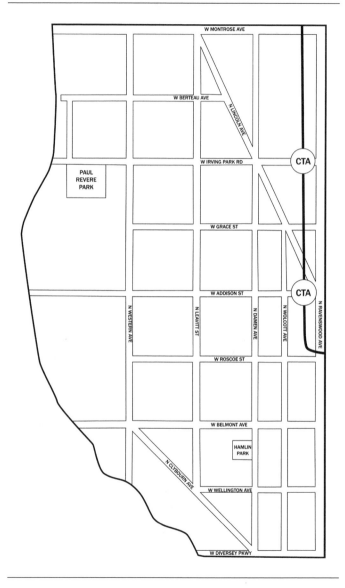

* The Great Fire of 1871 brought a demand for homes constructed of material other than wood. The Chicago brickyards were founded here along the Chicago River. High-quality clay pits were scattered along the riverbanks. The area was nicknamed "Bricktown." Old Chicago bricks are still in demand today. Lane Tech College Prep High School was built in 1934 over the old industrial site.

* The area was swampy, with "island" areas that were farmed. The North Branch of the river, between Addison and Lawrence, was straightened and deepened in 1907. The houseboat residents were moved out. Stopping the river overflow made the area more habitable, and the population expanded.

* From 1896 to 1918, the Selig Company operated a silent movie studio at Claremont and Byron. It produced and distributed hundreds of films. It made the first version of *The Wizard of Oz*; William Selig also discovered the actor Tom Mix. Selig has been called the "man who invented Hollywood." He left here for California and opened the first permanent film studio in Los Angeles. The "Diamond S" is still over the doorway of the present loft building.

* Bell and Howell was started by Albert Howell, who invented the film projector, and Donald Bell, a projectionist, in 1907 while Chicago was a center for moviemaking. They made equipment for the movie

industry in their factory, which was opened on Larchmont Avenue in 1914 and expanded in 1924. It was converted into condos; the clock tower is still there.

* Riverview Park was located near Belmont and Western from 1904 to 1967. A German social club purchased the land for a shooting range in 1888. Then two of the members bought the property, added the rides and originally called it Riverview Sharpshooters Park. Many Chicagoans have fond memories of the carousel, the roller coasters (like the Bobs and Silver Flash), the fun house, the Tunnel of Love and Shoot the Chute.

* The Eversharp Pencil Factory was located on Roscoe from 1924 to 1960. Chicago's first sit-down strike occurred here in 1937 but only lasted twenty-four hours because the police stopped all the workers' friends from passing in food. The building was converted into condos in 1990.

* WGN television studios are located here. WGN began airing in 1948 from the Tribune Tower. The first slogan of the *Trib*, the "World's Greatest Newspaper," was the inspiration for its call letters. The studios moved to Bradley Place in 1961. *Bozo's Circus* was a popular kid's show, *The Phil Donahue Show* was taped here and Chicago sports teams are followed on this station. It has been called the finest independent station in the United States. It became a national network in 1978.

* Half Acre Beer Company grew from humble beginnings in 2006. It recently added a taproom to its brewery on Lincoln. There are more than twenty-five local breweries in Chicago. Brews like Revolution, Metropolitan, Finch, Pipeworks and Atlas are also familiar favorites of beer lovers throughout the city.

Favorite Thing about North Center

Chicago's oldest food pantry has had many interactions with the residents, businesses, organizations and schools in North Center. The sense of community is amazing, and the desire to help those in need is inspiring.

Scott Best
Common Pantry

Place of Interest

St. Benedict's Church and School
2215 West Irving Park Road

The German Catholic farmers in the area were miles away from the closest school for their children. They started this parish in 1902 in a little wooden church and school. The members soon outgrew the worship space, and the present church was built in 1918. The St. Ben's neighborhood gets its name from the parish.

6. Lake View

Boundaries
N—Irving Park Road
S—Diversey Avenue
E—Lake Michigan
W—Ravenswood Avenue

Neighborhoods

Lake View	West Lake View
Wrigleyville	Belmont Harbor
Boys Town	Southport Corridor

How It Got Its Name

In 1854, a hotel called the Lake View House was built on the lake shore at Grace Street. A popular resort area was built up around it. Within a few years, the area bounded by Lake Michigan to Western Avenue and Fullerton to Devon was organized into Lake View Township. It became part of the city of Chicago in 1889.

Did You Know?

* In 1837, there were only two dirt roads in Lake View: Lincoln Avenue (Little Fort Road) and Clark Street (Green Bay Trail). The residents of the area then constructed the Lake View Plank Road, which ran from Diversey to Montrose. It is now

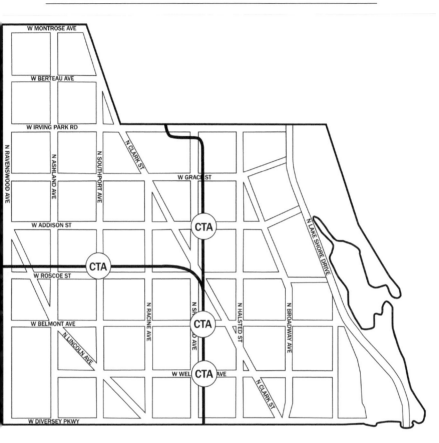

called Broadway Avenue. In 1856, a stagecoach line ran from the Lake View House to downtown Chicago. There was a cholera epidemic in Chicago during the years between 1848 and 1855. Residents fled to Lake View. Landowners began selling their property, and the village grew.

* Camp Fry was established at Clark and Diversey in 1864 to train the Illinois Infantry for the Civil War. It then became a POW camp to hold Confederate soldiers until the end of the war. Many of the detainees who died in the camp were buried at the nearby Rosehill Cemetery.

* The town hall was built in 1872 at Addison and Halsted. The district police station was located at the old town hall from annexation in 1889 until 2010, when a new facility was built next door.

* Lake View High School was built in 1874. It was destroyed by fire, and the current building was erected in 1886. It is the oldest secondary school in Illinois. Sections have been added over the years, and it now takes up an entire city block.

* Many Swedes and Germans moved into Lake View after the Great Fire of 1871. The Swedes built Trinity Lutheran Church in 1883. The Germans built St. Alphonsus in 1882. There was a Magdalen Asylum established in 1904 on Grace Street, where girls of "poor character" were held captive by the nuns.

* The beloved Wrigley Field was completed in 1914. It was first named (Charles) Weegham Field after the owner. He bought the Chicago Cubs in 1915. The field was sold to William Wrigley Jr. in 1920. It was called Cubs Park at

first, but in 1926, Wrigley named it after himself. The red marquee was put in place in 1934. The original vines were planted in 1937, along with the hand-turned scoreboard and bleachers, built by Bill Veeck. Ernie Banks popularized the nickname "Friendly Confines."

* Belmont Harbor is in Lake View. It was designed by landscape architect Ossian Simonds. The harbors were developed after the *Plan of Chicago of 1909*. The Chicago Park District runs ten harbors on the city lakefront. Belmont Harbor has been home to the Chicago Yacht Club Belmont Station since 1923 and the Belmont Yacht Club since 1973.

* Schlitz Brewing bought many saloons that would then sell its beer exclusively. Schuba's and Southport Lanes are two of the few remaining taverns to display the Schlitz globe logo relief on the building exterior wall.

* Alta Vista Terrace was made a Chicago Landmark District in 1971. It was placed on the National Register of Historic Places in 1972. A developer had visited England and admired the town homes there. He came back to build a block of row houses to serve as a bit of London in Chicago.

* The German flavor of the area has disappeared. Dinkel's bakery, on Lincoln since 1922, is one of the few remaining

reminders. Zum Deutschen Eck, Schwaben Stube, Math Igler's and all those German beer gardens are now gone. Lakeview has become a youthful, trendy, condo-filled area—a place to be seen.

FAVORITE THING ABOUT LAKE VIEW

We have loved the historic churches, buildings and pubs; the varied ages and ethnic roots of its population; and the turn-of-the-century graystones.
Steve and Teresa Laslo, longtime residents

PLACE OF INTEREST

Kwausila the Thunderbird Totem Pole
Lincoln Park at Addison

This showpiece was sculpted by Tony Hunt, chief of the Kwagul tribe of Vancouver Island, British Columbia, in 1986. It is a replica of the original totem pole that was erected in 1929. The Kraft Foods Company funded it as a gift to the children of Chicago. James L. Kraft started selling cheese in Chicago in 1903 from a horse-drawn wagon. He and his brothers went on to start processing cheese for distribution to retailers.

7. Lincoln Park

Boundaries
N—Fullerton Avenue
S—North Avenue
E—Lake Michigan
W—Chicago River North Branch

Neighborhoods
Lincoln Park Mid-North
DePaul Wrightwood Neighbors
Park West Ranch Triangle
Sheffield Neighbors Old Town Triangle

How It Got Its Name
In 1860, the city reserved sixty acres along the lakefront to be called Lake Park; it had been the City Cemetery. After the assassination of President Lincoln, the park was renamed. Lincoln Park was expanded from North Avenue to Diversey Avenue in 1869. Another expansion was made to Foster in 1934. The final expansion, to Ardmore, was made in the 1950s. The park now extends from Ohio Street Beach to Edgewater. Little Fort Road was also renamed Lincoln Avenue in 1865.

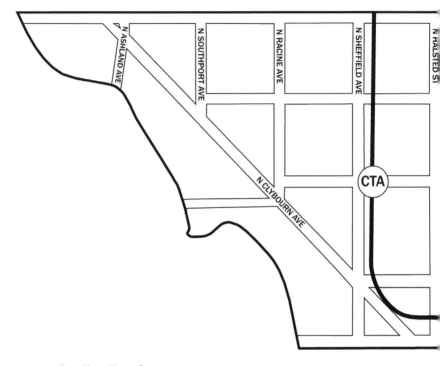

DID YOU KNOW?

* Michael Diversey donated property for St. Michael's Catholic Church in 1852. It became the heart of the German farming community here. Diversey came to Chicago in 1830 from Germany. English immigrant William Lill settled in Chicago in 1833 (more street names). In 1841, they bought the Haas and Sulzer Brewery together, the first commercial brewery in Chicago. It was renamed Lill & Diversey Brewery and

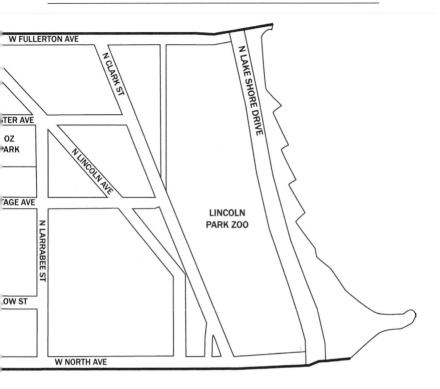

was sometimes known as the Chicago Brewery. It burned down in the Great Fire of 1871.

* DePaul University is the largest Catholic college in the nation. In 1875, the Vincentian priests, followers of St. Vincent de Paul, started a parish and school to serve children of the immigrants. St. Vincent's College opened in 1898 and was renamed DePaul University in 1907.

* The western part of the community, near the river, had been industrial since the 1800s. The eastern part, near the lake, was residential, with many mansions overlooking the park and lake.

* In the 1960s, Lincoln Park was targeted for "urban renewal." Many minorities were displaced via gentrification—the changes that occur when the wealthy acquire property that houses low-income individuals and families.

* There are many attractions to be found in the Lincoln Park community: the Lincoln Park Zoo, the Peggy Notebaert Nature Museum, the Chicago History Museum, the Lincoln Park Conservatory, the Theatre on the Lake and Caldwell Lily Pond.

* Second City Theater started on Old Town. It evolved from a group of students at the University of Chicago including Mike Nichols, Elaine May, Shelley Berman and Ed Asner. In 1955, the "Compass Players" started the first professional improvisation theater. In 1959, Second City was opened in a vacant Chinese laundry. John Belushi called it "the Oxford of comedy." It has a long list of successful alums to its credit.

* Old Town was originally named North Town. The community began sponsoring an annual art fair called "Old Town Holiday," and the name stuck. Old Town was

the home of many artists in the 1930s and many hippies in the 1960s, and it is the home of many yuppies now.

* Steppenwolf Theater was founded in 1974 by three high school and college friends: Jeff Perry, Terry Kinney and Gary Sinise. It has been located in Lincoln Park since 1982. The theater has helped launch the careers of many famous actors and has contributed to Chicago's reputation for distinguished theater.

* Crate & Barrel started on Wells in 1962. It had one employee then (and eight thousand now). It wanted to offer to Chicago stylish contemporary housewares at an affordable price.

* RJ Grunts opened in Lincoln Park in 1971 as the first restaurant of Lettuce Entertain You Enterprises, founded by Rich Melman and Jerry Orzoff.

FAVORITE THING ABOUT LINCOLN PARK

Lincoln Park is the ideal setting for my restaurant. It is classy, chic and exciting—just like North Pond.

Richard Mott, owner
North Pond Restaurant

PLACE OF INTEREST

Matthew Laflin Building
2001 North Clark Street

The first museum in Chicago was the Chicago Academy of Sciences. Natural history collections were displayed in 1857 at its location at Wabash and Van Buren. After the Great Fire of 1871, gunpowder tycoon Matthew Laflin donated funds to rebuild in Lincoln Park. The Chicago Academy of Sciences remained here from 1894 until 1999, when it moved and became the Peggy Notebaert Nature Museum. This refurbished structure became the Administration Building for the Lincoln Park Zoo.

8. Near North Side

BOUNDARIES
N—North Avenue
S—Chicago River
E—Lake Michigan
W—Chicago River North Branch

NEIGHBORHOODS

Gold Coast	Old Town
River North	Streeterville
Magnificent Mile	SoNo (south of North Avenue)
Washington Square	Rush Street

HOW IT GOT ITS NAME
It is very *near* and just *north* of the city center.

DID YOU KNOW?
* The area around the mouth of the river was called Checagou from an American Indian name meaning "wild leek" or "onion." The first nonnative permanent settlers were John Baptiste Point du Sable and his wife, Catherine. He was born in Haiti of African and French descent, and Catherine was the daughter of a Pottawattomie chief. They built a cabin on the north side of the river in about 1789 and established a farm and trading post. Pioneer

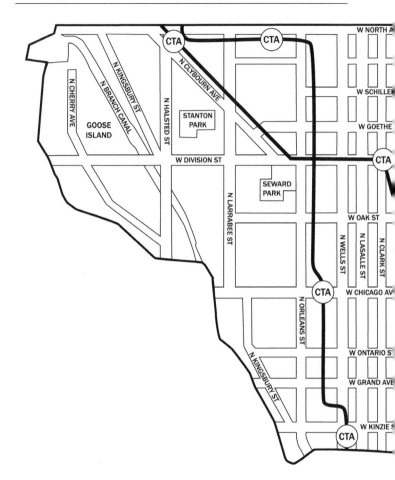

Court, the plaza at 401 North Michigan Avenue, has a bronze plaque commemorating the homesite. There is also a plaque identifying the campsite where Jacques Marquette and Louis Jolliet discovered Chicago in 1673.

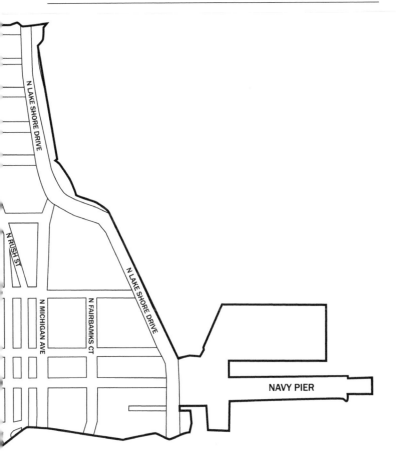

* Streeterville is named after "Cap'n" George Streeter. His steamboat ran aground in 1886. He filled in the land around it and claimed squatter's rights. Millionaire Nathaniel Fairbank (yet another street name) owned the shoreline and fought Streeter in court until 1918.

* Washington Square is also called "Bughouse Square." There is a memorial plaque naming it "Chicago's Premier Free Speech Forum." From 1910 to the 1960s, it was a place where soapbox orators came to preach about issues. There are still annual debates held by the Newberry Library.

* The Palette and Chisel Academy of Fine Arts was founded by students of the School of the Art Institute in 1895. In 1921, their club purchased an Italianate mansion on Dearborn. It still stands today to provide workspace for artists, art education and exhibits.

* Lake Shore Drive evolved from this area. In 1882, real estate magnate Potter Palmer managed to get a promenade and carriage way built in front of his lakeside mansion. It stretched from Oak Street to North Avenue. The Drive was extended north to Belmont in the 1920s, north to Foster in 1933 and on to Hollywood in 1957. The expansion south to Jackson Park was completed in 1934.

* Major attractions in Near North include the Newberry Library, the Water Tower, the Museum of Contemporary Art, Northwestern University, Loyola University and Centennial Fountain. Some of the great buildings are the Wrigley Building, the Tribune Tower, the John Hancock Building, the NBC Tower, Merchandise Mart, Trump Tower and the Marina City (aka "Corn Cobs"). Walk down Michigan Avenue and keep looking right and left.

* Navy Pier opened in 1916 as the Municipal Pier with both freight and passenger ships. During World War I, it housed sailors and recruits. Recreation and cultural activities resumed after the war. In 1927, it was renamed Navy Pier to honor the World War I navy personnel. The U.S. Navy moved out after World War II, and the University of Illinois moved in until 1965, when Circle Campus was built. In 1995, the pier was renovated and reopened to become the number-one tourist attraction in Chicago.

* Chicago treasure Studs Terkel grew up in the Near North. His parents ran a boardinghouse called Wells-Grand Hotel. He is a Pulitzer Prize winner who wrote about the oral histories of the common man.

* Developments like North Town Village and Parkside of Old Town have replaced the Cabrini-Green housing project, which stood from 1942 to 2010.

* The neighborhood between Oak Street and North Avenue was registered as the Gold Coast Historic District in 1978. After the Great Fire of 1871, large mansions were built in this area, and some still stand along Astor Street.

FAVORITE THING ABOUT NEAR NORTH

My favorite thing about living and working in the Near North Side is the easy access to the best that the city has to offer—the lake,

downtown, museums, theaters, restaurants, parks etc. and, since I bicycle everywhere, the bike paths that are starting to emerge on the north side.

*Carol Southard, resident
tobacco treatment specialist,
Northwestern Memorial Hospital*

PLACE OF INTEREST
*Plaza de las Americas
430 North Michigan Avenue*

Dedicated in 1996, this area honors the Organization of American States (OAS). There is a flag for each of the member countries. A sculpture of Benito Juárez, the famous Mexican politician, is located here as a tribute to the large number of Mexican immigrants in Chicago.

9. Edison Park

BOUNDARIES
N—Howard Street
S—Devon/Palatine Avenue
E—Harlem Avenue
W—Ozanam/Canfield Road

NEIGHBORHOODS
Edison Park

HOW IT GOT ITS NAME
The village was originally called Canfield. When developers began building residential subdivisions here in the 1880s, they installed six streetlights. They then called Canfield the first "electric suburb." In 1890, the town asked Thomas Edison, inventor of the lightbulb, if they could rename the community in his honor. He said yes, of course.

DID YOU KNOW?
* Edison Park is the farthest northwest community in Chicago. It was annexed into the city of Chicago in 1910.

* The Chicago and Des Plaines Rivers are only six miles apart here. This region was a summer camping spot for the

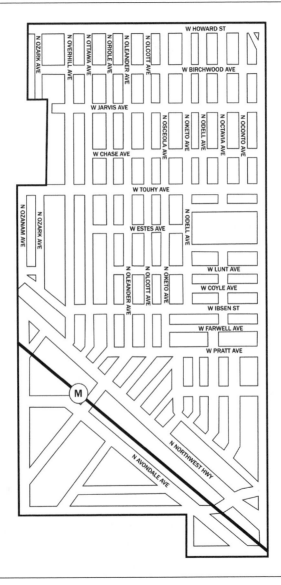

local American Indians. The area is on a ridge and was not as swampy as the surrounding land.

* Christian Ebinger; his wife, Barbara; and his parents were the first family to settle here in 1834. Rumor has it that they were on their way to Wisconsin when their only horse was bitten by a snake and died. So they decided that they had found "home" and started a farm. Christian's two brothers, Fredrick and John, and his sister, Elizabeth, joined them. Christian became the first pastor of the German Evangelical Association to be ordained in Illinois.

* The families of Jacob Wingert and Fredrich Blume followed. Wingert's son, John, married Blume's daughter, Dorothea. The settlement of German farmers was called "Dutchman's Point." The John Wingert House was built on Canfield Road in 1854 and became a Chicago Landmark in 1990. The Charles Turzak House on Olcott was built in 1938. It was designed by well-known architect Bruce Goff, who happened to be spending time at an artist colony in nearby Park Ridge. This home became a Chicago Landmark in 1992.

* The Old Trail Road is now Milwaukee Avenue. When the Ebingers and other farmers came here, it was simply a dirt lane running from the city center north to Wisconsin. The trail was covered with wooden boards, and it became a "plank road" in 1844. Finally, the wagons and horses could avoid the bumps and mud.

* When a railroad station was built here in 1853, developers made plans for a suburban community. That first old frame train station remained until it was replaced in 1959. The second station was demolished, and a new, attractive depot was built in 2011.

* In the 1890s, artist Emory Albright bartered two of his paintings for land and built a log cabin studio. His twin sons, Ivan and Malvin, also became prominent artists. Some of Ivan's works are included in the Art Institute of Chicago collection. Sculptor Leonard Crunelle lived nearby. Replicas of two of Crunelle's statues of Abraham Lincoln are located in the Lincoln Tomb in Springfield.

* Before the area became part of Chicago, the Northwest Highway was called Edison Park Avenue and was all residential. The houses were torn down after World War I and were replaced by storefronts. The area also experienced a growth spurt then, and many bungalows were added among the four squares and Dutch Colonial homes.

* The Edison Park Inn, located across the street from the Metra Station, has been a neighborhood icon since 1957. It is registered as an official "Blackhawks Bar" (the Blackhawks have approved locations throughout the city to best view their hockey games).

FAVORITE THING ABOUT EDISON PARK

Edison Park has a very small-town atmosphere, the kind where everyone knows your name. Edison Park also has a very rich history. For generations, residents have stayed in this community and built a foundation for the future and their children's future. It is a safe, charming neighborhood with terrific schools and a great sense of community.

Mary O'Connor, alderman

PLACE OF INTEREST

Monument Playlot Park
6679 North Avondale

This granite pillar is a memorial, with the names of the local men who served in World War I inscribed on it. The limestone eagle came from the old Cook County Courthouse, which was demolished in 1911.

10. Norwood Park

BOUNDARIES
N—Devon/Albion
S—Gunnison/Foster
E—Austin/Nagle
W—Ozanam/Cumberland

NEIGHBORHOODS

Norwood Park	Big Oaks
Old Norwood Park	Union Ridge
Oriole Park	

HOW IT GOT ITS NAME
In 1868, the Norwood Land Company bought up farms in the area and planned a village with many curving streets and an oval-shaped road called "the Circle." The name Norwood came from a popular book of that time. Clergyman and abolitionist Henry Ward Beecher (brother of Harriet Beecher Stowe) had written a novel called *Norwood* about a fictional New England town.

DID YOU KNOW?
* The first European settlers were Mark Noble Sr. and his family. They came to Chicago from Yorkshire, England, in 1830. He owned a sawmill and started the first Methodist

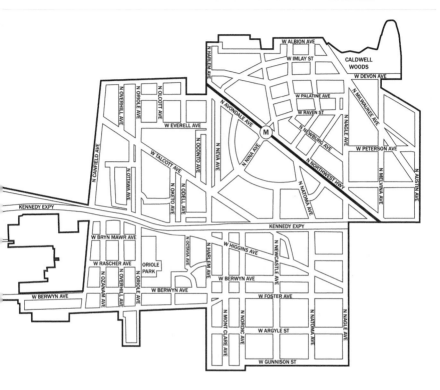

church in Chicago. In 1833, he acquired 150 acres at present-day Bryn Mawr and Newark. Noble Square and Noble Street in West Town are named after his sons, Mark Jr. and John Noble, who were civic leaders.

* Mark Noble Sr. died in 1839. His house had been built in 1833 and was sold to Thomas Seymour in 1868. It was later sold to Charlotte Crippen in 1916. It is the

oldest existing house in Chicago. Now called the Noble-Seymour-Crippen House, it is owned by the Norwood Park Historical Society. It is a city landmark and serves as a community center and museum.

* Charlotte Allen Crippen, a playwright, was married to a pianist. She started a community theater in the village and helped to build the first Baptist church. During World War II, she raised money for a hospital plane named the *Spirit of Norwood Park*.

* After the Great Fire of 1871, many gracious Victorian homes were built on large lots. The population was four hundred residents in 1880. The marshy northern section near the river was drained in 1910, enabling more development. The northwest section wasn't built up until after World War II. The Oriole Park neighborhood in the southwest section was constructed to house workers at the Douglas-Orchard Airport during World War II.

* The Norwegian Old People's Home was started in 1896 when Dr. Niles Quales bought the old Norwood Park Hotel. As the neighborhood grew, the name was changed to the Norwood Park Home and is now called Norwood Crossing.

* The Danish Old People's Home was built in Norwood Park in 1906. It is now the Danish Home of Chicago, a

senior living retirement community. Many Danes came to Chicago after defeat in the war with Prussia in 1864.

* Old Norwood Park is a historic district between Avondale, Harlem and Bryn Mawr. With its curved street pattern, it was developed to have a parklike layout. Informal horse races took place on "The Circle."

* The Passionist Monastery was built on Harlem in 1903. It is listed on the National Register of Historic Places. The building is now a senior residence center, and the architecture has been preserved.

* In 1920, the Sisters of the Resurrection bought fifty-two acres of the Anderson Onion Farm. They put it to use in 1953 when Resurrection Hospital was opened. Expansion began in the 1960s. The hospital was renamed Resurrection Medical Center, and the Resurrection Health Care system was organized in 1989. It became part of the Presence Health system in 2013.

* Jim Jacobs, the co-creator of the Broadway musical *Grease*, grew up in Norwood Park and attended Taft High School. The play is based on his 1950s rock-and-roll experiences here.

* Oddly, there is an unincorporated area on the western section of the community where residents

refused to become part of the city. Nearby Harwood Heights and Norridge are also unincorporated. These three unincorporated sections make up Norwood Park Township and are not included in the city of Chicago proper.

FAVORITE THING ABOUT NORWOOD PARK

Norwood Park has been referred to as the "hidden gem of the Northwest Side." It has beautiful homes leading back to the 1880s and the oldest building in Chicago. It has top-rated schools and business community.

Bea McDonough
Norwood Park Chamber of Commerce

PLACE OF INTEREST

Holy Resurrection
Serbian Orthodox Cathedral
5701 North Redwood Drive

Built in 1968, the interior of the cathedral is decorated with vibrant, colorful murals. The church has existed since the 1870s, when members first met in individual homes. There is a large Serbian population in Norwood Park. The annual "Serb Fest" is held on Serbian Road.

11. Jefferson Park

BOUNDARIES

N—Devon/Bryn Mawr

S—Lawrence/Gunnison

E—Chicago River North Branch/Metra railroad tracks/
Lavergne

W—Austin/Nagle

NEIGHBORHOODS

Jefferson Park Norwood Park East

Gladstone Park Indian Woods

Edgebrook Glen

HOW IT GOT ITS NAME

Jefferson Park was named after Thomas Jefferson, the country's
third president and writer of the Declaration of Independence.
In 1850, the farmers in the rural area between North Avenue
and Devon petitioned the state to form Jefferson Township.
The village of Jefferson was formed near Milwaukee Avenue
and Higgins in 1855 and was incorporated in 1872. The
whole township was annexed to Chicago in 1889.

DID YOU KNOW?

* John Kinzie Clark first came to Fort Dearborn in 1817 and
was hired to deliver mail between Chicago and Wisconsin

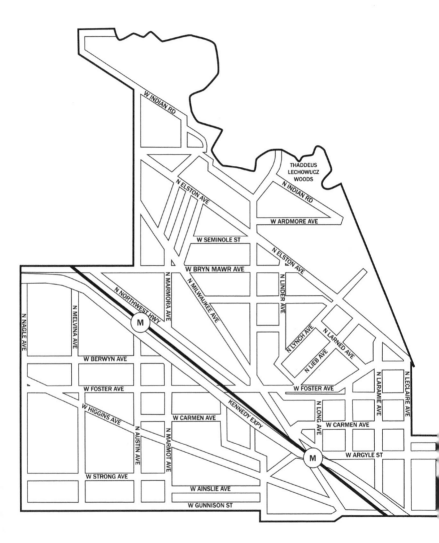

by horseback. He was the first settler to build a log cabin here in 1830. Six years later, he sold his cabin to J. Brownell and moved to Northfield. John Lovett and David Everett were other early squatters. The land wasn't legally offered for sale until 1838.

* Elijah Wentworth Sr., John Kinzie Clark's friend and fellow mail carrier, soon followed him here to build his tavern and inn. His wife, Lucy, and their daughters bought buckskins from the Indians and had a thriving business making gloves and mittens. The family was very active in organizing the local Methodist church. D.L. Roberts bought Wentworth's Tavern in about 1840.

* Martin Kimball established a farm and home here in 1837. The area was settled by English and German farmers in the 1830s. In 1850, there were only 115 households in the entire Jefferson Township.

* Sixteen-year-old Henry Esdohr and his fourteen-year-old brother, Herman, came alone from Prussia in 1866 and landed in the Jefferson Park area. Both became respected businessmen in the town of Jefferson. The farmers and travelers in Jefferson got their water from Henry's farm at Long and Higgins. The first Jefferson library was located in the farmhouse.

* The two main paths northwest from Chicago were Milwaukee Avenue (Old Trail Road and then Northwestern

Plank Road) and Elston Avenue (Woodstock Trail and then Lower Plank Road). Wealthy old codger Amos Snell owned parts of the roads and, to the chagrin of travelers, charged a toll in Jefferson Park, at Belmont Avenue and at Fullerton. When Jefferson Park was annexed to the city in 1889, citizens burned down the toll booths. Soon after, Amos Snell was found murdered. The case was never solved.

* The World War II monument stands at the site of an old watering trough for horses at Higgins and Milwaukee.

* In the 1880s, Jefferson Park was called the "Gateway to the City." It became a hub where farmers came to sell their produce and by which they trucked it into the city on the plank roads. That phrase is still appropriate today because of the Jefferson Park Transit Center. The CTA Blue Line, the Metra and many bus connections all meet here. There is a monument to Thomas Jefferson gracing the station.

* Important dates in Chicago transit: 1859—horse car service began; 1882—cable cars arrive; 1890—electric streetcars arrived; 1892—the first "L" rail line opened; and 1917—the first motor bus service was started. The "L" line names were changed to colors in 1993. More than 1.5 million riders use the "L" or buses every day.

* Metra was created in 1985 to bring a single identity to the many rail lines throughout the city. Chicago has more tracks

radiating in more directions than any other city. There are eleven lines, each with its own color, and 241 stations in the system. There are four downtown Metra stations.

* One of Chicago's largest Polish American communities resides in Jefferson Park. The Polish Cultural Center is located on Lawrence Avenue in the Copernicus Center. In 1981, it was moved into the old Gateway Theater, Chicago's first movie theater. The ornate interior was preserved, but the Solidarity Tower was added on the exterior to resemble the Royal Castle in Warsaw.

FAVORITE THING ABOUT JEFFERSON PARK

My favorite thing is the people. I have done many stories on the community, and it is great to see the energy and devotion of the local residents who volunteer to make Jefferson Park better.

Brian Nadig
Nadig Newspapers

PLACE OF INTEREST

Congregational Church of Jefferson Park
5320 West Giddings

This congregation was established in 1862 in a small wooden church. A second small church replaced it in 1896. This "new" church was built in 1929 in Classic Revival style.

12. Forest Glen

BOUNDARIES
N—Devon/Touhy
S—Foster Avenue
E—Cicero Avenue
W—Caldwell/Chicago River North Branch

NEIGHBORHOODS
Forest Glen	Wildwood
Edgebrook	South Edgebrook
Sauganash	Old Edgebrook Historic District

HOW IT GOT ITS NAME
The village was formed in 1874 and was named for Forest Glen, the estate of a Dr. Mercereau. The railroad station, built in 1883, was also given the name of Forest Glen.

DID YOU KNOW?
* The first owner of this land was Billy Caldwell, who was also known by his Pottawattomie name of Sauganash, which means "Englishman." His mother was a Mohawk Indian, and his father was an Irish soldier in the British army. Caldwell first came to Fort Dearborn in the fur trade business in about 1800. He became a well-respected representative of the Pottawattomie, Chippewa and Ottawa

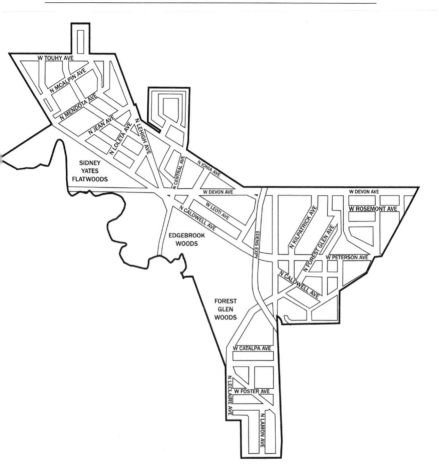

Indians during negotiations with the U.S. government. He received this land after his participation in the 1929 Prairie du Chien Treaty. It was called the "Caldwell Reserve." He and his wife built a cabin on the north side of the river near

Devon Avenue. In the 1833 Treaty of Chicago, the Indians ceded the last of their Illinois lands. In 1835, Billy Caldwell (street name) and his band of Pottawattomies moved west of the Mississippi River. He also has a neighborhood, a park, a school and even a golf course named after him.

* There is a bronze marker at the intersection of Caldwell, Rogers and Kilbourn that reads, "Old Elm Tree. The tree which stood here until 1933 marked the Northern Boundary of the Fort Dearborn Reservation, the trail to Lake Geneva, the center of Billy Caldwell's (Chief Sauganash) Reservation and the site of the Indian Treaty of 1835." Note that the treaty was signed in 1833; the Indians met here with the government to arrange for their departure in 1835.

* In 1840, Charles Johnson came from Sweden and bought some of Billy Caldwell's land. His farmhouse stood at Peterson and Cicero until 1955. In 1857, pioneer Captain William Hazelton acquired his land in this area through a grant for his service in the Civil War. He set up a community with an austere lifestyle and started the Congregational church. People who wanted to build here had to be interviewed, and there was to be no drinking, no smoking and no shenanigans. The Anderson family moved to Forest Glen to be neighbors to their friend William Hazelton. They built the Swedish Methodist Church in the 1870s, and it stood until 1976.

* In 1914, the Dixon Land Company developed a subdivision of fourteen homes for railroad executives to the east of the train station. This historic neighborhood is now called Old Edgebrook. There are now about fifty homes in this neighborhood, surrounded by the forest preserve. The Mary Burkemeier Quinn Park of Trees is a gift from her husband, Edward Quinn. His will instructed that his house be torn down and his property become a park in 1980.

* John Gray had a hotel here from 1850 to 1855 before he moved to Irving Park. The Sauganash neighborhood was started in 1922 on the land previously known as Gray's Farm. Nearly one hundred English Tudor– and Georgian-style homes were built. The first train service here was started in 1924. Developers built a community center on Peterson in 1927, and it was the only building on the block until 1944. It became a church in 1952. The Wittbold Nursery became the neighborhood of Wildwood.

* This area of stately, distinguished homes has a complex layout of streets—some are winding and some angled. Many of the streets have American Indian names. In the 1970s, when the mayor required city employees to live within Chicago boundaries, many administrators were attracted to this lush neighborhood.

Favorite Thing about Forest Glen

My favorite thing about Forest Glen is the neighborliness that runs from north to south and east to west. Living in the Glen, you can count on your neighbors to be friendly over the fence, shovel some of your snow just to be nice, share some tomatoes and give you a sidewalk-supervisor commentary when putting up your Christmas decorations.

Robert Murphy, president
Forest Glen Community Club

Place of Interest

Queen of All Saints Basilica
6280 North Sauganash

This parish was formed in 1929, and this new church was completed in 1966. It was designed in the Gothic style by Meyer & Cook Company. It was designated as a basilica by the Vatican because of its grand architecture.

13. North Park

Boundaries
N—Devon Avenue
S—Foster/Chicago River North Branch
E—North Shore Channel
W—Cicero Avenue

Neighborhoods
North Park Pulaski Park
Brynford Park Sauganash Woods
Hollywood Park

How It Got Its Name
In 1893, a group of Swedish American investors bought up farmland to form a subdivision. They advertised, urging Swedish immigrants to buy lots in "North Park." They also gave some of the area to Swedish Covenant College hoping to entice more people into the neighborhood and raise land values.

Did You Know?
* North Park University has its roots in the Swedish Covenant College. The Evangelical Covenant Church, which began in the North Park area in 1885, started a college in a Minneapolis church basement in 1891. After

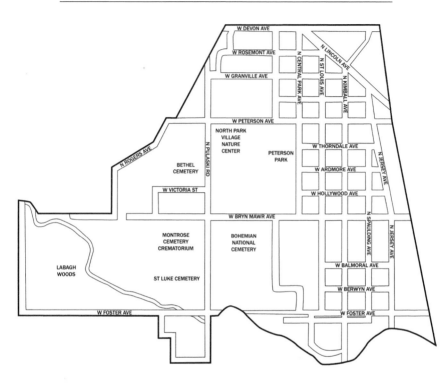

receiving the land from their fellow Swedes, they moved to their site along the Chicago River North Branch and became North Park College in 1894. In 1886, the church also started the "Mercy Home," which evolved into Swedish Covenant Hospital.

* Northeastern Illinois University is also located in North Park. It is a public state university with an enrollment of almost twelve thousand students on its sixty-acre campus.

The Chicago Teachers College opened a branch on the north side of Chicago in 1953, with classes held in local schools until it relocated to North Park in 1961. It was acquired by the state in 1967 and changed its name to NEIU. Its value statement reads, "Integrity, Excellence, Access, Diversity, Community."

* The Municipal Tuberculosis Sanitarium was located at Bryn Mawr and Crawford from 1915 to 1974. In 1910, ten thousand people were dying each year from tuberculosis, which was also called the "Great White Plague" or "consumption." The fenced area of 160 acres held men's and women's quarters, staff cottages, an administration building, a dining hall, a tunnel system and even a farm. The wonderful North Park Village Nature Center and Peterson Park are now situated on most of the site.

* Pehr Peterson (street name), a Swedish immigrant, came to this area in 1845. He established a large nursery and sold many of his trees to the city parks. He became known worldwide for his horticultural expertise. In 1911, the city bought his land for the building of the sanitarium.

* In 1980, Pehr Peterson's old property, the land that was home to the tuberculosis campus, was scheduled to be developed into strip malls and condos. The residents protested loudly and received approval to create the North Park Village Nature Center. There are forty-six acres of

nature preserve and an educational facility housed in the old sanitarium dispensary. Every year, a Maple Syrup Festival is held to tap the trees that Pehr Peterson had planted.

* North Park developed slowly. The number of residents was fewer than five hundred in 1910. Many bungalows and two-flats were built in the 1920s. The area had grown to a population of eleven thousand by 1930. The population is now more than twenty-two thousand.

* During World War II, Camp Sauganash was established in LaBagh Woods for the military police. After the war, the Sauganash Housing Project was built for temporary homes of returning veterans. It was torn down in 1955, and the land reverted back to the forest preserve.

* There are still signs of the Swedish history of North Park. The Swedish Shop has been located on Foster since 1950. Tre Konor is a popular Swedish restaurant. Blackhawks player Niklas Hjalmarsson has gone there for skagen and folekoda and says that it reminds him of home. The Swedish American Archives of Greater Chicago are housed in North Park University.

* WTTW, your "Window to the World," has offices and studios located in North Park. In 1952, when the creation of more TV channels was permitted, the Chicago Educational Television Association established a new public television

station. It first aired in 1955. It brought us our beloved Siskel and Ebert.

FAVORITE THING ABOUT NORTH PARK

We moved here because the public schools are superior. We stayed because crime is low; the parks are close by; the community has a little bit of every kind of race, color, ethnicity and sexual orientation; and our neighbors are awesome! My biggest worries are airplane noise and deer eating my plants.

Jewel Klein
Hollywood North Park Community Association

PLACE OF INTEREST

Bohemian National Cemetery
5255 North Pulaski

This cemetery was founded in 1877 by a group of Czech, Moravian and Slovak immigrants. A large Gothic-style gatehouse adorns the entrance. Creator of the Chicago Democratic machine Mayor Anton Cermak and many of the victims of the *Eastland* ship disaster are buried here. The Beyond the Vines mausoleum was erected for Cubs fans in 2005. It is made of bricks covered with ivy and even has a row of stadium seats.

14. Albany Park

BOUNDARIES
N—Foster/Chicago River North Branch
S—Montrose Avenue
E—Chicago River North Branch
W—Cicero/Elston

NEIGHBORHOODS

Albany Park	Ravenswood Manor
Mayfair	Koreatown
North Mayfair	

HOW IT GOT ITS NAME

Transportation and land speculation seem to go hand in hand. In 1893, a group of investors bought lots of land in this area. One of them, streetcar tycoon DeLancy Louderback, was from Albany, New York, and got to pick its name. The developers brought in electric streetcars on Lawrence in 1896. A real building boom took place after the Brown Line came to Kimball and Lawrence in 1907.

DID YOU KNOW?

* English immigrant William Harding (street name) received a land grant in the area in 1836. Richard and

Cornelia Harding Spikings were married in a cabin near the Chicago River North Branch at Hamlin in 1840.

* Peter Erickson and his family emigrated from Sweden in 1846. Erickson established a farm in the area that is now North Mayfair. For thirty years, his daughter, Jennie Peterson, ran the "Little Red School House" at Lawrence and Kostner. An artesian well was formed to the west of the school. The local farmers would come there daily to fill their water barrels.

* Richard Rusk was also an early settler here. He bought ten acres of land along the river in the northeast portion of the area in 1868. He built the Rusk harness horse racing track, which proved to be a popular place for gamblers from the city. The Diamond Race Track was started by Jack Diamond in the southeast corner of the area in 1883. It burned down in 1900. Marshall Field and Cyrus McCormick ran their horses there. In 1890, there were only two farms and unclaimed land in the section to the west of the racetracks. By 1930, there were fifty-five thousand people living in Albany Park.

* Dr. Norine Spencer and her husband, Dr. Charles Spencer, graduated from medical school and moved to Albany Park in 1908. They did house calls on foot, and there was no bridge over the Chicago River North Branch except for a small footbridge at Spaulding. They reported that the streets were not paved, and there were wooden sidewalks

with snakes crawling up through the boards. Lamplighters lit the streetlights at dusk.

* Ravenswood Manor is a historic district. This area of primarily single-family residences was developed in 1909 in the eastern part of this area. It was advertised as "First Suburb Beautiful of the New Chicago." It even provided motorboat tours on the river.

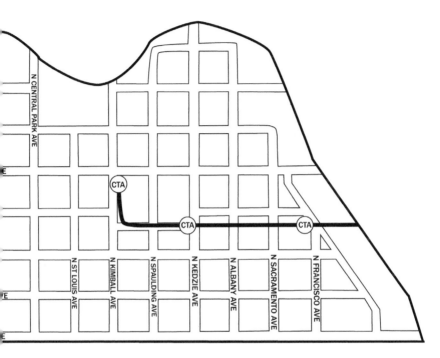

* German and Swedish farmers settled the area. Russian Jews began immigrating here in 1912. Albany Park was predominantly Jewish until the 1950s exodus to the suburbs. When so many people left, the area deteriorated, and absentee landlords came in. Urban renewal began in 1978, and a tree and landscaping plan was developed to beautify the neighborhood.

* In the 1980s, the area became home to the largest population of Korean immigrants in the city. Their presence is felt with the Korean Cultural Center, an annual Korean street festival and the offices of the *Korea Times* newspaper. Lawrence Avenue is nicknamed "Seoul Drive."

FAVORITE THING ABOUT ALBANY PARK

Albany Park is called "Chicago's Gateway to the World." Enjoy a dazzling array of award-winning restaurants, markets, bakeries and retail shops on Chicago's Northwest side. There is truly something for everyone here!

Albany Park Chamber of Commerce

PLACE OF INTEREST

Bungalow Historic District of North Mayfair
Foster to Lawrence and Pulaski to Kilbourn

Between 1910 and 1930, more than eighty thousand bungalows were built in the city. Chicago bungalows are one-and-a-half-story homes of brick construction with low-pitched roofs and offset entrances.

15. Portage Park

BOUNDARIES

N—Lawrence/Gunnison
S—Belmont
E—Kenton/Cicero
W—Austin/Narragansett

NEIGHBORHOODS

Portage Park Six Corners
Old Portage Park Wladyslawowo
BelmontCentral

HOW IT GOT ITS NAME

The definition of "portage" is the carrying of boats overland between two waterways or the track used in such carrying. American Indians and trappers carried their canoes five miles through this area over a marshy trail between the Des Plaines and Chicago Rivers. During the rainy season, the path would flood, and they could actually row their canoes across most of it. The Portage Park District was organized in 1912, and the name was adopted by the community.

DID YOU KNOW?

* Settlement began in 1841 when Sutherland's Inn was built on the Old Trail Road (Milwaukee Avenue) north

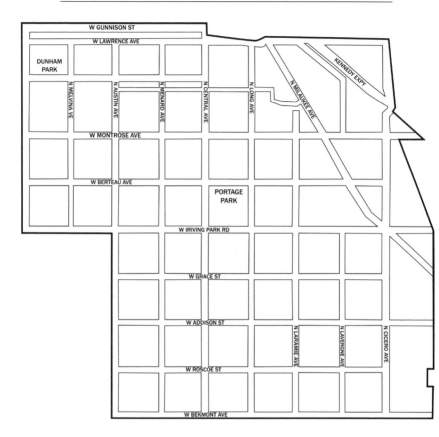

of Irving Park Road. A few years later, Chester Dickinson bought it and named it the Dickinson Tavern and Inn. It became a very popular place, and Jefferson Township was planned at a meeting held there. The inn was torn down in 1929; it was claimed to be the oldest brick building in Chicago at that time.

* Six Corners refers to the intersection of Irving Park, Cicero and Milwaukee. The Jefferson Township Town Hall was built at this intersection in 1862. In the 1870s, this area was a commercial center with a general store, a grocery and a bakery. Then, when Sears opened a store there in 1938, it became a very popular shopping district.

* There have been three grand movie palaces here. The Portage Theater, built in 1920, has been renovated and is now a showcase for independent films and music artists. The Patio Theater, built in 1927, has also been restored to its former glory and is a movie theater. Sadly, the Belpark Theater's lifespan only lasted from 1927 to 1955.

* The population tripled in the 1920s. As Polish residents climbed the economic ladder and moved out of their original neighborhoods to more middle-class surroundings, many settled in Portage Park (as well as in Belmont Cragin and Avondale). Recent immigrants from Communist Poland have also settled here. Wladyslawowo refers to the neighborhood around St. Ladislaus Church. Most Polish "patches" are centered around the local church. Polish immigrants have been in Chicago since 1837, and the city has claimed to have the largest Polish population outside Poland. Portage Park has the largest number of Poles of any community area. Chopin Park was named after the famous Polish composer and pianist. The Polish American Association, Millennium Polish Bookstore, Polish delis,

American Polish Aero Club and Polish-language schools can be found in this community.

* The convent of the Sisters of Nazareth is located here. The nuns came to Chicago from Rome in 1885 to minister to the Polish immigrants. They established St. Mary of Nazareth Hospital in 1894 during the nation's economic panic. Polish Jesuits came to Chicago in 1934 to serve Catholic Polish immigrants. The Jesuit Millennium Center was built in 2001 for the Sacred Heart Mission parish.

* Polk Bros. stores were familiar Chicago retailers from 1935 to 1992. Sol Pokovitz, who shortened his name to Polk in high school, and his brothers started their first appliance dealership on Central Avenue near Belmont.

* The National Veteran's Art Museum has been located at Six Corners since 2012. The Vietnam Veterans Arts Group was formed in Chicago in 1981, and its mission now includes all veterans.

Favorite Thing about Portage Park

Searching for great housing stock, including but not limited to brick bungalows? How about a great shopping district featuring Six Corners? Throw in convenient transportation and what I believe to be one of the more beautiful parks in Chicago, then I welcome you to Portage Park.

Twadar ("Ted") Szabo, realtor
past president, Portage Park Chamber of Commerce

PLACE OF INTEREST

Portage Park
4100 North Long

The park was created in 1913 by local citizens. The grounds cover an entire city block, with beautiful pathways and even a fenced dog walk. The Prairie-style fieldhouse was designed by Clarence Hatzfeld. An Olympic-sized pool replaced the old pond in 1959. The swimming events of the Pan American Games were held at the pool in 1959. The U.S. swimming trials for the 1972 summer Olympics were also held here.

16. Irving Park

BOUNDARIES

N—Montrose/Lawrence
S—Addison/Belmont
E—Chicago River North Branch
W—railroad tracks at Kenton

NEIGHBORHOODS

Irving Park
Old Irving Park
Villa District
Kilbourn Park
Merchant Park

West Walker
Little Cassubia
California Park
Independence Park

HOW IT GOT ITS NAME

In 1869, Charles Race from New York purchased farmland in this area from Major Noble. Race and some family members brought in other investors, who also contributed land. The group realized that access to railroad transportation would make development of the land very profitable. They made a deal with the railroad that if Mr. Race built a depot, the train would stop there. They decided to name the settlement after another New Yorker, Washington Irving, who had written *The Legend of Sleepy Hollow* and *Rip Van Winkle*. There was already a village called Irvington in southern Illinois, so

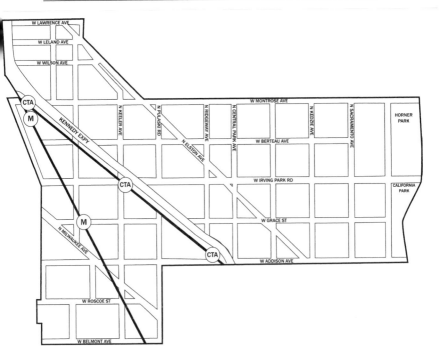

they picked the name Irving Park. Old Irving Park, west of Pulaski, has large homes with large lots on the land of the old Race farm.

Did You Know?

* Major Noble established a farm here in 1843. His house doubled as the Blackthorn Tavern to serve travelers along the Woodstock Trail (Elston Avenue). James Gleeson opened the Seven Mile House at the site in 1881. The Elston and Montrose intersection was known as Gleeson's Corners.

* Irving Park Road was originally an Indian trail. It later was called the Western Plank Road. The road was renamed for the area in 1870.

* In 1873, John Gray sold parts of his farm to start a settlement. The village of Grayland later became part of Irving Park. The Metra Grayland Station is still in use today. John Gray went on to be the sheriff of Cook County. Built in 1856, his home on Grace Street is still standing. The old Grayland Theater façade can still be seen at Irving Park Road and Cicero.

* John and Clara Merchant had a house built in the area in 1872. It is located on Kostner and is a Chicago Landmark. Clara was the daughter of John Gray, and she married John Merchant in 1856. Merchant Park is named after them.

* After the Chicago Fire of 1871, many people rushed to Irving Park to replace lost housing. The Dutch Reform Church, the first church in the area, was built in 1872 at Keeler and Belle Plaine. It remained the only place of worship in Irving Park until 1885. There was another building boom from 1900 to 1920, when most of the houses in this area were constructed.

* The Villa District was developed in 1902. Many of the homes were built in the Craftsman or Prairie style. The neighborhood marked the northwest end of the Polish Corridor along Milwaukee Avenue. It was known as Polskie

Wille (Polish Villas), but newspaper columnist Mike Royko called it the "Polish Kenilworth."

* In 1935, a group of immigrants from Latvia formed the Chicago Latvian Association. They purchased their community center on Elston in 1958 and added the Folk Art Museum to the site in 1964. The Irish American Heritage Center has been on Knox near Lawrence since 1985. A group of immigrants and first-generation Irish bought and renovated the old Mayfair Junior College. The center has a cultural center, a library, a ballroom, an auditorium and even an Irish pub. The Irish are the largest ethnic group in the city of Chicago.

* The Northwest Expressway was opened in 1960 to connect the Loop with O'Hare and the Northwest Tollway. It was built right through the middle of Irving Park and displaced many homes and businesses. The name was changed to the John F. Kennedy Expressway two weeks after the president's assassination in 1963.

FAVORITE THING ABOUT IRVING PARK

Old Irving Park is the best of city living. We are in an urban setting, ten minutes from downtown and O'Hare, but we foster a strong, tight-knit community of neighbors who care about each other and our neighborhood. It's a place to call home, not just a five-year pit stop before moving to the suburbs.

Lynn Ankney
Old Irving Park Association

The best thing about the Independence Park neighborhood is the sense of community that unites us—more than one person has said, "It's like a small town in the middle of the city." People move into this neighborhood not only because they want a house…they want a home.

Jim O'Connor
Greater Independence Park Neighborhood Association

PLACE OF INTEREST

Stephen Race House
3945 North Tripp

The house was designated as a Chicago Landmark in 1988. Stephen Race was the brother of Charles Race, Irving Park's founder. All of the men who developed the area built large, impressive homes for themselves. Sadly, most have been demolished.

17. Dunning

BOUNDARIES
N—Irving Park/Montrose
S—Belmont/Wellington
E—Austin Avenue
W—Cumberland Avenue

NEIGHBORHOODS

Dunning
Schorsch Village
Belmont Heights

Belmont Terrace
Irving Woods
Ridgemoor Estates

HOW IT GOT ITS NAME

Canadian D.S. Dunning came to the area in 1838 and made a land claim. He marked the borders of his property with deep furrows, a custom of early settlers. Some of his acreage was sold in 1841 to Cook County, which retained his name. Andrew Dunning bought 120 acres of land here after the Civil War.

DID YOU KNOW?

* In 1845, Cook County established its "poorhouse" out here in this remote part of the county. It was called an almshouse and touted to help the destitute, abandoned and homeless, but most people did not come here voluntarily.

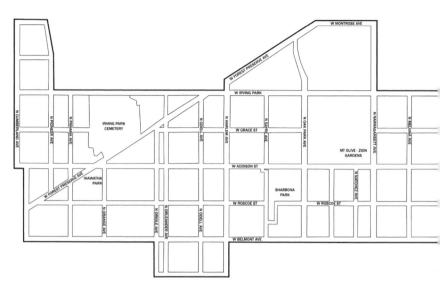

They were sentenced to do farm work and lived a miserable existence. In 1884, the Cook County Infirmary replaced the poor farm. It was moved to Oak Forest in 1911. The facilities were more than two miles away from a railroad station. In 1882, the county had a rail extension built to the complex and named the depot Dunning.

* The poor farm had an "insane" department, and in 1870, the Cook County Insane Asylum was built. It became known as the Cook County Institute at Dunning. Chicago parents would admonish their misbehaving children, saying, "Watch out or you'll go to Dunning." In 1912, the state took over and named it Chicago State Hospital. Most

people just kept calling it Dunning. In 1970, it became the Chicago Read Mental Health Center. The name changes reflect growth in the understanding of mental illness.

* In the 1990s, development of the area led to a shocking discovery when the construction unearthed hundreds of bones. Developers had found a forgotten graveyard. From 1854 to 1924, this was a potter's field where thirty-eight thousand unknown and itinerant poor, inmates from the poorhouse and insane asylum, 117 unidentified victims of the Chicago Fire of 1871 and orphaned children were buried. The Read Dunning Memorial Park near Irving Park and Narragansett was dedicated in 2001.

* Henry Kolze owned a tavern and the surrounding forestland. In 1910, he established Kolze Electric Grove. He strung up lamps, built a dance pavilion and provided orchestras, concession stands and a picnic area. Merrimac Park is now located on this popular spot. The Ridgemoor Estates residential area was built in 1980 on the rest of his property.

* Schorsch Village was built by four Schorsch brothers in 1916 (street name). They named Schorsch Avenue in honor of their father, Anthony. It was originally marketed as being in West Portage Park because they wanted to avoid association with the Dunning institutions.

* Forest Preserve Road runs along the Indian Boundary Line that was formed in a treaty in 1816. The line extended at an angle from Rogers Avenue in Rogers Park down through this area.

* There are three cemeteries in Dunning. Zion Gardens is a cluster of Jewish cemeteries first established in 1884. Illinois governor Henry Horner is buried here, along with architect Dankmar Adler and community organizer Saul Alinsky. Mount Olive Cemetery was developed by the Scandinavian Cemetery Association in 1886. Irving Park Cemetery was opened in 1918.

* The section north of Irving Park Road was bought from Cook County in 1980 and was added to the community area.

FAVORITE THING ABOUT DUNNING

Residents in Dunning have the best of both worlds—close proximity to the exciting city life but a safe and quiet neighborhood to call home. We also have a beautiful new library, great schools, a community garden and the new Dunning Neighborhood Organization (started January 2014). Dunning is a great city neighborhood on the rise!

Melissa Kaszynski, co-founder
Dunning Neighborhood Organization

PLACE OF INTEREST

Wilbur Wright College
4300 North Narragansett

It is one of the seven City Colleges of Chicago. The twelve thousand students receive associates degrees, vocational training and adult education. The other six City Colleges are Harold Washington in the Loop, Harry S Truman in Uptown, Kennedy-King in Englewood, Malcolm X in Near West Side, Olive-Harvey in Pullman and Richard J. Daley in West Lawn.

18. Montclare

BOUNDARIES
N—Belmont Avenue
S—Metra railroad tracks
E—Nashville/railroad tracks spur
W—Harlem Avenue

NEIGHBORHOODS
Montclare

HOW IT GOT ITS NAME
In 1873, land developers came to the area with the arrival of the railroad. They named the town Montclare after the city of Montclair, New Jersey. The train station name was changed to Mont Clare in 1874.

DID YOU KNOW?
* The first settler in the area was Joseph Lovett, who claimed land in 1834. His daughters married neighbors Joseph Rutherford, who had started a farm here in 1845, and William Sayre. Early settler William Sayre (street name) claimed land in 1836 and then, not able to gain title, had to buy the farm at the Jefferson Township Land Sales of 1838. He and other farmers who labored here used Grand Avenue, an old Indian trail then known as Whiskey Point Road, to take their

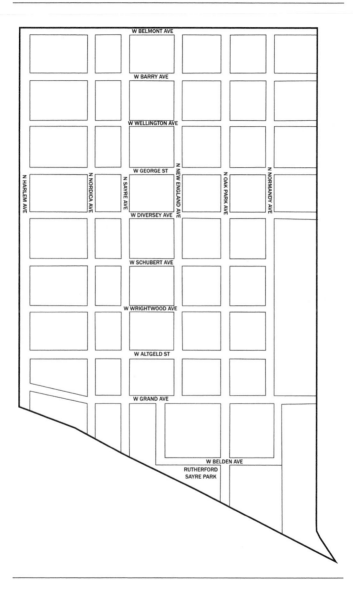

produce to the downtown markets. In 1872, Mr. Sayre gave the railroad right-of-way through his land; the Sayre train station was built, and a subdivision was platted.

* Thomas Rutherford (street name) was the first postmaster in Montclare. He donated property to the town for parkland, stipulating that it must contain a bowling alley. William Sayre also contributed land, leading to the creation of Rutherford Sayre Park.

* Montclare was still a small community in 1874 with only fourteen houses and a population of 120. Development was slow because the train stopped there only once a day. Then the Grand Avenue streetcar started service in 1907, and more residents followed. Most of the charming brick bungalows and Tudor homes were built in the 1920s. The intersection of Grand and Harlem became a thriving shopping district.

* Montclare is considered the heart of the Italian community of the Northwest Side. As Italians left the city center, they moved out along Grand Avenue to find peaceful tree-lined streets with a variety of housing styles. Harlem and Grand is called Little Italy on an honorary street sign. Many Italian restaurants and residents are nearby.

* Montclare is home to the Shriner's Hospital for Children Chicago. It has provided free orthopedic or rehabilitation

care, pediatric specialty care and social services for families since 1926.

* Montclare Theater was located on Grand Avenue from 1929 until 1985. Like many theaters in the 1930s, owners gave away free chinaware to "every lady purchasing a 30 cents ticket." The collections contained sixty-five pieces, so many more tickets were bought to complete the set.

* Want to try a true Chicago hot dog? Luke's on Harlem has been featured on the *Chicago's Best* TV show. The real thing consists of a Vienna hot dog on a poppyseed bun topped by yellow mustard, sweet green pickle relish, chopped onion, tomato wedges, a dill pickle spear and celery salt. No ketchup!

* Playboy Club founder Hugh Hefner grew up in Montclare. He said that he lived here when the streetlights were gas and when milk, ice and coal were delivered by horse-drawn wagons. Hefner attended Steinmetz High School.

* The Montclare TIF was designated in 2000 to support the construction of the senior housing complex—Montclare has an elderly population of 21 percent. TIF stands for Tax Increment Finance. It is public funding to a private developer for projects in "vacant blighted areas." A TIF is supposed to improve a distressed area and increase the tax revenue base. TIF abuse occurs when a project would have been built anyway, an area is declared blighted when

it really isn't and when politicians funnel money to friends who are developers.

FAVORITE THING ABOUT MONTCLARE

The people of Montclare are fantastic. They are very friendly and are like family. They make the best customers. Since we have been in business for twenty-nine years, even the second generation is coming in.

Agostino Fiasche
Ristorante Agostino Gustofina

PLACE OF INTEREST

Galewood-Montclare Library
6871 West Belden Avenue

The Galewood-Montclare Library was based in a small room in the Rutherford Sayre Park Fieldhouse until citizens fought for a new building in 2010. The Chicago Public Library has more than seventy locations in the city. The first library was opened in 1873 at LaSalle and Adams in a water station that had survived the Great Fire of 1871. England had donated more than eight thousand books to the city after the fire. A system of book delivery to neighborhood outposts started in 1874. The grand Central Library (now the Cultural Center) was built in 1897. The Harold Washington Library Center replaced it in 1991.

19. Belmont Cragin

BOUNDARIES

N—Belmont Avenue
S—Metra railroad tracks
E—railroad tracks at Kenton
W—Nashville/railroad tracks spur

NEIGHBORHOODS

Cragin	Belmont Central
Brickyard	Hanson Park

HOW IT GOT ITS NAME

Early manufacturer Cragin Brothers & Company opened a plant here in 1882. It made all sorts of metal products. It had the Cragin railroad stop built at Leclaire Street to service its workforce. Many industries followed, the population increased and the town of Cragin blossomed. The Belmont part derives from a main thoroughfare: Belmont Avenue.

DID YOU KNOW?

* In 1835, George Merrill operated a very popular tavern at the intersection of Grand and Armitage. There is a story that he bought the land from Indians for the price of a whiskey bottle. This neighborhood was given the entertaining name of Whiskey Point. Michael Moran built the Whiskey Point

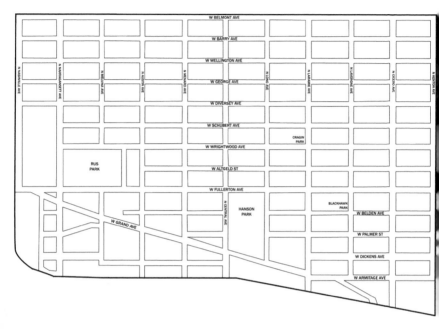

Hotel in 1864. Later, the Cragin Department Store and the Point Grill were established here.

* Residents numbered 200 in 1887 when there were only twenty-seven houses, a general store, two saloons and two schools in the area. In 1910, the population was 3,800. German, Scandinavian and Irish worked for the railroads and factories nearby. The population grew threefold in 1920 when the industrial area around the railroad tracks developed. The area between Diversey and Belmont, east of Laramie, was called Belmont

Park then. The Belmont-Central shopping district grew during the 1930s.

* The Falconer Bungalow Historic District is located between Laramie and Cicero from Diversey to Wellington. Laughlin Falconer, a Scottish immigrant, built his house here in the mid-1800s when the area was just prairie and the roads were just meandering ruts. Between 1915 and 1925, almost 350 bungalows were constructed around the Falconer home. There are ten bungalow districts in Chicago listed on the National Register of Historic Places.

* The large Riis Park has been located on Fullerton since 1916. There was a ski jump and a golf course in the park in 1929. Now there is a lovely lagoon accompanied by picnic grounds, an ice skating rink, an athletic facility and a fieldhouse. It is named after Jacob Riis, a photojournalist and reformer. He wrote *How the Other Half Lives* to draw attention to the struggles of the inner-city poor.

* The Hanson family donated part of their farm to the city for recreational use, so we now have Hanson Park. It used to be called the "Cabbage Patch," where Polish and German soccer leagues played. It is currently owned by Chicago Public Schools. The park includes a huge stadium used by city schools for all kinds of sporting events.

* The Belmont Central area has traditionally been Polish. You can still find popular Polish restaurants in the neighborhood. Belmont Cragin is now 79 percent Hispanic according to the 2010 census.

* Mike Krzyzewski, the basketball coach at Duke, grew up in Ukrainian Village, but he attended Weber Catholic High School here and was the captain of the basketball team. The school was closed in 1999.

* The Brickyard Mall was built at Narragansett and Diversey in 1970, when enclosed shopping centers were all the rage. It was developed on the old site of the Carey Brickyard, which explains the name. Business started to decline in the late 1990s, and the mall was demolished in 2001. A new outdoor setting of forty stores and restaurants has taken its place. It is called simply the Brickyard.

FAVORITE THING ABOUT BELMONT CRAGIN

The Belmont Cragin area has been great to Gene's Sausage Shop for over forty-one years. It is a great melting and evolving pot of many cultures and traditions.

Gene Luszcz
Gene's Sausage Shop

PLACE OF INTEREST
Radio Flyer Manufacturing
6515 West Grand

Look for the twenty-one-foot-tall red wagon that has graced the lawn since 1997. The company was started in 1917 by Italian immigrant Antonio Pasin. He began making wooden wagons in a small workshop. By 1923, demand had grown, and his business became the Liberty Coaster Company, moving its headquarters to Belmont Cragin in 1920. In 1930, he began making steel wagons, tricycles and scooters. The first steel wagon was called the Radio Flyer. The wagon became an American icon, and the company's name was changed.

20. Hermosa

BOUNDARIES
N—Belmont Avenue
S—Metra railroad tracks at Bloomingdale
E—Metra railroad tracks
W—railroad tracks at Kenton

NEIGHBORHOODS
Hermosa
Kelvyn Park
Ken Wel

HOW IT GOT ITS NAME
The neighborhood of Garfield was built here in the 1870s, and the Garfield train stop was established in 1875. When annexed to the city of Chicago in 1889, to avoid confusion with Garfield Park, the neighborhood was given the name Hermosa. It is not known for sure why this name was picked, but it is known that *hermosa* means gorgeous or beautiful in Spanish.

DID YOU KNOW?
* The largest group of settlers in this area in the 1870s was Scottish immigrants. They bought land from the Hayes Nurseries and named their settlement Kelvyn Grove after

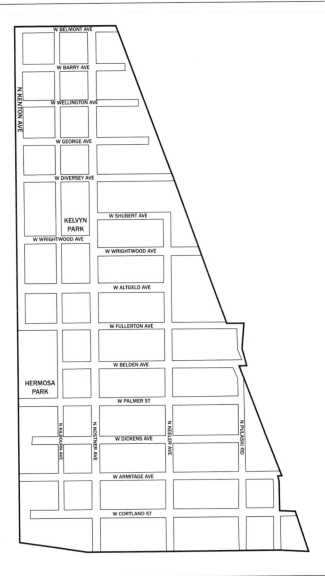

Lord Kelvyn of Scotland. German and Swedish farmers came next. Then the Polish, Italian and Irish residents arrived. The area is now composed mostly of Puerto Rican and Mexican residents.

* In 1870, Martin Kellar opened a tavern and hotel. The first house in the area was built in 1872. When the village of Garfield was founded, there were thirty homes with a population of 150 residents. There was a general store but no post office.

* The arrival of railroad transportation attracted industry. Many factories and warehouses were built here in the 1880s. The first industrial building was constructed in 1882 but was never put to use. In 1884, Laminated Wood Company bought the building and was the first industry to move here. Developers built cottages for all the factory workers. In 1907, streetcars came into the area, attracting more residents, and lovely bungalows were built.

* The area north of Fullerton was not developed until the 1920s. Many brick bungalows and two-flats were built. The neighborhood was named Kelvyn Park.

* Walt Disney was born in Hermosa. His parents came to Chicago in 1890. His carpenter father, an Irish immigrant, helped build the "White City" of the Columbian Exposition of 1893. Walt was born at home on Tripp Avenue in 1901

and lived there until he was five years old, after which the family moved away to a farm in Missouri.

* The Hammond Organ Company was located on Diversey from 1934 to 1985. The old factory is now a new company, Dock 6, which is a collective of seven furniture-making businesses.

* Hermosa Park was established in 1919. The fieldhouse was built in 1927. Cubs Care Rookie baseball camp is held here every year and at ninety other park district sites. The Cubs also run the Inner City Little League and the Reviving Baseball in the Inner City Program.

* The Consulate-General of Honduras is located on Fullerton Avenue. A Consulate-General represents its citizens living in a host country. It is responsible to help its citizens in distress, with emergency situations and to assist with legal documents.

* Hermosa is an example of how neighborhood ethnic demographics in Chicago keep changing. Chicago has always been a desirable destination for immigrants. In the 2000 census, 21.7 percent of Chicago's population was foreign born. In 1930, 26 percent of Hermosa's residents were foreign born, and in 2000, 35 percent were foreign born. In 2000, 12.9 percent of the U.S. population was foreign born. We are lucky because cities with a high

percentage of immigrants historically have been much more economically and socially vibrant.

FAVORITE THING ABOUT HERMOSA

My favorite thing about Hermosa is a bar called the Levee. The clientele of this bar is a mix of union people and the Puerto Rican locals who have been in the area for a while—they give the bar its flavor. I love its inclusive community spirit, and the owner, Warren, is a wonderful man.

Sarah Cunningham, resident

PLACE OF INTEREST

Mural
Railroad underpass at Pulaski

Street art is popping up all over Chicago. It is appreciated for enhancing dull areas and as an alternative to graffiti. The work often reflects the personality of the neighborhood. The Chicago Public Art Group was formed in 1971 to provide organizations and communities with permanent and meaningful murals, mosaics and sculptures.

21. Avondale

BOUNDARIES
N—Addison Street
S—Diversey Avenue
E—Chicago River North Branch
W—Pulaski/Metra railroad tracks

NEIGHBORHOODS
Avondale
Polish Village
Avondale Triangle
Belmont Gardens

HOW IT GOT ITS NAME
Avondale was first incorporated as a village in 1869. The area was developed by John Lewis Cochran, who was from Pennsylvania. He had also developed Edgewater and named many streets in the area after Pennsylvania towns. In 1869, 180 men died in the Avondale mine disaster in Pennsylvania. Perhaps it was named to honor the coal miners.

DID YOU KNOW?
* The first settler in Avondale was Abraham Harris, who emigrated from England in 1853. He fought in the

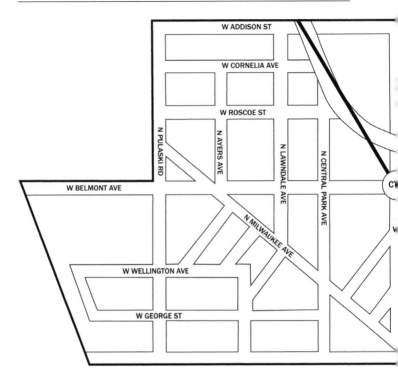

U.S. Civil War and policed prisoners of war at Camp Douglas. He then came to Avondale to make it home.

* The area was settled with the arrival of transportation. Horse-led trolleys arrived on Milwaukee Avenue when it was planked in 1848. Remember Amos Snell from Jefferson Park? He had a tollbooth at Milwaukee and Belmont. The Congress Restaurant was built nearby in 1850. The railroad tracks came here in 1870, and an Avondale stop was made. The first post

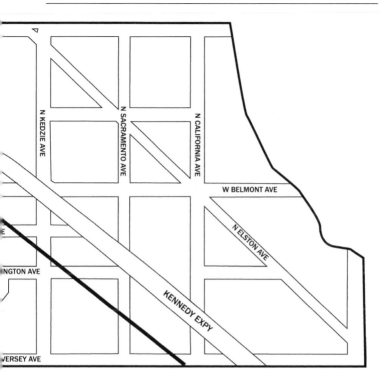

office was built near the train station in 1873. In 1882, cable cars were introduced but were replaced with electric powered streetcars in 1890. The elevated train (Blue Line) ended in nearby Logan Square in 1895 until it was extended in 1970.

* In the 1880s, a group of twenty African American families settled east of Milwaukee and Belmont. They built the Allen Church, the first church in Avondale.

* In 1894, many Polish immigrants began to settle in Avondale. Milwaukee Avenue became known as the "Polish Corridor." Many of the storefronts still reflect the longtime heart of the Polish community. Avondale has been called a "haven for political refugees from Poland."

* The Polish neighborhoods were formed around and named after churches. The Jackowo area surrounded St. Hyacinth Church, built in 1894. It was replaced by the Basilica in 1921. *Jacek* is Polish for Hyacinth. The Waclawowo area was near St. Wenceslaus Church, built in 1912. It was first a small wooden church; the present church was built in 1942. *Waclawa* is Polish for Wenceslaus. These two communities make up the Polish Village. The Milford Theater and Ballroom were opened at Milwaukee and Pulaski in 1917. The theater was nicknamed "Cinema Poliski." Both sites burned down in 1994.

* Henry Grebe & Company boatyard was established on the river north of Belmont in 1921. The company was famous for the style and quality of luxury yachts that it built for the wealthy. It also supplied many boats for the U.S. Navy in World War II. Its last boat was built in 1970. The Belmont River Club town houses are now at the location.

* From 1935 to 1971, the popular Olson Park and Waterfall complex stood at the corner of Diversey and

Pulaski. Walter Olson had a twenty-two-acre garden built adjacent to his Olson Rug factory. The building became Marshall Field's warehouse and is now owned by Macy's. Many factories were built in Chicago to take advantage of the extensive railroad system. Dad's Root Beer Company was created in 1937 and built a bottling plant and warehouse in Avondale at Washtenaw and the rail tracks along the Kennedy Expressway. The building has been converted into condos.

* Chicago has been known for its "corner bars." Avondale always had these neighborhood taverns, many with Polish names. For generations, these gathering spots were the heart of ethnic communities. You could find home-cooked meals and camaraderie on the corner. There are not many around anymore. Gentrification, changing lifestyles, city regulations and licensing or insurance costs are making them obsolete.

FAVORITE THING ABOUT AVONDALE

How well it represents classic Chicago: strong working-class roots, accessible public transportation and tremendous cultural diversity tied to its Polish and Hispanic communities.

Emily Taylor, president
Avondale Neighborhood Association

PLACE OF INTEREST

Garden of Memory
3640 West Wolfram

This is a monument to honor the many Polish men of Avondale who fought in the "Blue Army" under France in World War I. They were crucial to gaining independence for Poland. It is located next to St. Hyacinth Basilica.

22. Logan Square

BOUNDARIES
N—Diversey Avenue
S—Bloomingdale Avenue
E—Chicago River North Branch
W—Metra railroad tracks

NEIGHBORHOODS

Logan Square	Palmer Square
Koscuiszko Park	Bucktown
Belmont Gardens South	

HOW IT GOT ITS NAME
Its name derives from John Alexander Logan, who was born in Murphysboro, Illinois. Logan served in the Illinois Senate before entering the Civil War. He became a highly respected general in the Union army with the nickname of "Black Jack" Logan. After the war, he was a senator for Illinois from 1871 to 1877. He is also honored with a statue in Grant Park.

DID YOU KNOW?
* G.M. Powell had received a land grant of 160 acres in 1832 and built his residence near Armitage. The Powell House Hotel stood at Milwaukee and Fullerton from 1832 to 1872.

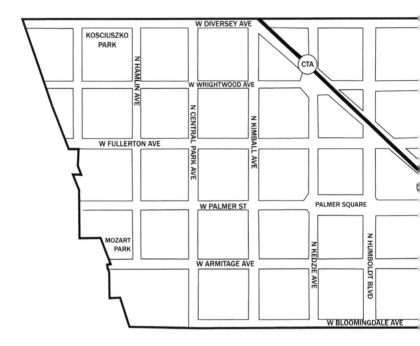

* Bucktown was settled by Polish immigrants in the 1838. It was nicknamed "Kozie Prery," Polish for "goat prairie" (a male goat is a buck—get it?). Bucktown extends into the West Town community area.

* Wrightwood Avenue was originally called Pennock Boulevard. In the 1880s, Homer Pennock founded

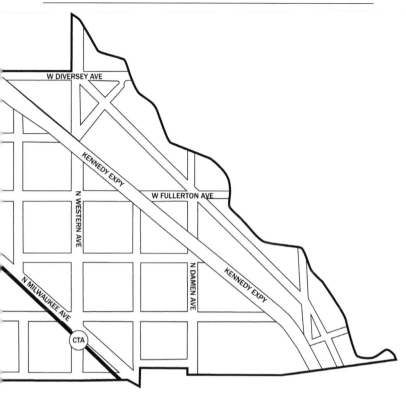

an industrial and residential town called, what else, Pennock. Unfortunately, his finances declined, and by 1903, Pennock was called a deserted village. In 1871, Mr. Pennock was already earning a poor reputation in Homer, Alaska, where he swindled many people in a fraudulent mining scam.

* The village of Holstein was located in Bucktown. It was established in 1848 by laborers from the Schlewig-Holstein region of Germany. There was also a village called Simons in the south-central section of the area and a settlement called Maplewood in the Logan Boulevard section.

* In the 1890s, wealthy immigrants built beautiful mansions along Logan Boulevard. The old-money elite along the lakefront didn't want the newly rich living near them. So we now have this lovely tree-lined street.

* Logan Square has four boulevards within its boundaries. They are part of the "Emerald Necklace." In 1869, three park districts were established. The west-side parks were Humboldt, Garfield and Douglas; the north-side park was Lincoln; and the south-side parks were Washington, Jackson, Gage and Sherman. The eight parks and six squares were to be connected with lush boulevards.

* The Bloomingdale Trail and Park is planned to run three miles along an unused elevated freight railroad line. Upon completion in 2014, there will be biking and walking trails and landscaped grounds.

* The Logan Theater was opened in 1915 as the Paramount Theater. The name was changed in 1922 when the Vaselopolis family bought it. The theater stayed in the

family until it was sold in 2011. Renovations were done in 2012 to reveal the original design and architecture that were hidden under layers of plaster. There is now a bar and lounge located on the premises.

* Mike Royko grew up in Logan Square in an apartment over his father's Blue Sky Tavern on Milwaukee Avenue. He wrote for Chicago newspapers from 1952 until his death in 1997. He won a Pulitzer Prize in 1972 for his writing. Mayor Daley said that no one captured Chicago like Royko. He targeted bullies who pushed around "people with no clout."

* There are nine urban gardens located in Logan Square. It seems like there is an urban farming revolution going on in Chicago. The city has adopted changes in the zoning laws to allow for agricultural projects. There are more than six hundred community gardens throughout the city.

FAVORITE THING ABOUT LOGAN SQUARE

The wonderful transformation of the neighborhood. It was a wasteland in 1990, and now it is fantastic to see people in the parks with their children or out walking their dogs. All the revitalization with new restaurants, bars and theaters in Logan Square is terrific. It is a fun community.

John Stephan, director
Logan Square Boys and Girls Club

PLACE OF INTEREST

Illinois Centennial Monument
Kedzie, Milwaukee and Logan Boulevard

Located on the actual Logan Square, it was erected in 1918 to commemorate the 100th anniversary of Illnois' entry into the Union. It was designed by Henry Bacon, who also designed the Lincoln Memorial in Washington, D.C.

23. Humboldt Park

BOUNDARIES
N—Bloomingdale Avenue
S—Kinzie/Metra railroad tracks
E—Kedzie/California
W—railroad tracks at Kenton

NEIGHBORHOODS
Humboldt Park
West Humboldt Park

HOW IT GOT ITS NAME
This area is named after Baron Alexander von Humboldt, a very famous German scientist, geographer and explorer. There is a Humboldt University in Berlin, and many other sites are named after him as well. Local German immigrants were pleased with this recognition.

DID YOU KNOW?
* The actual Humboldt Park isn't located in this community area. It is east of Kedzie in West Town.

* This area was sparsely populated until the nearby park was planned in 1869. Mostly German and Scandinavian immigrants settled here. The town of Pacific Junction was

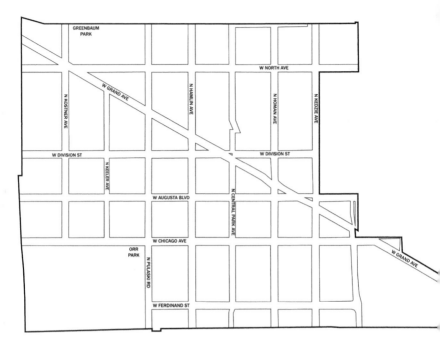

created in the northwest corner of this community area where the train lines intersected. Edward Simon's farmland, located in the southeast corner of this area, was subdivided. Naturally, Simons Subdivision was founded soon thereafter. The arrival of the streetcars in the late 1890s triggered more growth.

* In the early 1900s, more immigration groups settled in this area. There were many Irish and Italians who came to reside here. Many Russian and Polish Jews lived near the park.

* L. Frank Baum came to Chicago in 1891. He lived in Humboldt Park when he wrote *The Wonderful Wizard of Oz* in 1900. After great success, he moved to Hollywood in 1910.

* The Norwegian Lutheran Hospital was established on Francisco in 1894. The name was changed to Norwegian American Hospital in 1917. Three of the city's largest networks of community healthcare have locations in Humboldt Park: PCC Community Wellness Center, Erie Family Health Center and Access Community Health.

* One of the worst disasters in Chicago's history occurred in West Humboldt Park. The Our Lady of Angels School Fire took place on December 1, 1958. Ninety-two students and three nuns were killed. There is a historic marker and fire memorial at the site. The school was torn down, and a new one was built in 1960. The parish closed in 1999. The school is now Galapagos Charter School. But the church, the rectory and the convent have now been restored. The church was rededicated in 2012. The Mission of Our Lady of Angels has operated out of the campus since 2005 to provide outreach programs.

* The first Dominick's grocery store was opened at Ohio and Avers in 1918 by Dominick DiMatteo. The entire city was sorry when the chain of seventy-two stores closed in 2013.

* The Schwinn Bicycle Company was located near North Avenue and Kostner from 1901 to 1986. The new North-Grand High School was built at the site in 2004.

* Today, East Humboldt Park is mostly Puerto Rican, and West Humboldt Park is mostly African American. There are many organizations working tirelessly to promote community development. There are numerous programs to provide employment, health, youth and housing services among others.

* Industry has declined in the Unites States since the 1970s. Eleven thousand factory jobs have disappeared in Humboldt Park over the past several decades, and retail stores have closed. The atmosphere is changing in East Humboldt Park, though. Gentrification has come to the neighborhood. Some Hispanic families are happy to sell their homes at a big profit, but others are worried about being priced out of the area.

FAVORITE THING ABOUT HUMBOLDT PARK

Humboldt Park is close to some of Chicago's most notable assets, such as the Garfield Park Conservatory, the Puerto Rican Cultural Center and Chicago Park Districts' Humboldt and Kells Park. These assets add to the richness of the community.

Chet Jackson, director
West Humboldt Park Development Council

Place of Interest

George Westinghouse College Prep
3223 West Franklin

The previous Westinghouse Career Academy closed in 2007. The building was demolished, and this new school opened in 2009. Community activists, educators and parents fought for the new school. It has selective enrollment and offers a rigorous program.

24. West Town

BOUNDARIES

N—Bloomingdale Avenue
S—Kinzie/Metra railroad tracks
E—Chicago River North Branch
W—Kedzie Avenue

NEIGHBORHOODS

Humboldt Park East	Polish Downtown
Ukrainian Village	River West
East Village	West Town
Wicker Park	Smith Park
Noble Square	Goose Island
Bucktown South	Eckhart Park

HOW IT GOT ITS NAME

Here is another easy one. But wait, it is northwest of the Loop, isn't it? Some say the area was named West Town because Western Avenue was the city limit when the area was settled. The intersection of North and Western was the outermost corner of the city in 1851.

DID YOU KNOW?

* Mark Noble Sr. was the first settler here in 1830. He bought farmland here before he moved to Norwood Park.

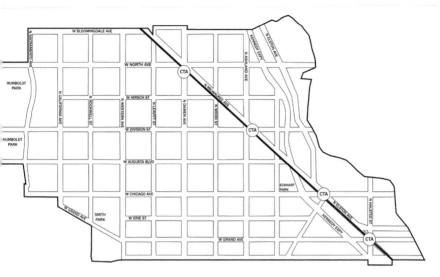

Development didn't really occur until the 1850s, when Milwaukee Avenue was planked.

* The Humboldt Park was created in 1869. The original design was by William LeBaron Jenney, the architect of the West Park System. It was modified by famed landscape architect Jens Jensen when he was the superintendent of the park in 1895. He was fired in 1900 for trying to fight corruption. Can you imagine? He was rehired in 1905 by a new reformed board. The boathouse of 1907, the Prairie-style fieldhouse of 1928 and the gorgeous Refectory Building and Stable of 1895 (now the Institute of Puerto Rican Arts and Culture) are still here. There are lagoons and even the "Little Cubs Field."

* Brothers Charles and Joel Wicker founded Wicker Park in 1870. Beautiful mansions were built there by German and Polish beer magnates. It was called "Beer Baron Row" and was also known as the "Polish Gold Coast."

* Polish immigrants settled around the Division, Milwaukee and Ashland intersection. This area was called "Polish Downtown." Half of Chicago's Poles lived here in "Kostkaville." St. Stanislaus Kostka Church, built in 1867, was the first Polish parish in Chicago.

* Many Ukrainian immigrants settled in this area. There are still three major ethnic churches: Sts.Volodymyr and Olha, St. Nicholas Cathedral and Holy Trinity. You can visit the Ukrainian National Museum, the Ukrainian Cultural Center and the Ukrainian Institute of Modern Art.

* The largest Puerto Rican community in Chicago is centered in Humboldt Park East. Division Street is known as "Paseo Boricua." Two fifty-nine-foot-tall metal images of the Puerto Rican flag have been placed on Division at Western and at Mozart to preserve the neighborhood identity.

* The Grand Avenue corridor and Smith Park were settled by Italian immigrants. The area around Grand and Ogden was known as "Little Sicily." Grand Avenue was to the Italians what Milwaukee Avenue was to the Polish and

Lincoln Avenue was to the Germans. Do you remember the Como Inn?

* River West is the area between the river and the Kennedy Expressway. It was once a thriving market and manufacturing area. Now it is also filled with warehouses converted into lofts and many newly built condos.

* Noble Square is between the East Village and Elston. Morton Salt Company was started in Chicago in 1848 and bought the facility on Elston in 1889. The "when it rains it pours" umbrella girl became its logo in 1914. Eckhart Park is also located in Noble Square. It was designed in 1907 by landscape architect Jens Jensen.

* Since 1990, West Town has made a great transformation from an area of decline to a neighborhood of young professionals. Take a walk along Division Street to check out all the trendy restaurants.

FAVORITE THING ABOUT WEST TOWN

West Town is a neighborhood destination which thrives on the principle of community and the subsequent charm created by this diverse, yet united, community. This is an area defined by a rich history of residents and the entrepreneurial pioneers who've helped maintain the essence of what truly defines Chicago: its neighborhoods.

West Town Chamber of Commerce

PLACE OF INTEREST

Polonia Triangle
Ashland, Division and Milwaukee

This area is headquarters to several Polish organizations. The fountain was named after author Nelson Algren, who lived in Wicker Park. The fountain has the inscription: "For the masses who do the city's labor also keep the city's heart."

25. Austin

BOUNDARIES
N—Metra railroad tracks
S—Roosevelt Road
E—railroad tracks at Kenton
W—Austin/Harlem

NEIGHBORHOODS

Austin	Austin Historic District
North Austin	South Austin
Galewood	The Island

HOW IT GOT ITS NAME

Henry Austin (street name) started a country village in 1865. It was a temperance settlement, banning the use of alcohol, and was originally called Austinville. Austin was part of Cicero Township until 1899. The rest of the township resented Austin's dominance and voted for Austin to be annexed to the city of Chicago.

DID YOU KNOW?

* Austin has the largest population of any community area in Chicago. The population was 1,000 in 1874, 4,000 in 1890 and 130,000 by 1930. It has had good transportation services since the 1800s. The railroad had a station here

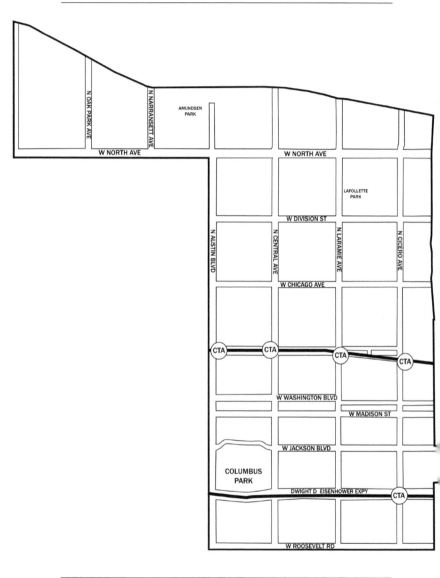

near Lake Street in 1848. Many electric streetcars traveled to Austin, and the Green Line "L" arrived in 1894. The Blue Line "L" didn't extend here until 1958.

* In 1835, the first settler, Henry DeKoven (street name), purchased prairie land here. Thirty years later, Henry Austin bought the DeKoven property. In 1842, the Six Mile House, a two-story tavern, was built for travelers on the old Indian Trail that was first called Pennsylvania Avenue here and then became Lake Street. Lake Street was planked in 1849.

* Austin Hospital was founded in 1923. It was renamed Williard Temperance Hospital in 1929. Then, in 1938, the Sisters of St. Casimir purchased it on the feast of Our Lady of Loretto and ran Loretto Hospital until 1991. It continues under a management company to provide medical and behavioral health programs.

* The northwest arm that extends from Austin Avenue to Harlem is called Galewood. The neighborhood is named after Abram Gale, who bought a large farm here in 1838. The railroad ran tracks through his property in 1873, and the land was subdivided to form a village. As part of the deal, a train station was built there.

* The Austin Historic District is centered on Midway Park, which is actually a parkway with large beautiful homes. Austin has eight Chicago Landmark buildings.

* Four of the many homes designed by architect Frederick Schock between 1886 to 1892 are in the historic district. Frank Lloyd Wright designed the Joseph J. Walser House on Central Avenue north of Madison in 1903. It became a landmark in 1984. The Charles Hitchcock House was granted landmark status in 1992.

* The Laramie State Bank Building at Chicago and Laramie was built by architects Cook & Meyer in 1927. The ornamentation was done by the Northwestern Terra Cotta Company, which had a huge plant at Clybourn and Wrightwood. The terra-cotta work includes coins, squirrels and beehives as symbols of saving. The city proclaimed it a landmark in 1995.

* Austin was settled by Irish, Italian, German and Scandinavian residents who were moving to what were then the "suburbs." The racial character of the neighborhood began changing from white to African American in the 1960s. In spite of rampant real estate blockbusting, the transition was slow until nearby factories closed in the 1970s. Many parts of Austin are beautiful and stable, but there are pockets of poverty and the crime that comes with it.

* There are two large parks in Austin. Columbus Park is considered the "crown jewel." It was designed by Jens Jensen in 1920 and includes a Prairie-style fieldhouse, lagoons and

a golf course. LaFollette Park is named after progressive reformer and Wisconsin governor Robert LaFollette.

* The West Side Health Authority was formed in 1988 in response to the closing of St. Anne's Hospital. It works with more than fifty organizations to assist the uninsured and address health disparities in minority populations. Circle Family HealthCare Network and PCC Community Wellness Center provide care to this underserved community.

Favorite Thing about Austin

The Austin community has a strong foundation and rich heritage that I am proud to be a part of as a resident and a state representative.
La Shawn K. Ford, Illinois state representative

Place of Interest

Austin Town Hall
5610 West Lake Street

This building was once the town hall for Cicero Township. Constructed in 1929, the hall was designed to resemble Independence Hall in Philadelphia. After the split from Cicero, it was used as a library and police station. It then became part of the West Parks Commission and was transferred to the Chicago Park District in 1934. The park has a gymnasium, an auditorium and a cultural center.

26. West Garfield Park

BOUNDARIES
N—Kinzie/Metra railroad tracks
S—Fifth Avenue/railroad tracks at Taylor Street
E—Hamlin Avenue
W—railroad tracks at Kenton

NEIGHBORHOODS
West Garfield Park

HOW IT GOT ITS NAME
It is west of Garfield Park, naturally.

DID YOU KNOW?
* Stagecoaches came through here along Lake Street to go to Oak Park and along Fifth Avenue to go to Lyons. Fifth Avenue was called Barry Point Road because the Widow Barry had an inn and stopover in Lyons. This area wasn't settled until after the Civil War.

* The railroad came to the area in 1873, and two thousand mostly Irish and Scandinavian employees settled nearby. They called their village Central Park. Their shops were built along Kinzie. Charles Voltz had a farm near

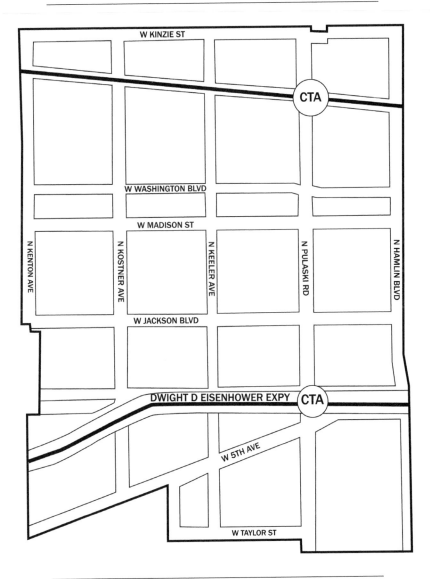

Madison and Kostner and sold them milk and produce. In 1888, a village called Mandell had a post office in the southwest section of the area. There was also a settlement called Moreland.

* The Gentlemen's Trotting and Racing Club was built at Madison and Pulaski in 1878. The racing patrons, jockeys and trainers all hung out at the saloons and beer gardens that sprang up nearby. The club was shut down in 1900 due to unscrupulous activity.

* There is also an espionage story here. The Simpson Optical Company made lenses for World War II instruments. One of its employees, Herbert Haupt, snuck away to Germany for training. But he was caught upon his return and arrested for attempting to steal secrets for the Nazis.

* In 1878, St. Phillip's Parish was founded at Keeler and Maypole. The name was changed to St. Mel's in 1896. St. Mel's school was opened in 1907. A new church was built on West Washington in 1910. St. Mel's High School for boys was started in 1912. St. Mel's High School and Providence High School for girls merged in 1968 and moved to Central Park Avenue south of Washington. The Catholic Diocese left the school in 1978, and it became independent. St. Mel's Church is now New Mount Pilgrim Missionary Baptist Church.

* The Midwest Athletic Club was built in 1926 at the corner of Madison and Hamlin. It was a lavish hotel and athletic clubhouse with a two-story ballroom. Muhammad Ali used the athletic center as a training site. It is now a handsome and affordable housing complex.

* The Congress Expressway was built in 1949–55 and displaced residents in the southern section of this community area. It was renamed the Eisenhower Expressway (aka "the Ike") in 1964. With forethought, Daniel Burnham had proposed a major western thoroughfare in his plan of 1909.

* Bethel Lutheran Church was founded in 1891. Bethel New Life's organization started in 1979. It began as a grass-roots program to rebuild housing. Bethel New Life expanded to increase services and is focusing on job creation and education to reverse decades of poverty. It has had a major impact on the community.

* The intersection of Madison and Pulaski has historically been the commercial center of the area. Family businesses like the Madigan Brothers store, the Baer Brothers store and the Wiley Brothers store were popular shopping destinations here until the 1960s. The Madigan's department stores were a Chicago fixture from 1881 until the last one closed in 1992. Madison and Pulaski is still a bustling area with low-cost shopping. There is a plan to redevelop the corridor to provide an attractive shopping environment.

* In 1959, overcrowding in Bronzeville brought African Americans to West Garfield Park. Between 1960 and 1965, the population changed from 85 percent white to 85 percent black. Then the riots of 1968 devastated the area, nearby factories left and retail business disappeared. With the appearance of unemployment and poverty, curbside drug markets and violence arrived. Residents have banded together with many local organizations to save and revitalize the community.

FAVORITE THING ABOUT WEST GARFIELD PARK

The enduring greatness of the neighborhood. The term greatness *applies because of the inherent strength and inspiring goodness of the boys and girls in this troubled west side neighborhood.*

Ralph Campagna, director
Off the Streets Boys and Girls Club

PLACE OF INTEREST

Hotel Guyon
4000 West Washington

Constructed in 1928, this was a 169-suite residential hotel, built by J. Louis Guyon, a French Canadian dance promoter, to house his Paradise Ballroom. There was to be no fox trot or shimmy—just "clean" dancing. It has been vacant and deteriorating for the past decade, but there are hopes to save this endangered landmark.

27. East Garfield Park

BOUNDARIES
N—Kinzie/Metra railroad tracks
S—railroad tracks at Taylor Street
E—CNW railroad tracks at Rockwell
W—Hamlin Avenue

NEIGHBORHOODS
East Garfield Park
Fifth City
Homan Square North

HOW IT GOT ITS NAME
Garfield Park is within its borders. The three parks of the West Parks system were originally called North Park (Humboldt), Central Park (Garfield) and South Park (Douglas). Central Park was renamed Garfield Park after President James Garfield was assassinated in 1981.

DID YOU KNOW?
* The park was designed by William LeBaron Jenney. The first 40 acres were opened in 1874, and it was gradually completed to include 185 acres. The corrupt park board

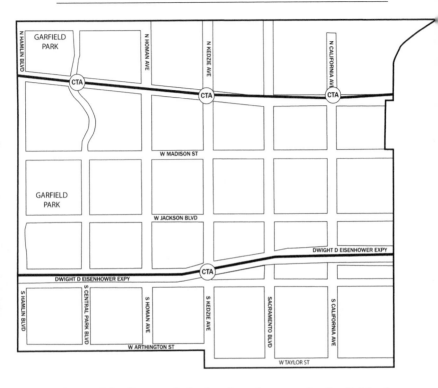

dragged its feet, and the landscaping was finally finished in 1905.

* Garfield Park Conservatory has been called "landscape art under glass." In the late 1880s, the three West Parks each had its own small greenhouse. In 1905, Jens Jensen demolished them to create one large conservatory. Restoration of the entire campus began in 1994. In 2012, the Grant Park Conservatory received the National Medal

for Museums award because of its innovative programs and its splendor.

* The first church in Garfield Park was Our Lady of Sorrows. It was built in 1890 to serve as a shrine to the Blessed Virgin. The first school was Marshall High School, built in 1893. The present school building was built in 1931 and was renovated in 1980.

* The first settlers here were Irish and German. In 1890, 40 percent of Chicago's population was foreign-born. Half of those were Irish or German. Italians and Russian Jews came to this area in the 1930s. In 1930, African Americans made up 15 percent of Garfield Park's population but are now 95 percent of the population.

* When the railroads came, so did industry. In 1905, Richard Sears built the headquarters for his mail order company on the southern border of this area connecting with North Lawndale. The four-block-long complex had a distinctive fourteen-story-high clock tower.

* With the Great Depression and World War II, many buildings were converted to small, overcrowded apartments or boardinghouses. The number of lower-income families increased here, so the Daughters of Charity nuns moved their Catholic Social Center to this area. They had been in the Near West Side since 1914 but continued here in 1947

as the Marillac House with the mission to empower those in need.

* Theodore Bunte built his candy company on Franklin Street in 1884. It made 50 million pounds of candy each year until the plant was closed in 1961. Chicago is the candy capital of America. We have been called the "city that smells of chocolate"—think Mars's M&Ms, Curtiss's Baby Ruth, Williamson's Oh Henry!, Fannie May's Pixies, Blommer's Signature Line and all those other goodies.

* The Graemere Apartment Hotel was located on the northeast corner of Washington and Homan from 1923 to 1977, when it was torn down. The ballroom was the site of many weddings and banquets. The dining room and Glass House Cocktail Lounge were quite popular.

* Bethany Hospital was started in 1921. It became part of the Advocate Health System and then was sold in 2010 to become the RML Specialty Hospital. RML is operated by Rush University and Loyola University Medical Centers in partnership with the Rehabilitation Institute of Chicago. The hospital is a long-term acute-care facility that treats medically complex conditions.

FAVORITE THING ABOUT EAST GARFIELD PARK
East Garfield Park is a breath of fresh air. I love the area, the people and the atmosphere. I love all the Blackhawk and Bulls fans

that come here for our good food. I've been here a long time, and I'm not going anywhere.

Wallace Davis Jr.
Wallace's Catfish Corner

PLACE OF INTEREST

Garfield Park Fieldhouse
100 North Central Park Avenue

Built in 1928, this was originally the West Park Commission Administrative Building. It became a fieldhouse when the Chicago Parks District took over in 1934. Known as the "Gold Dome Building," it has a breathtaking rotunda, a swimming pool, a gymnasium, a dance studio and boxing rings.

28. Near West Side

BOUNDARIES
N—Kinzie/Metra railroad tracks
S—Metra railroad tracks at 16th Street
E—Chicago River
W—railroad tracks at Rockwell Street

NEIGHBORHOODS

West Loop

Fulton Market

West Loop Gate

University Village

Fulton River District

Tri-Taylor

Greektown

Illinois Medical District

United Center

Little Italy

HOW IT GOT ITS NAME
This is really easy. It is very *near* and just *west* of the Loop.

DID YOU KNOW?
* The area south east of Halsted was the gateway for immigrants. First came the Irish and Germans, who helped to build the railroads; then came the Greeks and Italians. In the 1880s, Russian Jews came here. In the 1920s, African Americans came in the Great Southern Migration.

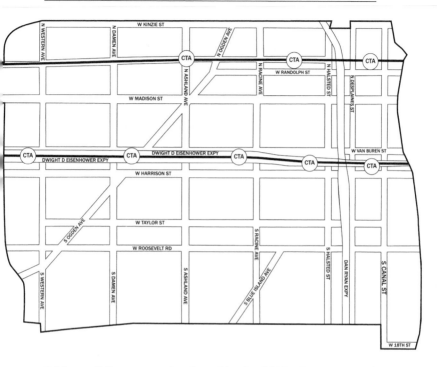

* Maxwell Street was developed in the 1840s. It was named after Dr. Philip Maxwell, who was a Fort Dearborn physician in 1833. In the 1880s, it became an open-air market with many Jewish and African American street vendors. Deals could be made—some legal and some not so much. It was home to the Chicago Blues and the Maxwell Street Polish. The University of Illinois at Chicago (UIC) was established nearby in 1965. It began to gradually buy up property. The market was displaced in 1994, and a watered-down version persists on Canal Street.

* Greektown was originally located on Halsted near Harrison. It was displaced to the north in the 1960s by the Eisenhower Expressway and UIC. Greektown introduced gyros and saganaki to the nation in 1968. The Italian population along Taylor Street declined after UIC was built, but Italian restaurants, churches and organizations remain in Little Italy. Check out Piazza DiMaggio.

* Union Park was created in 1853. It was named in honor of the federal Union of the northern states. Jens Jensen planted an experimental native plant garden, the "American Garden." The park had a rustic bridge, a small lake, a little zoo and an observation tower.

* Beginning in the 1930s, Union Park became a meeting place for May Day labor events. The area nearby is called "Union Row" because the headquarters of many labor groups are located here. The park is still a point for protest marches and music festivals today.

* Union Station was designed by Daniel Burnham, although he died before it was completed in 1925 after ten years of construction. It is Chicago's busiest train terminal. Chicago has been the nation's railroad capital for more than 150 years. Amtrak and Metra both operate out of the station.

* Holy Family Church was completed in 1857 by Father Arnold Damen (street name). It is the second-oldest church

in Chicago (Old St. Patrick is the oldest). In 1870, St. Ignatius College was started to serve children from junior high school through a bachelor's degree. The concept of high school wasn't realized at that time. The college name was changed to Loyola in 1909. St. Ignatius became a high school, and the college moved to Rogers Park in 1912.

* In 1889, Jane Addams and Ellen Gates Starr opened a Settlement House. The heirs of Charles Hull gave them a rent-free lease to his house. The neighborhood to the east was full of overcrowded tenements of poor immigrants. Many immigrants were unprepared for the hardships they would face, and settlement houses were established to help them assimilate. Jane and Ellen set out to improve the lives of the newcomers and started a child care, education, cultural programs and social service center at Hull House. Both Jane and Ellen were activists who fought hard for the rights of children, women and laborers.

* The Chicago Stadium opened here in 1929. It was the world's largest indoor arena at that time. There is a commemorative plaque that reads "Chicago Stadium—1929–1994—Remember the Roar," located near the north side entrance of the United Center. The stadium was demolished, and the United Center was opened across the street in 1994; it is the largest arena in the United States. It is home to the Chicago Blackhawks and the Chicago Bulls. Can you hear the crowd from the

"Madhouse on Madison"? Many other events are also held here.

FAVORITE THING ABOUT NEAR WEST SIDE

The Near West Side is resilient! Residents have sustained themselves through the ravages of fires following Dr. King's assassination, they have shared in the transformation of the Henry Horner Homes into new residential settings [and] *they have been involved with the presence of the United Center in their midst. Portions have gone from skid row to fashionable. Through sheer staying power, the community has blossomed!*

Walter Burnett, alderman

PLACE OF INTEREST

Palace Grill
1408 West Madison

This landmark diner has been in the West Loop since 1938. The Lemperis family have owned and operated it since 1955. The present owner, George Lemperis, is a favorite host of Blackhawk players and fans, politicians, media personalities and, as he always says, "the greatest customers in Chicago." It has been voted as the Best Place for Breakfast by the *Sun Times*.

29. North Lawndale

Boundaries
N— Fifth Avenue/Arthington/Taylor
S—18th Street/Cermak/railroad tracks
E—railroad tracks at Campbell
W—railroad tracks at Kilbourn

Neighborhoods
North Lawndale
K Town
Homan Square
Douglas Park

How It Got Its Name
The name Lawndale was given to the area by real estate developers Merrill & Decker in 1870. The area was sparsely populated until the company built the subdivision. It advertised the attractiveness of Douglas Park and the accessibility of the train that had come to the area in 1862.

Did You Know?
* Ogden Avenue was originally an Indian portage trail. Have you noticed how many of our diagonal streets started this way? It became the Southwest Plank Road in 1848. It was named Ogden in 1872 in honor of Chicago's first

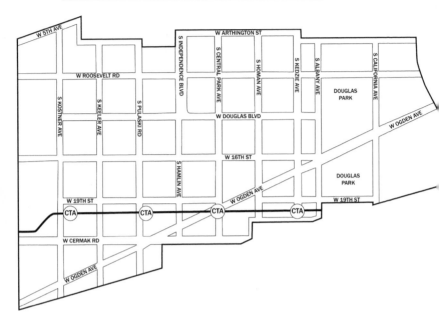

mayor, William Ogden. Parts of it were bricked in 1900, but it wasn't paved until 1920. It was designated the historic Route 66 in 1926.

* Development began here after the Great Fire of 1871. The western section of this area (now K Town) became the neighborhood of Merigold when the real estate firm of W.A. Merigold & Company sold land here. Plant workers moved here to work at nearby factories.

* In 1890, many Czech immigrants began to settle here. By 1900, Chicago had the world's third-largest Czech

population. Czech immigrants were either Catholic or Freethinkers who avoided any church affiliation. Our Lady of Lourdes Bohemian Church was built in 1892 at 15th and Keeler (then called 42nd Avenue). The Czech Free Thinkers School was built nearby in 1909. The Merigold area was called Novy Tabor (New Camp), and Millard Avenue became known as "Bohemian Millionaires' Row." The popular Bohemia Club was opened in 1912 on Douglas Boulevard. In 1917, immigrant Czech athletes formed an amateur recreational soccer club that went on to become the best team in Chicago. They played in the Sparta Stadium, at Cermak and Kostner, from 1921 until 1950. Sadly, the stadium was replaced by a parking lot in 1962.

* The first electric streetcars arrived on Roosevelt Road in 1892. The Douglas Park "L" service began in 1902 as a branch of the West Side "L," which had started in 1892. The service was cancelled in 1952. The Pink Line "L" has provided public transportation to the area since 2006.

* The 1920s brought in the Jewish era. North Lawndale became the largest Jewish settlement in the city, with one quarter of the total Chicago Jewish population. There were more than seventy synagogues in Lawndale, along with Jewish schools, clubs and community centers. Mount Sinai Hospital was founded in 1919 to serve poor immigrants. North Lawndale was called the "Jerusalem of Chicago."

* Ethnic makeup changed again in the 1950s when the area became African American. But the riots of 1968, after King's assassination, devastated the area. The industrial base eroded in the 1970s when companies like Sears, Western Electric, Sunbeam, Zenith, RCA and nearby International Harvester moved out. The population in 1960 was 125,000 but had dropped to 41,000 by 2000. Once home to the most graystones in the city, there are now many empty lots and deteriorating sites. New housing complexes like Homan Square and the work of many community groups are contributing to recovery. The Graystone District of K-Town has been added to the National Register of Historic Places.

* Benny Goodman made his musical debut at the Central Park Theater here in 1921. Golda Meir lived here in 1917 and worked at the local library. Cobra Records was located here in 1956 and launched many blues artists. Martin Luther King Jr. made this area the home base of his northern civil rights movement in 1966. Columnist Irv Kupcinet, actress Kim Novak and comedian Shelley Berman all grew up in North Lawndale.

FAVORITE THING ABOUT NORTH LAWNDALE

My favorite thing about North Lawndale is the people, the community—the stories of triumph and resiliency that are embedded within this community.

James Brooks, pastor
Lawndale Christian Health Center

PLACE OF INTEREST

Douglas Park Cultural and Community Center
1401 South Sacramento

This was originally the Douglas Park Fieldhouse, built in 1928. The park first opened in 1879, and one of the city's first public bath facilities was located here. Jens Jensen developed the beautiful Monumental Garden in 1905. The park was named after Stephen Douglas, who debated and lost to Abraham Lincoln. Douglas was the senator for Illinois from 1847 to his death in 1861. He is buried on the south side on 35th Street, near the lake in the Oakland Community Area.

30. South Lawndale

BOUNDARIES
N—18th Street/Cermak/railroad tracks
S—Stevenson Expressway
E—railroad tracks at Campbell
W—railroad tracks at Kenton

NEIGHBORHOODS
South Lawndale
Marshall Square
Little Village
Piotrowski Park

HOW IT GOT ITS NAME
This is the south section of the Lawndale community, which was developed in 1870.

DID YOU KNOW?
* The Chicago Portage traversed this area. There was a trail (now the route of the Chicago Sanitary and Ship Canal) between the Des Plaines River and the West Fork of Chicago River. It made transportation from the Great Lakes to the Mississippi River possible and made Chicago a great hub. During heavy rains and when the Des Plaines

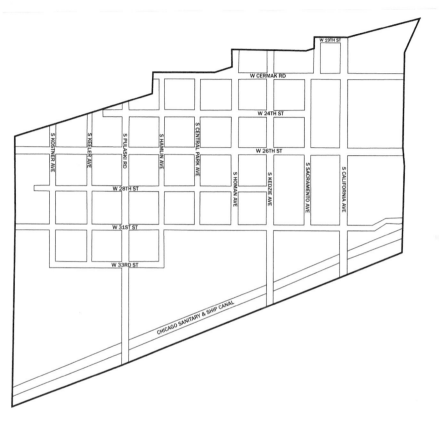

River overflowed, the area became a dismal swamp (called "Mud Lake") that extended east to Kedzie.

* Peter Crawford, from Scotland, was the first settler in this area. He became a real estate speculator who started the farming village of Crawford (named after himself,

of course) in 1863. The Lawndale section of the area was business and residential. The whole area came to be known as Lawndale-Crawford. In 1913, 40th Avenue became Crawford Avenue in his honor. But in 1933, to win Polish votes, Mayor Kelly changed the name to Pulaski. Businessmen and residents fought the change in court for nineteen years to no avail. However, the Crawford Avenue name still exists in many places outside the city limits.

* Eastern Europeans settled here in the 1880s. They came to work at the nearby McCormick Reaper Company (later International Harvester). Since the 1950s, a heavy concentration of Mexican immigrants has resided here. South Lawndale has been called the "Mexico of the Midwest." The name Little Village (or La Villita) was given to the neighborhood in 1964 by a Czech and Hispanic committee to distinguish the area from North Lawndale.

* "Bridewell" is an old English word for a short-term jail. Chicago's Bridewell Jail was first located in the "vice district" at Polk and Wells. It relocated near 26th and California in 1871 and was renamed the Chicago House of Corrections (but 1890 maps still labeled it as Bridewell). Cook County's first jail was built in 1850 at Hubbard and State. There was constant overcrowding (just like today). In 1928, the county jail was moved to a larger facility built next to Bridewell. In 1969, the two facilities merged into the Cook County Department of Corrections.

* In 1885, John Shedd developed part of Millard & Decker's subdivision. He reserved 1.13 acres for a park at 23rd and Lawndale. It is still called Shedd Park. John Shedd came to Chicago in 1872 and started work at Marshall Field's as a stock boy. In one of those classic success stories, he became president of the department store in 1906 after Marshall Field died.

* Drugstore owner Jacob Baur moved to Chicago from Indiana in 1888. He started the Liquid Carbonic Factory to make carbonic gas for soft drinks. He achieved fame for inventing the soda fountain. He built a huge Prairie-style building and relocated his company to 31st and Kedzie in 1910. The Washburne Trade School moved into the building in 1935. At one time, the school had twenty-eight different programs run by union workers to train young people to become craftsmen, with great success. In 1970, the unions began pulling out and complained that the board of education did not understand apprenticeships and gave the school little support. The unions were accused of avoiding integration. The school closed in 1993 and was demolished in 2009.

* The Marshall Square Theater was built in Art Deco style in 1917 at Cermak and Marshall Boulevard. It originally staged vaudeville acts. It was restored in 1990 and now houses the Apollos 2000 hall. Marshall Boulevard was named after real estate developer James Marshall.

* St. Anthony Hospital will move to 31st and Kedzie after being in Douglas Park for more than one hundred years. The complex will include the hospital, an office building, a garage and retail space. It is scheduled to open in 2016.

FAVORITE THING ABOUT SOUTH LAWNDALE

Little Village is known as the Mexican Capitol of the Midwest, with the 26th corridor known as the "Second Magnificent Mile" due to the business vibrancy of the district. But what I love the most about South Lawndale is that it is the youngest community in the city of Chicago and is vibrant, energetic and aspiring.

Mike Rodriguez, director
Enlace Chicago

PLACE OF INTEREST

Little Village Gateway
26th Street at Albany

The sign reads, "Bienvenidos a Little Village." The arch and clock were gifts from Mexico and were erected in 1991; 26th Street is often referred to as "Calle Mexico."

31. Lower West Side

Boundaries

N—railroad tracks at 16th Street
S—Chicago River South Branch/Stevenson Expressway
E—Chicago River South Branch
W—railroad tracks at Campbell

Neighborhoods

Pilsen

Heart of Italy

East Pilsen

South Water Market

Heart of Chicago

How It Got Its Name

Another one of those location designations: it is lower than the West Side.

Did You Know?

* Irish and German immigrants first settled here to build the railroads and the Illinois & Michigan (I&M) Canal in the 1840s. Czechs, Poles and other eastern Europeans came in 1870s and developed the area. The Pilsen neighborhood was named after the Czech city of Plzen. The Czechs built St. Procopius Church in 1883, Slovenes built St. Stephens Church in 1898 and the Polish built St. Adalbert in 1912.

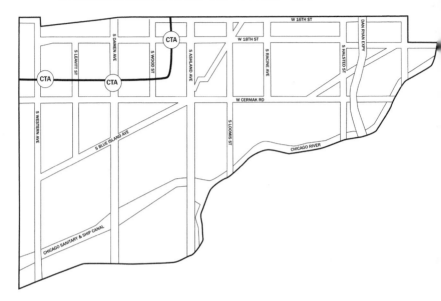

* Lots of industry near the river attracted the immigrants. Trade work could be found at several breweries. The Schoenhof Brewery was built in 1862 at 18th and Canalport, and the building still stands today. There were massive lumberyards, factories, sweatshops and warehouses. The South Water Market was relocated here in 1925. The five-block-wide market area has been redeveloped into the University Commons condos.

* The Lower West Side has many of the oldest buildings in the city. The first floors of many houses are below street level. In 1875, to make way for a new sewage system, streets were raised five to ten feet higher. Some

homeowners lifted their buildings to the new elevation, but many remained below street grade.

* The Lower West Side has been an entry point to Chicago for many immigrants throughout its history. The population density is nearly twice that of the rest of the city. The Howell Neighborhood House was founded in 1894 to assist immigrants in adapting to a new culture. It became Casa Aztlan in 1970, with much the same mission. Recycling at work! The Gads Hill Social Settlement was founded in 1898. The name was changed to Gads Hill Center in 1916, and it is still operating today. The organization serves low-income families to meet their changing needs, with an emphasis on education.

* The Heart of Chicago, in the lower-west part of the area, was settled by Italians from Tuscany. A row of restaurants and shops on Oakley south of Cermak has been nicknamed "Heart of Italy" to preserve its identity as a last Italian stronghold.

* Since the 1960s, the area has become predominantly Mexican. Pilsen is proud of its Mexican identity; colorful murals, tile mosaics and parades on the 18th Street corridor reflect its tradition. The National Museum of Mexican Art was opened at Harrison Park in 1987. It is the nation's largest Latino art institution. East Pilsen is known as the arts district. Gentrification is sneaking into the area, but "Muppies"

(Mexican yuppies) are moving back to the neighborhood to help save the culture.

* The Jesuits founded Cristo Rey High School in 1996 to offer a college prep education to families with limited financial means. It is based on the Cristo Rey work-study model where students work five days each month at an entry-level job with a professional company. The students gain a great experience, and the company helps to pay their tuitions. This innovative business model worked so well that it became famous throughout the country, and a network of schools was set up to replicate the program. Christ the King (the English form of Cristo Rey) High School was opened in Austin in 2008.

* George Halas was born and raised in the Lower West Side. In 1920, "Papa Bear" Halas organized and coached the Decatur Staleys football team. The next year, he moved them to Chicago to play at Wrigley Field and changed the name to the Chicago Bears in honor of the Cubs. Halas coached the team until 1967 and continued as the chief executive officer until he died in 1983. The Bears made Soldier Field their home in 1971.

FAVORITE THING ABOUT THE LOWER WEST SIDE

I love the bohemian, artistic feel of the Lower West Side. It has a unique character. The location is so central—it is close to

downtown, to the train and to UIC. There are plenty of options when living here.

Cesar Gonzalez, owner
Pl-zen Gastropub

Place of Interest

Thalia Hall
1227 West 18th Street

The Hall, built in 1892, was designed to be a replica of the Old Opera House in Prague. It served as a meeting hall and cultural center, with residences in upper floors. The apartments and corner restaurant have been renovated, and the intact hall is being restored. It became a Chicago Landmark in 1989.

32. Loop

Boundaries
N—Riverwalk
S—Roosevelt Road
E—Lake Michigan
W—Chicago River

Neighborhoods

Financial District	Grant Park
Retail District	Millennium Park
Theater District	Chicago Harbor
Printers Row	Education Corridor
South Loop	New East Side

How It Got Its Name

Cable cars came to Chicago in 1882 and were followed by electric trolleys in 1890. They arrived downtown from all directions and used a multi-block-long rectangular area as a turnaround. Some say that the name "Loop" was used then to describe this center. The name did not become official until 1897, when the Union Elevated Railroad completed the "L" terminus in the central business district. The quadrangle that united the various elevated train lines was dubbed the "Union Loop."

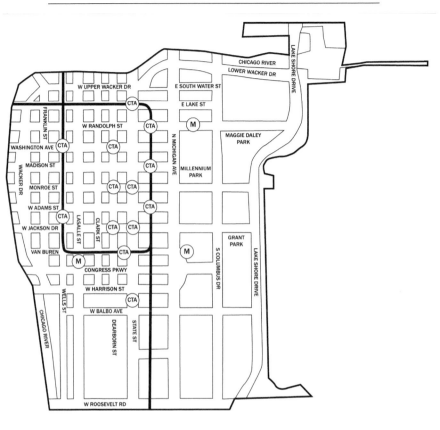

DID YOU KNOW?

* American Indians have inhabited this region since six thousand years ago. Early European explorers and traders recorded the presence of Indian villages in this area. A Miami Indian tribe was established here in the 1600s. Pottawattomie Indians came to Chicago in the 1750s

and had a village in the Loop area. They had the most interactions with the European explorers, fur traders and early settlers. Their forced relocation is a long, sad tale. Most left the Chicago area after the Treaty of 1833. Some Pottawattomies remained near Wolf Lake until 1847. There are still Pottawattomies in Wisconsin, Michigan, Kansas and Oklahoma. Their headquarters is located in Shawnee, Oklahoma.

* You could say that this area is where it all started. The value of Chicago's location as a commercial hub was recognized early. Fort Dearborn was established here as a military outpost in 1803. There were only two houses across the river at that time. The Point du Sable home was owned by Jean Lalime, the Indian interpreter at the fort, in 1803 and by John Kinzie in 1804. (John Kinzie later murdered Jean Lalime but was acquitted.) The cabin of Antoine Ouilmette (as in Wilmette, Illinois) had been built in 1790. The fort was named after Henry Dearborn, the secretary of war under Thomas Jefferson. It had its own garden, well, infirmary, trading store and Indian agency. The fort was burned down in the Indian uprising of 1812 and was rebuilt in 1816. It was closed in 1836 and demolished in 1857. There are markers at Michigan and Wacker.

* The "Forks," where the Chicago River split into the North and South Branches, was known as Wolf Point. There was a cluster of inns located here. The first tavern,

Miller House, was established in 1827 by brothers Samuel and John Miller. They started the first ferry service in 1829 with Archibald Clybourne (street name). Samuel Miller married John Kinzie's daughter, Elizabeth. The Wolf Point Tavern was built in 1829 by James Kinzie, son of John Kinzie, and was run by Archibald Caldwell, the cousin of Archibald Clybourne. Elijah Wentworth (street name) also ran this tavern before he went to Jefferson Park in 1830. Mark Beaubien, who had lived here since 1826, began taking in travelers in 1829 and called his house the Eagle Exchange Tavern. He later put up an addition and named it the Sauganash Hotel after his friend Billy Caldwell. This was the Loop's first hotel. Alexander Robinson had a trading house and tavern here in 1831. He was the son of a Scottish father and Ottawa mother and became the chief of the united alliance of the Pottawattomie, Chippewa and Ottawa tribes. He was given land near the Des Plaines River for helping to negotiate the Treaty of 1833 and died there in 1872. The Green Tree Tavern was also built by James Kinzie in 1833. Wolf Point seems like one of those places "where everyone knows your name."

* By 1833, with a population of two hundred, Chicago was large enough to be recognized as a town. There was a public square at the site of the present City Hall County Building. The first bridge over the Chicago River was built of logs in 1832. The first post office was established in 1833. The first village board meeting was held at the Sauganash Hotel in

August 1833. St. Mary's Catholic Church, the first church, was built in 1833 at Lake and State. The first newspaper, *Chicago Democrat*, was also started in 1833. The city adopted the seal and motto "Urbs in Hortis" ("City in a Garden") in 1845.

* Chicago officially became a city in 1837. The population had already grown to 4,170. William Butler Ogden defeated John Harris Kinzie to become the first mayor (but they both got street names). By 1850, the population had reached 20,000. We kept growing and growing to 1 million in 1890. We reached the 3 million mark in 1930. The 2010 census reported a population of 2,695,598.

* Chicago's first civil disturbance was the Lager Beer Riot. In 1855, there was a low voter turnout for the elections. A group called the "Know-Nothings" was able to sneak into office. Levi Boone, great-nephew of Daniel Boone, became mayor. He headed a law and order coalition that was anti-immigrant, anti-Catholic and anti-alcohol. It closed the saloons on Sundays. Police arrested tavern owners who ignored this new law. The Irish and German laborers, who liked to have a friendly drink on their only day off, marched to support the tavern keepers, and a riot ensued. The next year, those laborers made sure to vote, and they booted stuffy Mr. Boone out of office.

* The Great Fire of Chicago occurred in 1871. It started near DeKoven and Clinton. The fire burned northeast with

fierce rapidity and consumed everything in its path all the way up to Fullerton. It killed hundreds and destroyed three square miles. Poor Catherine O'Leary was blamed. The press claimed that her cow kicked over a kerosene lamp, but the O'Learys claimed that they were asleep in bed. The city council cleared them of all charges in 1997.

* Chicago loves its architecture, and rightly so. There had been many wood-frame homes and buildings in the Loop before the Great Fire. Afterward, the houses were gone, and new buildings had to be fireproof. The Loop had to be rebuilt, and our architects rose to the challenge. The "Chicago School" was a group of architects that promoted new technology to create innovative tall buildings. The Loop is full of wonderful buildings that made Chicago the center of modern architecture. Some of those creative pioneers were Louis Sullivan, Dankmar Adler, John Root, William and John Holabird, Martin Roche and Daniel Burnham. William LeBaron Jenney (of the West Parks Commission fame) designed the world's first skyscraper. The Home Insurance Building was built in 1885 at Lasalle and Adams. At ten stories, it was the tallest building to have a steel framework. It was demolished in 1931. The ten-story Montauk Building was built in 1883, and the eleven-story Rookery was built in 1888. The Monadnock Building, built in 1891–93 with seventeen stories, was the tallest with load-bearing masonry and has also claimed to be the first skyscraper.

* We were later honored to have architects Ludwig Mies van der Rohe, Skidmore Owings & Merrill, Jahn Helmut, Stanley Tigerman, Kohn Pederson Fox and many others. Thank you for all the fabulous, brilliant buildings!

* Let's not forget the sculptures. We are able to enjoy *Flamingo* by Alexander Calder; *The Picasso*; *Cloud Gate* by Anish Kapoor; *Agora* by Magdalena Abakanowicz; the *Four Seasons* mosaic by Marc Chagall; *Sun, Moon and One Star* by Joan Miró; *Monument with Standing Beast* by Jean DeBuffet; and many other treasures throughout the city.

* The Chicago Architectural Foundation has walking, boat, trolley, "L" train and even bike tours, as well as many other programs to discover. Come experience the amazing places and spaces throughout the Loop districts.

* After Chicago annexed so many adjacent townships, the street and numbering system was chaotic. Streets would suddenly change names, and there were also duplicate street names. In 1909, a new street grid plan was adopted. The intersection of Madison and State became point zero. Each city block was marked out in increments of 100. There are eight blocks to a mile. The main thoroughfares are roughly every four blocks, or every half mile. Even-numbered buildings are on the north and west sides of the streets. Odd numbers are on the south and east sides.

* In 1835, the area east of Michigan Avenue was designated as "public ground" and officially named Lake Park in 1847. The railroad built a breakwater and added rail beds. After the Great Fire of 1871, the burned debris made the first of many landfills. The area was renamed Grant Park in 1901. Since the first Petrillo Bandshell was built in 1931, the park has offered free outdoor classical music festivals. Buckingham Fountain was dedicated in 1927. The Cancer Survivors Garden was added in 1996. Millenium Park was completed in 2004. The Maggie Daley Plaza is slated to open in 2015.

* Chicago, with all of its spunk, has had its share of public disorder. The labor strikes of McCormick Reaper in 1885, Pullman in 1894, Stockyards in 1894 and Republic Steel in 1937 are some notable ones. The Haymarket Riot in 1886 was the most remarkable. May Day (May 1) has been known as workers' and immigration rights day since the 1886 national general strike striving for an eight-hour workday. Four days later, on May 4, 1886, a crowd of laborers at Randolph and DesPlaines in the West Loop was listening to speeches against unsafe working conditions and unfair employer practices. Out of nowhere, a bomb was thrown, and the police began firing on the crowd. Labor leaders were put on trial for anarchy. The 1889 Haymarket policeman statue had been vandalized and has been moved inside the police academy. In 2004, a memorial sculpture was

installed on DesPlaines. An honorable mention goes to the 1968 Democratic National Convention Riot, and a special recognition goes to the Teacher's Strike of 2012. A report stated that the "3 Ds" of Chicago public school reform are Destabilization, Disinvestment and Disenfranchisement.

* The *Plan of Chicago of 1909*, also known as the Burnham Plan, was developed to make Chicago a grand and well-ordered metropolis. The city had grown so rapidly, and there was concern that it would be chaotic without sufficient urban planning. Daniel Burnham, Edward Bennett and the Commercial Club of Chicago created a masterful urban plan hoping to ensure economic prosperity and a high quality of life.

* The Iroquois Theater Fire of 1903 occurred only one month after its opening. More than six hundred people died. It was the deadliest theater fire in the nation's history. For weeks before the incident, the Chicago Fire Department had reported the lack of fire safety measures, but it was told that nothing could be done. The theater owners had called it "fireproof."

* The *Eastland* Disaster occurred in July 1915. The Western Electric Company had chartered the steamship *Eastland* to take 2,500 passengers on an outing to Michigan City, Indiana. The ship was top-heavy and unstable. After the passengers boarded, the ship tilted and rolled over into the

river. There were 848 deaths, and one-third of those killed were Czech immigrants.

* Chicago's first central public library was built in 1897. There are two gorgeous stained-glass domes and rooms that look like palaces. It became the Chicago Cultural Center in 1991 and offers free events, wonderful exhibits and tourist information. The Department of Cultural Affairs is located in the center. Look for the Bronze Cow, which serves as a reminder of the Cows on Parade exhibit of 1999, near the Washington Street entrance. The Harold Washington Library Center was opened to the public in 1991. Notice the owls, symbols of wisdom, perched on top of the building. Look for the wall medallions depicting Ceres, the goddess of agriculture; seed pods; cornstalks; the "Windy City Man"; and the "Y" symbol.

FAVORITE THING ABOUT THE LOOP

"Variety" and "ease" seem to be the operative words. We can walk or take public transportation to almost every restaurant, cultural venue or grocery store. The very accessible lakefront presents year-round beauty, while Millennium Park offers free concerts in the summer; Navy Pier shows us weekly fireworks from Memorial Day to Labor Day.

Marilynn Rochon and Jerry Hiller, residents
St. Peter's in the Loop
Repair My House Program

PLACE OF INTEREST
Louis Henri Sullivan's Initials
Sullivan Center
State and Madison

Architect Louis Sullivan was known for his ornamentation on building façades. This gem, with its cast-iron leaves, vines and berries, was built in 1899 for the Schlesinger & Mayer Store. Additions were made until 1904, when it became the Carson, Pirie and Scott Building. Carson's remained here until 2007, when the building was renamed the Sullivan Center. There are offices on the top floors, and City Target was opened in the lower two floors in 2012. The initials can be found above the corner entryway.

33. Near South Side

BOUNDARIES
N—Roosevelt Road
S—26th Street
E—Lake Michigan
W—Chicago River South Branch/Clark/Federal

NEIGHBORHOODS

Prairie District Museum Campus
Dearborn Park Northerly Island
Central Station McCormick Place

HOW IT GOT ITS NAME
Yes, it is *near* to and *south* of the Loop.

DID YOU KNOW?
* The first settlers here were the Irish, German and Scandinavian laborers who worked on the I&M Canal. They lived in small wooden cottages near the river.

* After the Great Fire of 1871 burned the mansions along the lakefront on Michigan Avenue, houses were no longer present in the Loop, and the wealthy rebuilt grand homes on Prairie, Michigan and Indiana Avenues south of 16th Street. There are still eleven mansions left in Prairie District.

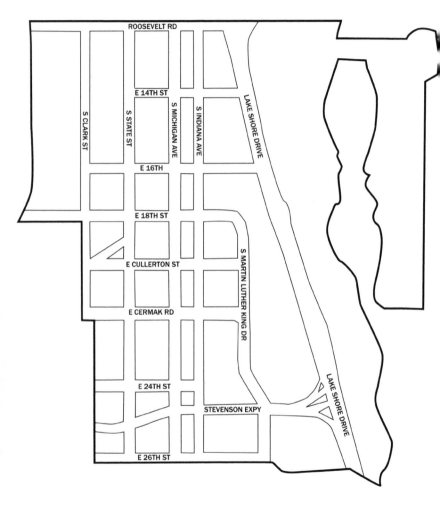

The Clarke House is one of the oldest standing houses in the city. It was built in 1836 and is now a museum. The Glessner House was built in 1886 and is also a museum today. The U.S. Soccer Federation is now housed in the home of Wallace Kimball, the piano manufacturer. The Keith House is used for special events. The area had the mark of conspicuous consumption by the likes of Field, Armour, Pullman and others.

* Mercy Hospital is the city's oldest hospital. The Rush Medical College opened in 1843. It started as the Illinois General Hospital of the Lakes in 1850 for clinical education. In 1846, a group of Sisters of Mercy came to Chicago from Ireland, where the order was founded. In 1851, the hospital was transferred to the nuns and renamed Mercy Hospital. It moved to the Near South Side at 26th and Prairie in 1863.

* Quinn Chapel, the oldest African American church in Chicago, was built in 1891 at 24th and Wabash. The first congregants were mostly former slaves. It became a Chicago Landmark in 1977.

* The Field Museum (1924), the Shedd Aquarium (1930) and the Adler Planetarium (1930) are all part of the Museum Campus.

* The "South Side Levee" was a red-light district from 1893 to 1912. The area between 18th Street and Cermak

west of State Street was full of brothels, saloons, gambling houses and at least one opium den. The Everleigh Club was a notorious, opulent bordello run by Minna and Ada Everleigh. The flamboyant sisters screened their clients and catered to the rich and famous. In 1911, a booklet called *The Social Evil in Chicago* prompted reform.

* South Michigan Avenue was known as "Motor Row" in 1905–36. The new auto industries built flashy showrooms and service shops to promote their cars. It was later known as "Record Row" when Chess Records and other labels recorded blues artists in this area.

* In the 1920s, the Great Migration brought many African Americans north to the area. A thirty-block strip along State Street became known as the "Black Belt." Because of discriminatory realty practices, black residents had difficulty finding housing in the city and were segregated here.

* The 1933 World's Fair was held to celebrate "a century of progress." The "Rainbow City" was built in Burnham Park in the area of Northerly Island and McCormick Place. The performance of fan dancer Sally Rand was a big hit. One of the red stars on the Chicago flag symbolizes the fair. (The other three stars represent Fort Dearborn, the Columbian Expo and the Great Fire of 1871.)

* Soldier Field was built in 1924 and renovated in 2003. The Gold Star Families Memorial is located east of the stadium to honor fallen police officers. McCormick Place was built in 1960. The Chicago Firefighter Paramedic Memorial is located southeast of the convention center, next to the eighteen-mile-long Lakefront Trail.

FAVORITE THING ABOUT THE NEAR SOUTH SIDE

As a historian, I love the Near South Side because its history encompasses every era of Chicago history, from Chicago's oldest house to modern town houses and highrises, and from the Gilded Age mansions to buildings constructed for the printing and automobile industries.

William Tyre, director
Glessner House Museum

PLACE OF INTEREST

Hilliard Towers
2031 South Clark Street

The CHA apartment complex was designed by Bertrand Goldberg, who also designed Marina City, River City and Prentice Hospital. It is an award-winning center that opened in 1966. Goldberg felt that public housing should be a place where residents would be proud to live. It is now owned by a private company and was renovated and preserved in 2004. The towers have been listed on the National Register of Historic Places since 1999.

34. Armour Square

Boundaries

N—18th Street
S—Pershing Road
E—Dan Ryan Expressway
W—Chicago River/railroad tracks at Stewart Avenue

Neighborhoods

Chinatown
Park Boulevard
Armour Square
Wentworth Gardens

How It Got Its Name

This area was named in honor of Phillip Armour, Chicago's captain of the meatpacking industry. He started Armour & Company in 1867. It became the world's largest meatpacking company. He famously said that they "used everything but the squeal." He started Armour Institute of Technology in 1893; in 1940, it merged with the Lewis Institute to became Illinois Institute of Technology. Armour was known as a philanthropist, while most of his employees lived in slums.

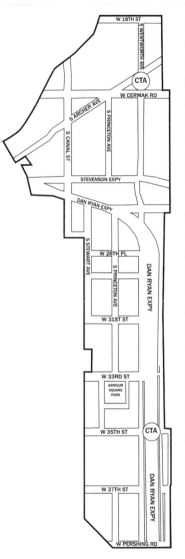

DID YOU KNOW?

* The first residents were more of the Irish, German and Scandinavians who labored nearby. In 1899, a large group of Italian immigrants settled in the area. These residents built the Santa Maria Incoronata Church in 1904. It is now St. Therese Chinese Catholic Mission. The Old Neighborhood Italian American Club is still located in Armour Square. There was also a large Croation population. St. Jerome Church was built in 1912 and still holds Mass in both English and Croatian. The annual Velika Gospa festival is held on August 15 to celebrate the Feast of the Assumption and commemorate the moment when townspeople of a small Croatian village prayed to the Virgin Mary and approaching enemy soldiers turned back. In the 1920s, the "Black Belt" extended through here. A small African American population remains.

* T.C. Moy and his brothers were the first Chinese immigrants to come to Chicago in 1878. More Chinese came from the West Coast after they finished building the transcontinental railroad. They first settled in the South Loop, but bigoted landlords raised their rents to outrageous rates. So, they moved en masse into Armour Square in 1912. The On Leong Association Building, now known as Pui Tak Center, is a Chicago Landmark. It was built in 1928 and was known as the Chinatown "city hall." Immigrants continue to come to this enclave.

* Armour Square Park was created in 1905 as part of the South Parks neighborhood park system. It is most commonly known as the "park next to White Sox Field." The landscaping was designed by Frederick and John Olmsted, and the fieldhouse was designed by Burnham & Company.

* Jack Johnson, the first black heavyweight boxing champion, had a club called Café du Champion here in 1912. He had to flee the country one year later when he was charged with violating the Mann Act because he took his white wife across state borders.

* Old Cominskey Park was built in 1910 and demolished in 1991. From 1975 to 1991, it was the oldest standing baseball field. It was first called White Sox Park until the owner, Charles Cominskey, named it after himself. The

new Cominskey Park was opened in 1991 in an adjacent location. U.S. Cellular bought naming rights in 2003. The first ever all-star game was played at the old park in 1933. Bill Veeck gave us the pinwheels and exploding scoreboard.

* The Park Boulevard housing complex is being constructed at the site of the old Stateway Gardens, one of those boxy public housing high-rises that needed to be demolished.

FAVORITE THING ABOUT ARMOUR SQUARE

Visiting Armour Square is like going from the Great Wall to the Great Lakes: Chicago's Chinatown.

> *Gene Lee, lifelong resident*
> *Chicago Chinatown Chamber of Commerce*

PLACE OF INTEREST

Ping Tom Memorial Park Pagoda
300 West 19th Street

The park is named after Ping Tom, a Chinese businessman and civic leader. He was the moving force behind the creation of the park but died from cancer before it was completed. Chinatown had been lacking green space for forty years after its only park was demolished for the expressway. The park was dedicated in 1999. A new fieldhouse and boathouse were built in 2013.

35. Douglas

BOUNDARIES
N—26th Street
S—Pershing Road
E—Lake Michigan/Vincennes
W—railroad tracks at LaSalle/Federal

NEIGHBORHOODS

Bronzeville	Groveland Park
The Gap	Illinois Institute of Technology
Prairie Shores	Illinois College of Optometry
South Commons	Lake Meadows

HOW IT GOT ITS NAME
Stephen Douglas owned much of the land in the area. He gave sixty acres to the government to open Camp Douglas. It ran from 1861 to 1865 as a training camp for Civil War soldiers and later as a prisoner of war camp, holding twelve thousand Confederate soldiers at a time.

DID YOU KNOW?
* Willard Myrick came here in 1836 and started the city's first stockyard. He opened Myrick's House and Bull's Head Tavern for visiting cattlemen. It stood at 29th and Cottage Grove from 1839 to 1854.

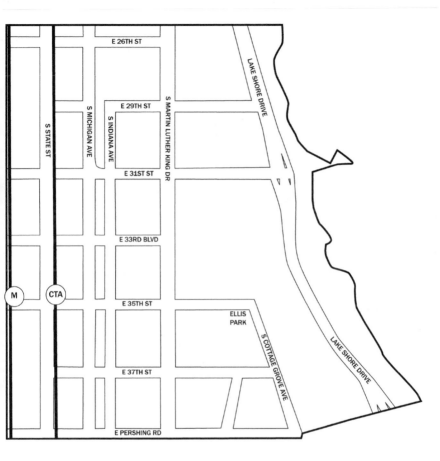

* Old Chicago University was located in this area from 1857 to 1886, when it closed because of financial difficulties. It included the Union College of Law, Chicago's first law school.

* Jewish immigrants were the first community to settle here in 1872. They built the KAM Temple synagogue, designed by Adler & Sullivan, in 1890. It has been the Pilgrim Baptist Church since 1922. The Jewish population also founded Michael Reese Hospital in 1880 with money donated by Michael Reese, a real estate developer. It was a prominent research and teaching hospital, the largest in Chicago, until 1991, when it was purchased by a corporation. It was officially closed in 2009. The Lakeside Club, a Jewish social club, was built in 1887. In 1917, it became Unity Hall, headquarters of the People's Movement political organization led by Oscar DePriest.

* Two famous African American newspapers, the *Chicago Defender* and the *Chicago Bee*, located their headquarters here. Both of their office buildings are now Chicago Landmarks.

* In the 1910s, Douglas became an African American area and was called the "Black Metropolis." A newspaper editor gave the area from 26th Street down to 51st Street, into the Grand Boulevard Community Area, the title of "Bronzeville." It was the heart and soul of Chicago's African American culture. Many famous black citizens resided here: author Richard Wright; poet Gwendolyn Brooks; musician Louis Armstrong; singers Lou Rawls, Nat King Cole and Sam Cooke; boxer Joe Louis; Bessie Coleman, the first black female pilot; Andrew Rube Foster, founder of Negro League baseball; artist and author Margaret Taylor

Burroughs; Marquette and Olympic track star Ralph Metcalfe; photographer Gordon Parks; and others.

* The 1919 Race Riots began at 35th and State, an area called "the Stroll." A black youth crossed the imaginary "white/colored" line at the 29th Street Beach and was stoned to death. A police officer wouldn't arrest the guilty men, and all hell broke loose for days.

* The Sunset Café was located on 31st Street from 1921 to 1937. It was renamed the Grand Terrace Ballroom in 1937, lasting until it was closed in 1950. Louis Armstrong came to Chicago in 1922 and recorded his first record here. Other popular clubs included the Royal Gardens and Dreamland Café.

* The Victory monument was built in 1928 in honor of the African American members of the National Guard who served in World War I. They were called the "Fighting Eighth" regiment, and the names of the 137 soldiers who lost their lives are inscribed.

FAVORITE THING ABOUT DOUGLAS
Douglas is a historic site of African American achievement in arts, culture, business, politics and sports. This community's unique landscape and assets are preserved as the Black Metropolis National Heritage Area.

Harold L. Lucas
Bronzeville Visitor Information Center

Place of Interest

Monument to the Great Northern Migration
26th Street at Martin Luther King Drive

The plaque reads, "This bronze monument depicts a man wearing a suit made of shoe soles rising from a mound of soles. The soles, worn and full of holes, symbolize the often difficult journey from the south to the north. It commemorates all the African American men and women who migrated to Chicago after the Civil War. Erected in 1996."

36. Oakland

BOUNDARIES

N—35th Street
S—43rd Street
E—Lake Michigan
W—Vincennes/Cottage Grove

NEIGHBORHOODS

Oakland
Bronzeville

HOW IT GOT ITS NAME

* Samuel Ellis (street name) ran a tavern at 35th and the Vincennes Trace in the 1830s. Charles Cleaver came to Chicago from London in 1833. In 1858, he bought acreage from Mr. Ellis. Cleaver built a soap plant and then established a company town, calling it Cleaverville. There was a general store, a town hall, a church and a few blocks of wooden homes. He named his own estate and its road Oakwood. Developers who subdivided the adjoining land in 1871 kept the theme and called the area Oakland.

DID YOU KNOW?

* The main street through the area was the Indian trail from Fort Dearborn to Detroit (now the Dunes Highway in

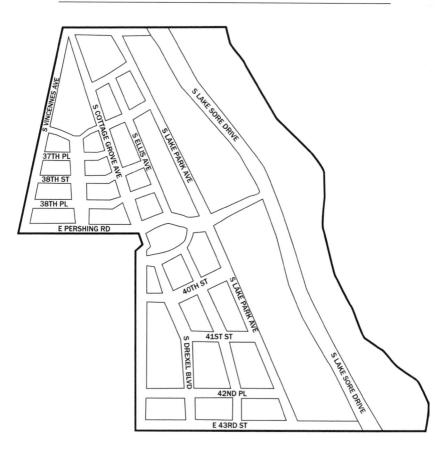

Indiana). Charles Cleaver named it Cottage Grove Avenue because of a small cottage that sat in a pretty grove of oak trees. In 1859, to ensure transportation for his village, Mr. Cleaver enticed the Illinois Central Railroad to make a train stop at 39th Street. The station was called Five Crossings.

* The development created in the 1870s included many elegant graystones. Oakland became an elite neighborhood. The Drexel family of Philadelphia donated land to establish Drexel Boulevard in order to make their property more desirable. Many Jewish families moved here in the 1870s. The wealthy began to move out in 1900, and the homes became apartments and rooming houses. Mostly Irish families moved in during the transition.

* Burnham Park is located on the lakefront adjacent to the area. The park was created in 1920 and runs from Grant Park to Jackson Park. It is an outgrowth of the *Plan of Chicago of 1909* and was named after Daniel Burnham. Montgomery Ward promoted the idea that the lakefront should remain "forever open, clear and free."

* The Abraham Lincoln Center was the first work of Frank Lloyd Wright. It was built in 1888 to serve as the All Souls Church for his uncle, Reverend Jenkins Lloyd Jones. It became a settlement house in 1905 to serve new residents and continues to offer social services to assist the community today.

* The first Walgreens drugstore was located at 42^{nd} and Cottage Grove in the Barrett's Hotel. In 1901, Charles Walgreen started the conglomerate that now has 7,700 stores.

* Hannah Greenebaum Solomon lived in Oakland when she founded the National Council of Jewish Women, which fought for social reform in Chicago.

* The Oakland Square Theater opened here in 1916 and was the city's largest movie theater at that time. After it closed in 1966, Jeff Fort purchased the building and made it the headquarters for his crime organization. He called it the El Rukns Grand Major Temple. Police seized the temple in 1989 and tore it down.

* Muddy Waters, the "Father of Chicago Blues," was an Oakland resident from 1954 until 1974, when he moved to Westmont, Illinois. His birth name was McKinley Morganfield, but his grandmother who raised him in Mississippi gave him the nickname of "Muddy" because he loved to play in the muddy waters of a nearby creek.

Favorite Thing about Oakland

We are on a journey for justice. The desperation of the neighborhood has led us to build a movement to reclaim public education.

Jitu Brown
Kenwood Oakland Community Organization

PLACE OF INTEREST

Home of Ida B. Wells
3624 South Martin Luther King Drive

Ida B. Wells first became a civil rights activist in 1884 when a train conductor ordered her to move and she refused to give up her seat. She went on to become a journalist who was best known for documenting bigotry and the lynching of black men in the South. She and her husband, Ferdinand Barrett, lived in Chicago from 1919 to when she died in 1931.

37. Fuller Park

BOUNDARIES

N—Pershing Road

S—55th Street

E—railroad tracks at Federal

W—railroad tracks at Stewart

NEIGHBORHOODS

Fuller Park

HOW IT GOT ITS NAME

Fuller Park was part of the South Parks neighborhood parks system. It was named after Melville Fuller. He was a leading attorney in Chicago and was a South Parks commissioner. He was a U.S. chief justice of the Supreme Court from 1888 to 1913.

DID YOU KNOW?

* In 1865, Irish settlers built modest frame houses here. They worked for the nearby railroads. In the 1870s, 10 percent of Chicago's laborers worked for the railroads. A large railroad roundhouse—a circular building for housing, repairing and switching railroad cars—was built here in 1871.

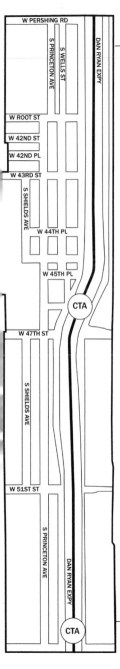

* St. Anne's Church was founded in 1869 at Wentworth and Garfield. The parish was formed in an old Jewish synagogue. In 1971, it was renamed St. Charles Lwanga after a Ugandan man (later sainted) who was killed in 1886 for his faith. It was demolished in 2010.

* By 1930, Irish residents had begun to move out as housing deteriorated. German and Austrian immigrants moved in to work at the railroads and stockyards. In 1945, Fuller Park was 80 percent white.

* African American Chicagoans were restricted to live in the "Black Belt." The rents there were actually higher in the run-down buildings owned by absentee landlords. After segregated housing policies were overturned in the 1950s, African Americans began moving to Fuller Park. By 1970, it had become 97 percent black.

* The Dan Ryan Expressway was opened in 1962. It was named after the Cook County Board of Commissioners president, who had worked to ensure its construction. The city used its powers of eminent domain

to demolish hundreds of buildings in 1953–54. The expressway split the Fuller Park area in half and displaced one-third of its residents.

* The neighborhood parks movement began in 1900. Half of Chicago residents lived a mile or farther from a park. The South Parks Commission felt that a new type of neighborhood parks system would provide green spaces and promote social reform. The parks had recreation facilities and fieldhouses with libraries, classrooms and auditoriums. Fuller Park and ten other parks were built in 1905. The Fuller Park fieldhouse, designed by Edward Bennett, has retained most of its original architecture. The park layout and landscaping were designed by John Olmsted and his brother, Frederick Law Olmsted, who had planned New York's Central Park. In 1911, three more neighborhood parks were opened in the South Parks district.

* Fuller Park has had the highest rate of elevated lead levels of all the community areas in the city and has been the third-most lead-contaminated neighborhood in the country. The most likely culprit was lead-contaminated soil and dust from the old rail yards and industry. In 1997, Michael and Amelia Howard were concerned about contaminated illegal dumpsites and organized volunteer residents to haul away two hundred tons of debris from vacant lots. In 1999, a whopping 39.0 percent of the children in Fuller Park had elevated levels of lead in their

blood. By 2011, there had been improvement—only 2.5 percent had elevated lead levels.

FAVORITE THING ABOUT FULLER PARK

Almost all of the neighborhood kids seem to hang out at Fuller Park. They have so many activities for the kids, like the after-school programs and summer youth camp. There is a beautiful fieldhouse, a gym, a pool and lots more.

Aurelia Daniels
Fellowship Missionary Baptist Church

PLACE OF INTEREST

Eden Place Nature Center
43rd Place and South Shields

After a three-acre dumpsite was cleaned up, the community opened an environmentally friendly park center. It is a subsidiary of the Fuller Park Community Development Corporation. There are outdoor classrooms, a produce garden and a prairie reserve. It has been honored with the Conservation and Native Landscaping Award.

38. Grand Boulevard

Boundaries
N—39th Street
S—51st Street
E—Cottage Grove Avenue
W—railroad tracks at Federal

Neighborhoods
Grand Boulevard
Bronzeville
Washington Park Court
Legends South

How It Got Its Name
In 1897, the South Parks Commission landscaped and developed the main thoroughfare from Grant Park to Washington Park and named it Grand Boulevard. It was renamed South Park Way in 1928. It was again renamed Martin Luther King Drive in 1968.

Did You Know?
* Wealthy residents began moving into the mansions built along the boulevard. Middle-class Irish, English and Scots also moved into the adjoining neighborhoods. The Irish started St. Elizabeth of Hungary parish in a small frame

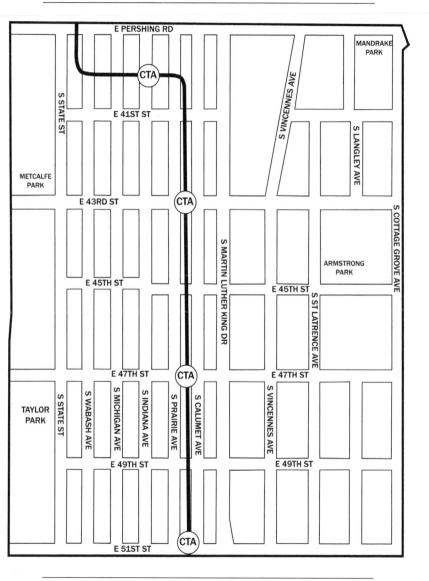

church in 1881. It was replaced by a grand edifice at 41st and Grand Boulevard in 1891. St. Elizabeth and St. Monica consolidated in 1924.

* St. Monica was the first black Catholic church in Chicago. It was founded in 1894 by Father Augustus Tolton, the first black priest in the United States. He is now on his way to sainthood.

* Corpus Christi Church was also an Irish parish started in 1881, at 49th and Grand Boulevard. When Irish families moved away in the 1920s, Corpus Christi became a segregated black parish. Franciscan nuns and priests ran the parish from 1932 until 2002. It is now served by Nigerian priests and the Franciscan sisters.

* German Jews moved into the area in the late 1890s. Temple Isaiah on 45th Street was built in 1899. It was the last work of Dankmar Adler. The Ebenezer Baptist Church moved into the building in 1921.

* Jewish residents also built the Sinai Temple at 46th and Grand Boulevard in 1915. It was closed a mere ten years later when the neighborhood demographics were changing. Corpus Christi High School was opened at the site in 1926. It moved to the old Saint Xavier College site at 49th and Cottage Grove in 1946 and became Hales Franciscan High School, an all-male African American college prep school. The old Sinai Temple is now Mount Pisgah Baptist Church.

* Provident Hospital was established in 1891 by Dr. Daniel Hale Williams, the first African American cardiologist. It was the country's first hospital with black physicians. Emma Reynolds had been denied admission to all of Chicago's nursing schools because she was black. With Dr. Williams, she opened a nursing training facility for black women adjoining the hospital.

* Grand Boulevard was a nightlife hot spot. The Savoy Ballroom was built in 1927 at 47th and Grand Boulevard. The Harlem Globetrotters started there. (I bet you thought they came from New York!) Most of the players attended Wendell Phillips High School and originally called themselves the Savoy Big Five. The Regal Theater opened next door in 1928. It featured music from the likes of Ray Charles, Louis Armstrong, Billy Eckstine, Ella Fitzgerald, Duke Ellington, Count Basie and others.

* The Robert Taylor Homes were completely demolished by 2007. In their place stands a beautiful neighborhood of row houses and condos called Legends South. High-rise public housing, built in the late 1950s, had quickly deteriorated and become infested with gangs and drugs. "Operation Clean Sweep" was started in 1988 to regain control by police raids. It was ineffectual and resented by law-abiding residents. Demolition of the high-rises began in 1998, and mixed-income redevelopment was established throughout the inner city.

FAVORITE THING ABOUT GRAND BOULEVARD

Grand Boulevard is a community with a rich history of African American achievement and a deep tradition of celebrating and sharing its cultural contributions to Chicago and the world.

Pat Dowell, alderman

PLACE OF INTEREST

Harold Washington Cultural Center
4701 South Martin Luther King Drive

The Center opened in 2004 on the site of the old Regal Theater. It contains a performance theater for the Broadway in Bronzeville program, its Tap Dancing Academy and other events. It also has spaces for educational programs, meeting rooms and a computer lab. A bronze statue of Mayor Harold Washington adorns the entrance.

39. Kenwood

BOUNDARIES
N—43rd Street
S—Hyde Park Boulevard
E—Lake Michigan
W—Cottage Grove Avenue

NEIGHBORHOODS
Kenwood
Indian Village
North Kenwood

HOW IT GOT ITS NAME
The area's first resident was Jonathan Asa Kennicott, who had come to Chicago in 1836. He earned his medical degree from Rush Medical College in 1843. He built a home south of 43rd Street in 1856 and named it Kenwood in honor of his mother's birthplace in Scotland. A train station was built in 1859 at 47th Street, and it was also named Kenwood.

DID YOU KNOW?
* Dr. William Egan was another early settler. He had come to Chicago from County Kerry, Ireland. He owned a square-mile estate with extravagant gardens and named

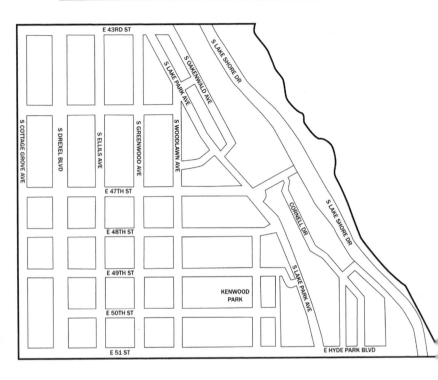

it Egandale. He helped to organize St. James, the first Episcopal church in Chicago. Dr. Egan was considered the most eloquent Irish orator in the city. He led efforts to form the Irish Famine Relief project.

* A fashionable neighborhood grew around the doctors. The location near the lake and the presence of a train station enticed many wealthy residents to build large homes with spacious lawns after the Great Chicago Fire.

The Chicago Beach Hotel, a huge, glamorous resort with a private beach, was built in 1890. It served as a hospital during World War II and was then torn down.

* A group of luxury high-rise apartment buildings was erected in the southeast portion of Kenwood in the 1920s. Many of them bear Native American names such as the Algonquin, Narragansett, Chippewa and Powhatan. The neighborhood became known as Indian Village.

* Famous past residents of Kenwood include Louis Sullivan, Muhammad Ali, Bill Veeck and Barack and Michelle Obama. Julius Rosenwald also lived here. He was a president of Sears & Roebuck and was a true philanthropist. In 1913–30, the Rosenwald Fund built more than five thousand schools for African American children in the South; he also had constructed the Michigan Boulevard Garden Apartments courtyard complex, with 450 units, to provide decent, affordable housing for Chicago's working-class families.

* The first synagogue in Chicago was formed in 1847 in the Loop for the KAM congregation. It moved to the Douglas area in 1890. It then constructed the KAM Temple at 50th and Drexel in 1923. The congregation merged with the Isaiah Israel Temple in 1971, and its synagogue is now located across the street from President Obama's former home. The old KAM Temple became home to the Rainbow PUSH headquarters in 1972.

* After working at the 1893 Columbian Expo, several hundred Japanese immigrants remained and settled in Kenwood and Hyde Park. Chicago was the top destination choice among Japanese released from the internment camps of World War II. They faced less discrimination than on the West Coast. In 1945, many settled along Clark Street in Uptown. Chicago has the eighth-largest Asian population of cities in the United States.

* For a long time, North Kenwood did not fare as well as the section south of 47th Street. Many of the mansions were torn down, and vacant lots were left. But it is making a comeback to keep up with the southern part of the area, which had remained a stable, integrated neighborhood. The North Kenwood Historic District homes have been refurbished, and older homes that were deteriorating are being rehabilitated. The Kenwood Oakland Community Organization (KOCO) is very active in the area.

FAVORITE THING ABOUT KENWOOD

Kenwood is a demonstration of faith, hope and possibilities. I want the children of Kenwood to feel safe, honored and empowered.

Monica Haslip, director
Little Black Pearl Organization

PLACE OF INTEREST

Blackstone Library
4904 South Lake Park Avenue

The Blackstone Memorial Library was the first branch of the Chicago library system. Built in 1904, it was designed by architect Solon Beman. The murals in the rotunda have the themes of labor, literature, art and science. It was named after railroad executive Timothy Blackstone (street name). It became a Chicago Landmark in 2010.

40. Washington Park

BOUNDARIES
N—51st Street
S—60th Street/63rd Street
E—Cottage Grove/Martin Luther King Drive
W—railroad tracks at LaSalle

NEIGHBORHOODS
Washington Park

HOW IT GOT ITS NAME
Frederick Law Olmsted laid out plans for Washington Park in 1873. It was completed in 1880 as part of the South Parks system. And yes, it was indeed named after George Washington, our first president.

DID YOU KNOW?
* The railroad came to the area in 1853. A depot was built at 63rd and LaSalle. The station was known as Chicago Junction. There was nothing but wetlands south of the intersection. The "L" line came to 55th Street in 1893.

* Irish and German railroad workers and meatpackers were the first settlers here in 1856. Affluent Chicagoans built along the boulevards. In the early 1900s, African Americans began moving southward along the Black Belt.

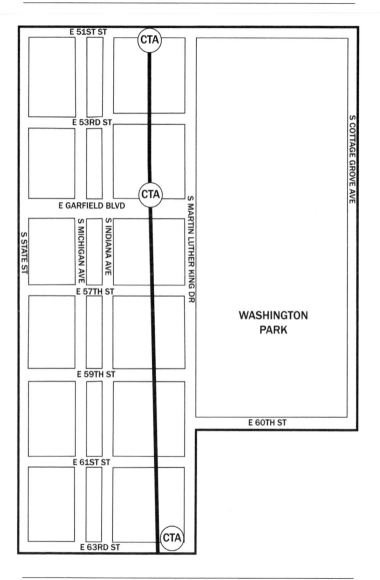

* Jesse Binga came to Chicago in 1893 with ten dollars in his pocket. He rose to become a successful banker. He moved into Washington Park in 1917 as one of the first black owners. His home was repeatedly bombed and is now a landmark.

* Chicago Orphan Asylum was located on Grand Boulevard from 1898 to 1939. The city leaders organized it in 1847 after the cholera epidemic. It was run by a women's board and was originally housed in rented homes. The building became the Parkway Community House from 1940 to 1957 and was an anchor for the Bronzeville community. It is now home to Chicago Baptist Institute. The building was approved as a Chicago Landmark in 2008.

* James Farrell started writing in an apartment overlooking Washington Park. He lived with his immigrant Irish grandparents here and attended the nearby University of Chicago in 1925–29. The neighborhood became the basis of his Studs Lonigan trilogy.

* The DuSable Museum is the first museum in the country dedicated to the study and preservation of African American history. It was founded in 1961 by Dr. Margaret Burroughs. In 1973, the Chicago Park District donated the park administration building to house the institution. The Harold Washington wing was added in 1993.

* The annual Bud Billiken parade and picnic terminates in Washington Park. It has been held since 1929, when Robert Abbott, founder of the *Chicago Defender*, wanted to do something special for the youth who sold the newspaper. It is the largest African American parade in the United States. A "Billiken" is a good-luck figure that was designed by an art teacher in St. Louis. She sold the patent to a Chicago company. It was all the rage in 1910. There was a column in the newspaper by Williard Motley depicting Bud Billiken as the "Guardian Angel of Black Children."

* The University of Chicago has purchased land west of the park with plans for expansion. There are also plans for a "Gateway to Washington Park," a large residential, retail and office complex to be built on Martin Luther King Drive. The community is hoping for revitalization without the displacement of its residents.

FAVORITE THING ABOUT WASHINGTON PARK

Washington Park is the best a park can offer: 366 acres of green space, largest playing field in Chicago [Harold Washington Common Ground], *Lorado Taft's* Fountain of Time, *DuSable Museum of African American History, the General Richard L. Jones Armory, the first tree arboretum in the city and much more. Come join the fun.*

Cecilia Butler, president
Washington Park Advisory Council

Place of Interest

Fountain of Time

Cottage Grove at the end of Midway Plaisance

The 127-foot-long sculpture was created by Lorado Taft in 1922. The work took fourteen years to complete. It features Father Time hovering over one hundred figures headed toward a common fate. A reflecting pool adds to its beauty. Restoration took place in 2002. Lorado Taft was a renowned Chicago artist. He also created the *Fountain of the Great Lakes*, located at the Art Institute.

41. Hyde Park

BOUNDARIES
N—East Hyde Park Boulevard
S—60th Street
E—Lake Michigan
W—Cottage Grove Avenue

NEIGHBORHOODS
Hyde Park
East Hyde Park

HOW IT GOT ITS NAME
Paul Cornell (street name) came to Chicago from New York in 1853 and bought land as a real estate speculator. He named the village Hyde Park to make it sound ritzy, like Hyde Park, New York. He built the Hyde Park Hotel and negotiated for a Hyde Park railroad stop.

DID YOU KNOW?
* The University of Chicago was established in 1892 with funds from John D. Rockefeller and land from Marshall Field. It has been known as the "Gray City" because of its unified Gothic architecture with limestone façades. There have been eighty-seven Nobel laureates who were associated with the school. The university's presence is felt throughout the community.

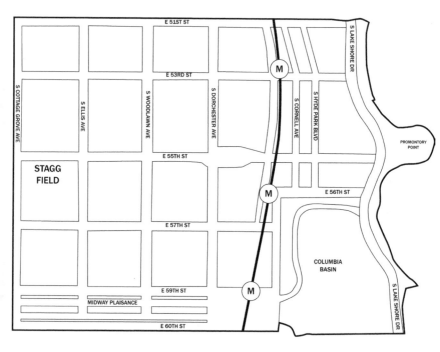

* The World's Columbian Exposition of 1893 was held in Jackson Park, with an amusement park located along the Midway Plaisance. It was known as the White City because the structures in the Court of Honor were clad in white stucco. Only two buildings from the fair are still standing. The Palace of Fine Arts became the Museum of Science and Industry in 1933. The building exterior was crumbling in 1926, and Julius Rosenwald contributed millions to have it reduced to the steel skeleton and rebuilt in stone. The second existing building had been the World's Congress Auxiliary

Building on Michigan Avenue at Lake Park (later expanded to become Grant Park). It was taken over by the Art Institute of Chicago after the expo ended. The world's first Ferris wheel was introduced at the expo. The fair made the general public familiar with hamburgers, soda, Cracker Jack, postcards, cream of wheat, Juicy Fruit gum and Pabst Blue Ribbon beer. There were pavilions for fifty foreign countries and forty-three states. The expo influenced the City Beautiful movement and led to the *Plan of Chicago of 1909*.

* The Robie House was designed by Frank Lloyd Wright in 1910. It was built for Fredrick Robie, a bicycle manufacturer, and his wife, Lora, a graduate of the University of Chicago. It is considered a masterpiece of the Prairie style.

* In the 1930s, Hyde Park was a popular resort area, with more than one hundred hotels. The Hotel Windermere, the Shoreland Hotel and the Picadilly Theater and Hotel were popular. Most of the hotels became apartment buildings after the Great Depression.

* Enrico Fermi achieved the first nuclear chain reaction in 1942 in a lab under the Stagg Field football stadium. There is now a sculpture by Henry Moore called *Nuclear Energy* that was erected at the site on Ellis Avenue in 1967.

* Some of Hyde Park's notable residents have included writers Saul Bellow, Bayo Ojikutu, Edna Ferber and Ben

Hecht; lawyer Clarence Darrow; social activist Al Raby; alderman Leon Depres; physician Quentin Young; Chicago mayor Harold Washington; comedian and activist Dick Gregory; U.S. Secretary of Education Arne Duncan; and Arnie Morton, who opened his first restaurant in Hyde Park.

FAVORITE THING ABOUT HYDE PARK

The good thing about Hyde Park is that everything you need is right there: groceries, restaurants, Promontory Point, the excellent Hyde Park Records, a wealth of used bookstores and all the resources of the University of Chicago. Since my day job is in the Loop, I leave Hyde Park daily via the (twelve-minute!) Metra ride, but there are plenty of people who rarely leave, and one understands why.

Mary Hornschemeier Bandstra, resident

PLACE OF INTEREST

Promontory Point
Burnham Park at 55th Street

Commonly known as "the Point," this man-made peninsula was created in 1926, having been designed by Alfred Caldwell. The fieldhouse was built in 1937. The Wallace Memorial Fountain was installed in 1939. The grounds also contain stone council rings that are used as fire pits. A pedestrian tunnel under Lake Shore Drive leads to the park. There have been many weddings held at this lovely location—*Star Wars* creator George Lucas and Chicago businesswoman Mellody Hobson had their wedding reception here in 2013.

42. Woodlawn

BOUNDARIES

N—60th Street
S—67th Street
E—Lake Michigan
W—Martin Luther King Drive/South Chicago Avenue

NEIGHBORHOODS

Woodlawn
West Woodlawn

HOW IT GOT ITS NAME

Woodlawn Avenue is the center of the community. It was named after Woodlawn Park, the mansion of Stephen Douglas, which was located north of 35th Street near the Douglas monument.

DID YOU KNOW?

* James Wadsworth was one of the first settlers in 1859. There were only five Dutch farms in the area at that time. It remained a lonely location until it grew in anticipation of the Columbian Exposition.

* The southern half of Jackson Park extends into Woodlawn. A replica of the *Statue of the Republic*, the Japanese Garden on Wooded Island, beautiful lagoons and bridges are all

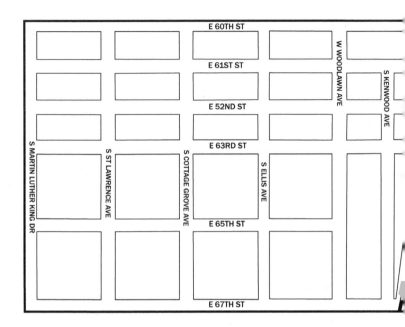

reminders of the Columbian Expo. The Jackson Park Golf Course was originally built in 1899.

* The section just south of Washington Park became the place for fun. In 1890, the Balneum Open Air Natatorium was located here. The Sans Souci Amusement Park was opened in 1899 at 60th and Cottage Grove. It featured rides, concerts, an arcade, a Japanese tea garden and, naturally, a beer garden. Frank Lloyd Wright designed the entertainment complex called Midway Gardens at the Sans Souci in 1914. The amusement park was closed in 1920.

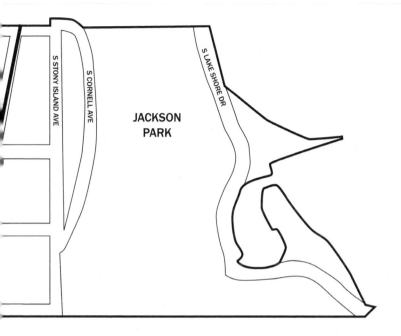

* The White City Amusement Park was located nearby at 63rd and Grand Boulevard from 1906 to 1933. The large "Electric Tower" and the buildings were lined with white lights. The White City Ballroom attracted orchestras during the big-band era. The first Goodyear commercial blimp was launched from a hangar here in 1919.

* The Trianon Ballroom opened in 1922 at 62nd and Cottage Grove. It was considered Chicago's most lavish dance hall. It maintained "high social standards," and the patrons were monitored to ensure appropriate

behavior. It was sold in 1954 to avoid integration and then closed in 1958.

* The Washington Park Race Track and Club was built at 61st and Grand Boulevard in 1884. Its Jockey Club was an exclusive venue. It attracted Chicago's elite, even though there were many betting scandals. It was closed by the city in 1905 in an effort to curb gambling.

* The Hansberry family were some of the first African Americans to move into Woodlawn in 1937. A white homeowner, Anna Lee, filed suit in an attempt to restrict them from the neighborhood, but she lost the case. Lorraine Hansberry based her play *Raisin in the Sun* on their experience with white flight and the struggle to integrate.

* The U of C expanded south of the Midway Plaisance when it built Burton Judson Courts residence hall in 1931. Some of its other notable buildings in Woodlawn have been the law school, designed by Eero Saarinen in 1955; the School of Public Policy, designed by Mies van der Rohe in 1965; the art-like Chiller Plant, designed by Helmut Jahn in 2009; and South Campus Residence Hall, designed by Goody-Clancy in 2009.

* The Lorado Taft Midway Studios are located in Woodlawn. Mr. Taft trained students here from 1907 until he died in 1936. The University of Chicago now owns the building, which became a Chicago Landmark in 1993.

FAVORITE THING ABOUT WOODLAWN

Experimental Station runs a bike shop and youth program called the Blackstone Bicycle Works. My favorite thing about Woodlawn is its kids. Despite the profoundly challenging circumstances with which most of them must contend every day, they remain joyous, curious and affectionate.

Connie Spreen, director
Experimental Station

PLACE OF INTEREST

Grand Ballroom
6315 South Cottage Grove

The Loeffer Building was erected in 1923. The Cinderella Restaurant and Dance Hall were originally housed here. It went through several ownership and name changes before becoming the Grand Ballroom in 1941. It was a swinging place in its day. The building was shuttered in 1995 until it was completely restored in 2005. A gorgeous setting prevails once more.

43. South Shore

BOUNDARIES

N—67th Street

S—79th Street

E—Lake Michigan

W—railroad tracks at Kenwood Avenue

NEIGHBORHOODS

South Shore

Jackson Park Highlands

HOW IT GOT ITS NAME

Charles Ringer bought the old Windsor Park Golf Club in 1918 and named his new subdivision South Shore. Real estate developers called the whole area the "South Shore District" to take advantage of the elite image of South Shore Country Club. There had been an assortment of settlements that grew up around each of the train stations at Essex, Bryn Mawr, Parkside, Cheltenham Beach and Windsor Park.

DID YOU KNOW?

* In 1856, Ferdinand Rohn and a few other German farmers used roads along the ridges to get through the swampland that covered the area. Christian Clemenson

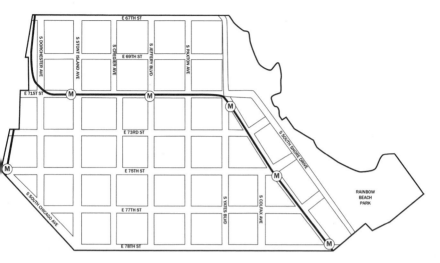

came from Denmark in 1892 and had a large flower farm and a shop on Exchange Avenue. The Krause family had another early farm in the area.

* The South Shore Country Club was founded in 1906 with members from prominent Chicago families. It included such amenities as a golf course, riding stables, a private beach and a luxurious Mediterranean resort–style clubhouse. Memberships declined in the 1960s, and although Jews and African Americans were moving into the surrounding neighborhood, they were restricted from joining. Rather than "lowering the bar and relax the qualifications," the club closed in 1973. The Chicago Park District bought the facilities and opened the South Shore Cultural Center in

1975, fondly known as the "Palace of the People." The golf course is still popular, and the clubhouse offers dining, entertainment and educational programs. The Obamas had their wedding reception here.

* The thirty-two horses of the Chicago Police Department Mounted Unit have been housed in the cultural center riding stables since 1974. In a tradition started in 1982, each horse has taken the surname of a policeman who was killed in the line of duty.

* The 1893 Columbian Expo triggered land sales and a housing explosion. The Jackson Park Highlands neighborhood was built in 1905 on a ridge overlooking the golf course. There are grand homes spread out on large lots. Enrico Fermi, Ramsey Lewis, Gayle Sayers and Bo Diddley have lived here.

* The first church in the area was the South Chicago Congregational Church, built in 1887. St. Bride's, built in 1887, was the first Catholic church. The South Shore Temple was founded in 1927. The main commercial center was located at 72nd and Jeffrey. Swedish, English, German, Jewish and Irish were the main ethnic groups in the community until 1960. As African Americans moved in, white flight followed.

* The Windsor Bathing Beach opened in 1890. The Rocky Ledge Beach opened north of there and was soon renamed

Manhattan Bathing Beach in 1908. Both had grand piers and pavilions. The beaches were combined, expanded and named Rainbow Beach in 1918 after the U.S. Army Rainbow Division of World War I.

* The 1960s brought the Thunderbird and Breakers Motels to the shoreline. The neighborhood youth had their prom at the Southmoor Hotel and hung out at Wee Folks Toys, the Overflow, Cunis Ice Cream Shop, Melody Lane Soda Shop, Carl's Red Hots and Hackl's Bakery. They could go to see a movie at the Rhodes Theater, Hamilton Theater or Avalon Theater.

FAVORITE THING ABOUT SOUTH SHORE

Definitely the ever-present shoreline of Lake Michigan; it cools in the summer and challenges in the winter—always something beautiful to behold.

Robert Dougherty, lifelong resident

PLACE OF INTEREST

Miller House
7121 South Paxton

Advertising executive Allan Miller had this house built in 1915. It was designed in the Prairie style by architect John Van Bergan, who worked with Frank Lloyd Wright and Walter Burley Griffin. This home is his only design left standing in Chicago (although there are still examples of his work in Oak Park and other suburbs). It became a Chicago Landmark in 1993.

44. Chatham

HOW IT GOT ITS NAME
In the 1880s, there was a large picnic grove called Chatham Fields in the central part of the community area. A subdivision was built on the site in 1914, and it kept the Chatham name.

DID YOU KNOW?
* The area was a swampy land used for duck hunting. In 1860, a few farmers settled here and called it "Hogs Swamp." The Fisher Farm was sold to become part of Chatham Fields.

* There were two other subdivisions in the area. In 1889, Italian stonemasons settled in a community called Avalon

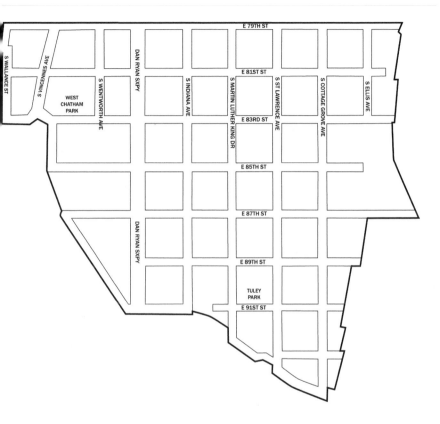

Highlands. Dauphin Park, later named Chesterfield, was settled in 1889 by Irish and Hungarians.

* There was a population boom in the 1920s. Cottage Grove Avenue became the commercial center of the community and is now a historic district. Landmarks like

the Brookline Building (1921), the Chatham Center (1926) and the Champlain Building (1928) are still standing. Stop by at Chicago's very own (since 1949) Garrett Popcorn Shop while you are in the district.

* The area has had an unwritten code of conduct that continues today. It is now a solidly middle-class African American community. The neighborhood is filled with lovely, well-maintained homes that have larger-than-average lots. A large network of block clubs fosters pride in the neighborhood.

* Nat King Cole Park has a reputation for the high-quality basketball games played at the park. Nathaniel Adams Coles came to Chicago in 1921 and attended DuSable High School before dropping out to become a musician and singer. His father was the pastor of a Baptist church near this community area.

* Brown Memorial Park was named after Sidney Brown, the first African American fireman to die in the line of duty. He died in 1983 in an attempt to save children in a burning house.

* Mahalia Jackson, the famous gospel singer, lived in Chatham. She launched her career at a nearby Baptist church. She also played an important role in the civil rights movement. Soon after she moved here in 1958, her front window was shot out, and she had to seek police protection.

* Ernie Banks, Mr. Cub, was also a resident here. He moved here soon after his marriage to Los Angeles socialite Eloyce Myles in 1959. He was a volunteer at the Chatham YMCA for many years. Banks was elected to the Baseball Hall of Fame in 1977.

* Simeon High School has been known for its basketball program. Chicago Bulls player Derrick Rose, Marquette University player Steve Taylor, Duke University player Jabari Parker and University of Dayton player Kendall Pollard all starred there.

* Classical musicians Demarre and Anthony McGill are from Chatham. Demarre is the principal flute of the Seattle Symphony, and Anthony is the principal clarinet of the Metropolitan Opera Orchestra of New York. They both attended the Merit School of Music after-school program and played for the Chicago Youth Symphony

Favorite Thing about Chatham

More specific than any locality, today the name Chatham represents a state of mind. And that state of mind is one that refuses to let anybody dictate our identity and our aspirations.

Jahmal Cole
Role Model Movement
author, Torch of Decency

PLACE OF INTEREST

Landmark Building
8000 South Cottage Grove

This building is part of the Chatham–Grand Crossing Landmark Commercial District. It was constructed in 1930 and designed by the architectural firm Kocher & Larson. It includes eighteen condos, all of which have been remodeled. The building is clad with terra-cotta twisted columns, floral medallions and scrolls.

45. Avalon Park

BOUNDARIES
N—76th Street/79th Street
S—87th Street
E—South Chicago Avenue
W—IC railroad tracks

NEIGHBORHOODS
Avalon Park
Stony Island Park
Marynook

HOW IT GOT ITS NAME
Avalon Park Community Church was established in 1896. It is said that it was named after the Isle of Avalon in the legend of King Arthur. The church was on a hill surrounded by swampy marsh, much like the isle. The church successfully led an effort in 1910 to change the community area name to Avalon Park.

DID YOU KNOW?
* The area was originally called Pierce's Park when Jonathan Pierce started a development in 1888. It also had the nickname of "Pennytown" because of the Penny General Store.

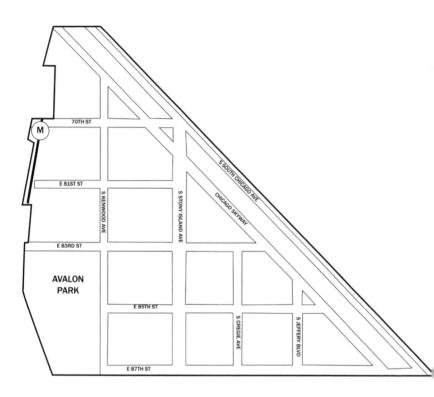

* The early construction was in the northern section of the area because the southern part was so wet and marshy. Many of the homes were shanties built on stilts. German and Irish railroad workers moved into the area in the 1880s.

* The community areas in the southeast part of the city were part of the Hyde Park Township from 1861 until

annexation in 1889. Hyde Park Township had a contagious disease hospital in what is now Avalon Park.

* In 1910, a sewer system was built, and it helped to drain the mucky water from the area. Construction of homes quickly ensued. In 1913, E.B. Shogren and Company began selling lots for development near the 83rd Street station.

* In 1930, a large number of Swedish immigrants settled here. Most worked at the steel mills, railroads and factories. Swedes had begun coming to Chicago in 1840 and were the third-largest immigrant group in Chicago. They progressively began moving to the city outskirts in the 1920s.

* Reverend Addie Wyatt was pastor of the Vernon Park Church on Stony Island. She was a champion of organized labor and civil rights. She lived in Chicago from 1930 to 2012. Wyatt was the first female president of the Packinghouse Workers Union, a founding member of the National Organization for Women and one of *Time* magazine's Women of the Year in 1975.

* Marynook subdivision was built by developer Joseph Merrion in 1950–54. Catholics, Jews and Protestants resided there in equal numbers. The neighborhood became African American in 1965. Saul Alinsky said that "for most people integration means the period of time that elapses between appearance of the first Negro and the community's

total transition into a Negro ghetto." Block-busting and unscrupulous real estate agents stimulated the white flight. The whites who did stay for a while began feeling more isolated and eventually moved on too.

* Stony Island Park subdivision was also built after World War II and targeted the GIs and their families. The neighborhood got its name because it overlooked a rocky ridge in the swamp to the south that was called Stony Island.

* The public library branch was established in 1928 in the Avalon Park Community Church. It was moved to a rented storefront. In 2006, a beautiful new library was built with cathedral ceilings and high windows on the upper portion. There is large suspended wood sculpture by Barbara Cooper.

* Football player Dick Butkus, basketball player Juwan Howard and comedian Bernie Mac attended Chicago Vocational Career Academy here.

* The Chicago Skyway Bridge runs over the eastern edge of the community area. It is a 7.8-mile toll road that was built in 1958 to connect the Dan Ryan Expressway to the Indiana Toll Road. In 2005, a ninety-nine-year lease was given to a private company to assume operations. It paid the short-of-cash city the amount of $1.8 billion to have the right to the tolls. This was the first privatization of any existing toll road in the country.

FAVORITE THING ABOUT AVALON PARK

Picturesque two-story homes built in the early 1950s create a pleasant working-class neighborhood. Quietly nestled on the southeast side of Chicago, Avalon Park offers a great opportunity to be in close proximity to quality schools and transportation. Nearby public transit and expressways make it an ideal location for those who work in the Loop and south suburbs to commute with ease. Many nearby schools are boasting about an increase in test scores and quality curriculum. Avalon Park offers a boutique shopping experience on many of its major thoroughfares. If you are looking for a community that has all of your amenities in arm's reach, then Avalon Park is for you.

Frankye Payne
Southeast Chicago Chamber of Commerce

PLACE OF INTEREST

New Regal Theater
1641 East 71st Street

This opened as the Avalon Theater in 1927. Its Moorish design was eye-catching. Movies were shown here until 1970. It became a church for many years and then reopened in 1987 as a theater named after the Regal Theater in Bronzeville. It closed in 2003 and is now on the endangered landmark list.

46. South Chicago

Boundaries
N—79th Street
S—Calumet River
E—Lake Michigan
W—South Chicago Avenue

Neighborhoods
South Chicago
The Bush

How It Got Its Name
The first village here in 1836 was called Calumet. Then came a development by James Bowen in 1856. He called it Ainsworth. The post office was established in 1856, and the train station was named Ainsworth in 1857. The retail and residential area around Commercial Avenue was called South Chicago, and the whole area became known as South Chicago in 1874 to promote industry.

Did You Know?
* There is a story that the mouth of the Calumet River was considered for the site of Fort Dearborn. The U.S. Army engineer became smitten with a fur trader's daughter who lived on the Chicago River, and she was chosen instead. The Calumet became "Chicago's Other River."

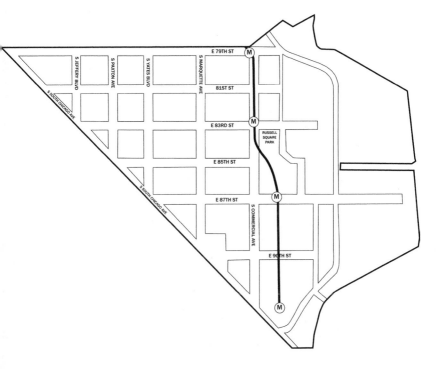

* The first settler in the area was Lewis Benton, who bought land along the river. He built a stagecoach stop called the Calumet House in 1836. Gideon Jackson opened the Eagle Tavern in 1836.

* An early farmer was German immigrant Andreas von Zirngibl. He died in 1855 and was buried on his property. His headstone still stands at 92nd and Calumet,

surrounded by scrap metal. It was restored in 1988. The inscription notes that he was "a veteran of the Battle of Waterloo."

* In 1880, the North Chicago Rolling Mill opened its South Works. In 1889, it became Illinois Steel and then U.S. Steel South Works in 1901. The plant closed in 1992. The grueling work at the mill provided jobs to immigrants from almost every country.

* South Works was located in an area called "the Bush" (so named because it was on the sandy shoreline that had only shrubs). It had been a picnic area with a pavilion. The name was retained by the neighborhood that grew up between the mill and South Shore Drive.

* The Millgate neighborhood was located south of the mill in the southeast corner of the community area. All the entrances to the South Works could be accessed from there.

* In 1869, James Bowen became the first president of the Calumet and Chicago Dock Company. It was created to develop and operate the harbor facilities. The river was dredged to form Calumet Harbor.

* Many Mexican immigrants began working at the mill during the 1919 strike. Our Lady of Guadalupe Church

was built in 1924 and is the oldest Mexican Catholic church in Chicago. The National Shrine of St. Jude was established in 1929 when many millworkers were losing jobs because of the Great Depression. (St. Jude is the patron saint of hopeless causes.)

* Commercial Avenue has traditionally been just that—the commercial district. Goldblatts Department Store stood there for many years. The company started in 1914 and had forty-seven stores throughout the Chicago area. It closed down for good in 2000.

* There are grand plans to renew the South Works site. The Chicago Lakeside Development will be an innovative mix of residential and commercial space with its own schools, marina and lakefront park. There will be many years before completion.

FAVORITE THING ABOUT SOUTH CHICAGO

Being in the South Chicago neighborhood for the past thirteen years, I have learned that it is a neighborhood of resilient people. It has so much potential. I can only hope that the future is brighter for those who live and work here.

Sarah Ward, director
South Chicago Art Center

PLACE OF INTEREST

Drake Fountain
92nd Street, South Chicago Avenue and Exchange Avenue

The fountain is also known as the Columbus monument. It was a gift to the city from hotel owner John B. Drake in 1892. Originally it stood outside the City Hall County Building but was moved here in 1909. It was designated as a Chicago Landmark in 2004.

47. Burnside

BOUNDARIES
S—95th Street
E—railroad tracks
W—IC railroad tracks
N—87th Street tracks

NEIGHBORHOODS
Burnside

HOW IT GOT ITS NAME
The Illinois Central Railroad built a train station at 95th Street in 1862. It named it Burnside to honor Civil War general Ambrose Burnside. He had been an executive at the ICRR before the war. (The term "sideburns" was derived from the general's name because he had unusual, bushy side whiskers.)

DID YOU KNOW?
* Colonel William Jacobs bought a lot of land in the area. He subdivided it in 1887 and used the train station name of Burnside. The first post office and store were established in 1889. The first saloon, called the House of All Nations, was built in 1905. Since its start, the area has often been called the "the Triangle."

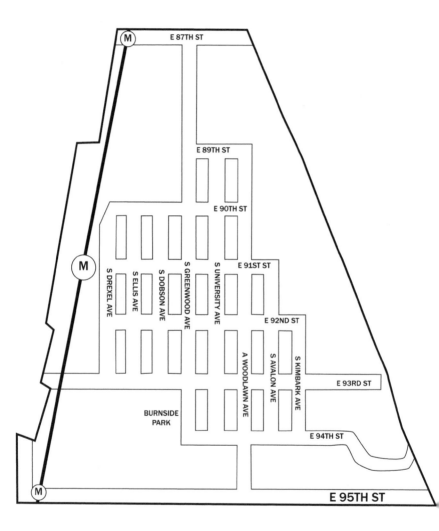

* Hungarian immigrants began settling here in 1889. They built the Our Lady of Hungary Church in 1905. It was the city's first Hungarian church. John Kovacs founded the Holy Mary social organization in 1905, and it built the Hungarian Center in 1927.

* Poles and Italians followed in the 1890s. The second-largest Ukrainian community in Chicago (after Ukrainian Village) also settled here and built St. Peter and Paul Church in 1911. Many families from Dobra were members of the church. They had fled the poverty that they suffered under Austrian control of their village.

* Burnside was another swampy area. Before the sewer system was built, children would canoe down the street following every heavy rain. More people moved in after it was drained. The Burnside Settlement House opened in 1912 to help the immigrants learn the ways of a new country.

* Residents found work at the railroads and the industry that built up around the tracks. The Burnside Steel Foundry employed hundreds of laborers from 1921 to 1979. It closed after a horrible explosion—a huge ladle containing molten steel tipped over. Twenty workers were burned and four more killed. The nearby Verson Steel Company was another big employer. It was started in 1917 by Morris Verson, a Russian immigrant, and became a successful manufacturer of machine parts. It was sold in

1986 and closed in 2005. A. Finkl & Sons Steel moved from its location in Lincoln Park to the sites of these companies in 2012.

* Burnside is the smallest of all the community areas. It is isolated by the railroad tracks at three of its boundaries. There is limited access to the area from east–west streets. It is the second-least-populous area after Fuller Park.

* Schmid Elementary School has a team in the Streethawks League. It is one of the many youth programs of the Chicago Blackhawks, who provided their equipment. The Blackhawks are one of the "Original Six" NHL teams. Go Hawks!

* "Brownfield" is a term used for abandoned industrial sites that are affected by contamination. Some of the old industrial sites have been environmental and health hazards. The Burnside Industrial Corridor has been targeted by the city for brownfield redevelopment—to turn it into a brightfield.

FAVORITE THING ABOUT BURNSIDE
Burnside is a family-friendly place with lots of love in our church.

Sharyn Campbell
Burnside Community Baptist Church

PLACE OF INTEREST

Harold Washington Elementary School
9130 South University Avenue

This school opened in 1918 and was called Oliver Perry Elementary. In 1962, Perry Elementary was a "whites only" school. Black children who lived in the area had to attend the extremely overcrowded Burnside Elementary in Chatham. Many classes were held in "Willis Wagons," a term used for portable classrooms. (The superintendent of schools was Benjamin Willis.) A boycott sit-in was held to protest discrimination and helped to spark the civil rights movement. The school's name was changed in 1988.

48. Calumet Heights

BOUNDARIES

N—87th Street
S—95th Street
E—South Chicago Avenue
W—railroad tracks

NEIGHBORHOODS

Calumet Heights
Pill Hill
Stony Island Heights

HOW IT GOT ITS NAME

Samuel Gross bought land in 1887, developed it and called the subdivision Calumet Heights. It was on a stony ridge overlooking the Calumet River.

DID YOU KNOW?

* The ridge was covered with oak trees, but the rest of the area was swampland. There were only a few travelers through the area along the Chicago–Michigan Post Road.

* The first residents came in the 1880s to work in the railroad yards in the western section of the area. Their settlement was called Judd after Norman Judd, a Chicago attorney and politician.

* There was a small quarry at 92nd Street from 1868 to 1886. Workers dug for Niagra limestone to be used for building. The neighborhood was then called Stony Point because of the nearby quarry. It wasn't filled in until the 1920s after it was flooded and had become a swimming hole.

* There were a few houses in the area when the railroad arrived in 1881. The Stony Island Heights neighborhood was formed in 1890 in the eastern section. It was followed by South Chicago Heights in 1891. It was home to businessmen and prosperous steel mill workers. After World War I, the population grew to three thousand residents. Most were Polish, Italian and Irish immigrants. The real building boom occurred after World War II.

* St. Ailbe Church was founded as a wooden-frame building in 1892. The present church was built in 1955. It changed from an Irish and Polish church to an African American church in the 1970s. The St. Ailbe School was started in 1927. The neighborhood was then called Calumet Gateway.

* Before 1907, residents had to travel fifteen miles to the nearest hospital. The South Chicago Hospital first started in the old Morgan Farmhouse. A new brick hospital was opened one year later. It is now Advocate Trinity Hospital.

* Most development of the area took place after World War II. The modern homes in the area called Pill Hill

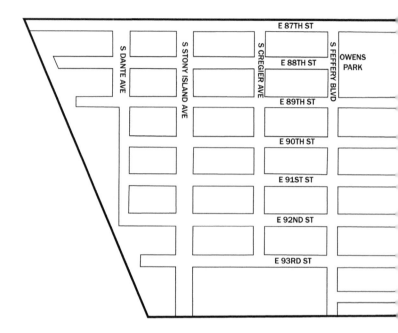

were built between 1954 and 1967. It is said that it was called Pill Hill because many of the doctors from South Chicago Hospital lived there.

* Owens Park was built in 1947 and was originally called Stony Island Park. It was renamed in 1980 after Jesse Owens died. He had won four Olympic gold medals in the 1936 Berlin Olympics. At one time, he was the head of the Chicago Boys Clubs and served on the

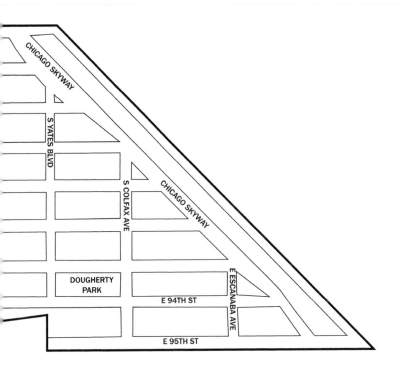

Illinois Athletic Commission. His birth name was James Cleveland Owens. When he was nine years old, a new teacher asked his name, and he responded, "JC." She misunderstood, and he was called Jesse for the rest of his life. A beautiful new fieldhouse was built in the park in 2009.

* Calumet Heights has remained a stable middle-class neighborhood, with well-kept brick homes on quiet streets.

The area is residential, with a shopping district at 87th and Stony Island.

FAVORITE THING ABOUT CALUMET HEIGHTS

My favorite thing about Calumet Heights is its cohesivenss—it is very appealing. The unity of the community and support of each other are commendable.

Reverend Dr. Larry D. Pickens
Southlawn United Methodist Church

PLACE OF INTEREST

Bronzeville Children's Museum
9301 South Stony Island Avenue

This is the first and only African American children's museum in the country. It started in 1993 in Evergreen Plaza and reopened in this larger, beautiful space in 2008.

49. Roseland

Boundaries
N—87th Street/91st Street/railroad tracks at Burnside Avenue
S—103rd Street/115th Street
E—IC railroad tracks at Cottage Grove
W—railroad tracks/Halsted

Neighborhoods

Roseland	Princeton Park
Fernwood	Rosemoor
Lilydale	Sheldon Heights

How It Got Its Name
The original village was called Hope. In 1873, the town elected to establish its name as Roseland because almost all of its cottages had red rose gardens.

Did You Know?
* John Smith built the first structure in the area in the late 1830s and called it Smith's Tavern. He died in 1847, and it was then known as the Eleven Mile House. It became a gathering place for the early settlers. It stood at 92nd and South Michigan until 1955, when it was torn down to make room for the Dan Ryan Expressway.

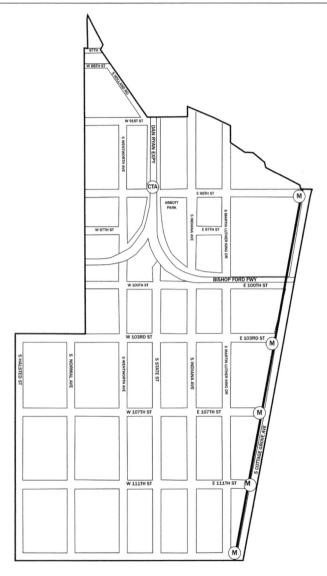

* Dutch farmers first settled the area in 1849. They called the area De Hooge Prairie (High Prairie) because it was drier and higher than the other Dutch settlement in South Holland. They brought lumber from Chicago by cart to build their shanties and their own church. Cornelius Kuyper opened the first little general store. During the Civil War, the Dutch farmers were part of the Underground Railroad and protected escaping Southern slaves.

* The area remained a close-knit Dutch community until 1880, when workers for the Pullman factory began moving in. The workers chose Roseland to avoid living in the controlled company town of Pullman. The Dutch farmers, such as Jakob and Pieter DeJong and Simon Dekker, made huge profits selling their land to developers, who subdivided the properties.

* In 1890, the Illinois Central Railroad developed the northeast corner of the area, near the train station, into the Burnside Shops South. The yard had a large roundhouse and repair facility. It was closed in 1970.

* In 1960, Roseland was a prosperous part of town, with many blue-collar workers in the steel mills and manufacturing plants. When the plants closed, white residents moved away. The stores moved away with them. The State Theater, the Roseland Theater, Berman's Department Store, Gately's People Store, Sears and

Penneys are all gone now. African Americans moved in during the 1970s. But the economic decline continued, and it has become a blighted area. Drugs came to the area, and violence followed. There are educated professional residents and community organizations that are working to turn it around.

* Chicago State University moved into the old site of the Burnside Railroad Yard in 1972. The school had been located in Englewood for 102 years, starting as a teacher training school in 1867, with classes held in an old freight car. In 1870, the new building was erected, and the school was called Cook County Normal School. It has gone through many name changes since then. In 1897, it was Chicago Normal School; in 1913, it was Chicago Normal College; in 1938, it was Chicago Teachers College; in 1965, it was Illinois Teachers College Chicago South; in 1967, it was Chicago State College; and finally, in 1971, it became Chicago State University.

FAVORITE THING ABOUT ROSELAND

There is always an underlying reason for violence. Our outreach mediators are working to get youth back in school, provide job training and counseling and engage them into positive activities—with successful outcomes.

Richard Willis
Cease Fire Roseland

May our government leaders guide us for soul and not for profit.

Dr. Chandra Gill
Blackademically Speaking

PLACE OF INTEREST

Roseland Fire Station
34 East 114th Street

The first Chicago fire brigade started in 1832. A church bell was used to sound an alarm. The fire crew was all-volunteer until 1858, when the Chicago Fire Department was organized. The agency stopped using horse-drawn engines in 1923 and was the first fire department in the nation to be completely motorized. The sliding pole was invented in Chicago. Since 1961, the Fire Academy has stood at the site of the infamous O'Leary barn at 558 West DeKoven Street. There is a memorial bronze flame sculpture on site to commemorate the Great Fire of 1871.

50. Pullman

BOUNDARIES
N—95th Street
S—115th Street
E—Stony Island Avenue
W—Cottage Grove Avenue

NEIGHBORHOODS
Pullman
Cottage Grove Heights
London Towne

HOW IT GOT ITS NAME
In 1880, George Pullman began developing four thousand acres of land in a remote area of empty plain. He named the village Pullman, after himself.

DID YOU KNOW?
* George Pullman built a huge factory to make luxury railroad sleeping cars—the Pullman Palace Car Company. He also built a company town with brick houses and town homes. Chicago architect Solon Beman designed the company buildings and housing. The town was complete with a theater, a library and shops. Pullman felt that ideal living conditions would discourage strikes and build the

moral character of the employees. It sounded good until the workers realized that he controlled every aspect of their lives. He would choose who would perform at the theater, what books would be shelved in the library and what shops would be allowed. He even had spies reporting on the residents' behavior. Some called it indentured servitude. However, by 1885, the population of the town had reached nine thousand.

* During the severe economic depression of 1894, Pullman initiated layoffs and lowered wages. He did not lower rents, however. Pullman refused to discuss the employees' dissatisfaction with poor wages and unfair treatment. A national work stoppage was called for. After two months, federal troops were sent in to intervene. All union employees were fired.

* The Greenstone Church was built in 1881 using serpentine rocks with a green hue. It was meant to be a nondenominational church, but the workers wanted services in their own religion and language. Presbyterians then took it over. They then sold it to the Methodists in 1907.

* George Pullman died in 1897. President Lincoln's son Robert Todd Lincoln became the head of the company. In 1898, the Illinois Supreme Court ordered the Pullman Company to sell all non-industrial property, and the tenants

began to own their homes. Business dwindled, and the company closed in 1957.

* The company not only made the sleeping cars, but it also operated the service. It hired black men and women as porters and maids. They were overworked, underpaid and mistreated. But the African American community held the porters and maids in high esteem because they had steady jobs and got to travel around the country, a rare opportunity at that time. The porters organized into a union in 1925. The company fought against them until Congress passed a law that said it could not interfere with unions. A labor agreement was signed in 1937.

* Cottage Grove Heights is in the northern section of the area. Jays Foods was located here from 1927 to 2007. It was started by Leonard Japp, who originally sold pretzels. In 1929, the company began making Mrs. Japp's Potato Chips. The name was changed in December 1941 for political correctness. Jays potato chips are now sold by Snyder's of Hanover.

FAVORITE THING ABOUT PULLMAN

Pullman is a place where a visitor can learn about the many aspects of its multifaceted history: the town, its founder, the rail car company and its employees and the nation's first black labor history museum.

Dr. Lyn Hughes, founder
A. Phillip Randolph Pullman Porter Museum

PLACE OF INTEREST

Florence Hotel
11111 South Forrestville

This hotel was named after George Pullman's daughter. It was completed in 1881 for the salesmen and suppliers who came to visit the factory. Alcohol was banned in the rest of the town but was allowed here for visitors. The State of Illinois now owns it as part of the Pullman State Historic Site.

51. South Deering

BOUNDARIES

N—95th Street
S—130th Street
E—Calumet River/Burley Avenue
W—Bishop Ford Expressway/Stony Island

NEIGHBORHOODS

South Deering
Trumball Park
Jeffrey Manor
Vets Park

HOW IT GOT ITS NAME

It is named after the Deering family. William Deering owned Deering Harvester. The company bought the steel mill here in 1900 to produce the metal for its equipment. William retired in 1902, and his sons, Charles and Robert, took over. They merged with McCormick Company in 1902 to form International Harvester. In 1903, they renamed the town after themselves.

DID YOU KNOW?

* The first few settlers came in 1845 and built Chittenden Road along the river in 1847. In 1848, eight different railway

lines came through the area. The industrial development didn't occur until after the Civil War. The area became part of Hyde Park Township in 1874.

* The first company to build in the area was Joseph Brown Iron and Steel Company in 1875. The plant was located along the river, and the company built housing for the workers. Brown's Mill became the official name at the post office in 1878, but the area was informally called Irondale. In 1882, Brown sold to Calumet Iron and Steel. It was owned by J.C. Cummings, so naturally the town name was changed to Cummings. A major strike took place, and there was an economic depression in 1883; the company never recovered. Calumet Iron and Steel was sold to South Chicago Furnace Company in 1898. It was bought by Deering Harvester in 1900. In 1902, after a merger, it was then called Wisconsin Steel Works and was the area's largest employer until it closed in 1980.

* Abe Kleinman came the South Chicago as a child with his family in 1844. In 1873, he built a large hunting lodge at 111th Street. He had a reputation as an expert sharpshooter.

* Only about one-tenth of the area is residential. The first immigrants who settled here to work at the mill were German, Irish and Scandanavian. Poles, Italians, Austrians and Bulgarians followed. That is how America became known as a "melting pot." Mexican families settled here in

1928. Jeffrey Manor and Trumbull Park housing complexes were built in 1938.

* Trumbull Park Homes is listed on the National Register of Historic Places. The housing project is an example of the creation of affordable housing following the Great Depression era. When they were built, no minorities lived in the area. In 1953, a black family relocated to the complex, and six months of rioting ensued. White home owners attacked and screamed racial epithets. Ten additional African American families moved in, and more violence followed.

* The General Mills Cereal Plant was located here from 1929 to 1995, after which there were no more Wheaties and Cheerios made here. The Ford Assembly Plant has been here since 1924 and continues to be a leading industry in South Deering.

* Remnants of the Calumet Wetlands are still here. Dead Stick Pond, Heron Pond and Big Marsh and Indian Ridge Marsh are undergoing ecological rehabilitation, and a conservation area has been established. Indian Ridge and Big Marsh have been handed over by the city to the Park District. They will be natural plain environments. Calumet Lake became a ship turning basin with slips in 1925.

* Harborside International Golf Center is located north of Lake Calumet. It was opened in 1995 as a links-style

course in the tradition of golf's Scottish roots. There are sand dunes, rolling terrain and tall grasses instead of trees. It has a beautiful Craftsman-style clubhouse and is opened to the public.

FAVORITE THING ABOUT SOUTH DEERING

My favorite things about South Deering are the people. They are hardworking and care about their families.

Tommy Palley
Hienie's Shrimp House

PLACE OF INTEREST

Calumet Fisheries
95th Street at the bridge

Calumet Fisheries was established in the northeast corner of the area in 1948. The Kotlick-Toll family smokes their own seafood on site using special oak logs. It is one of the few smokehouses left in Illinois. It has been highlighted on the Food Channel by Anthony Bourdain and on *Check Please!*

52. East Side

BOUNDARIES
N—Calumet River
S—116th Street
E—Lake Michigan/Indiana state line
W—Calumet River/railroad tracks at Burley Avenue

NEIGHBORHOODS
East Side

HOW IT GOT ITS NAME
When annexed by the City of Chicago in 1889, the residents chose the East Side name for the post office because it is *east* of the Calumet River. It is the easternmost part of the city.

DID YOU KNOW?
* Ashkum, a Pottawattomie Indian chief, had lived on a land grant at the mouth of the Calumet River. He left the area after the Treaty of 1833. His daughter, To-goh, sold land east of the river to George Ewing (street name). In 1830, Reverend William See was given the right to operate a ferry across the river at 92nd Street. It was run by Timothy Hale and then by Johann Mann, who also owned Mann Tavern. Johann was married to Therese Archange, Antoine Ouilmette's Pottawattomie niece. In 1839, a toll bridge was

built so that the stagecoach line to and from Indiana could cross the river. Railroads came through the area in 1848, and bridges were built for their passing.

* In 1838, a fifteen-foot-tall stone obelisk marker was erected at the state line boundary. It was restored in 1988 and still stands.

* James Pendergast was the first settler in the area. He was soon followed by Frank Degman. Michael Doyle and Roger Murphy came one year later. In 1865, there were only a few people living in the area.

* Eggers Woods Forest Preserve was originally called Grove Forest. It is now named after Frederick Eggers. He was a German immigrant who started Bethlehem Lutheran, the first church in the area, in 1874.

* In the 1870s, industrial companies began buying up land. Real estate developers followed. In 1873,

Douglas Taylor built the village of Taylorville and the Ewing Hotel. His own mansion stood near the lakefront where Calumet Park is now located. In 1874, Charles Colehour built the village of Colehour. His home at 102nd and South Avenue H still stands and is said to be the oldest home in the area. The first Colehour Post Office was in Matthew Gallistel's general store. Andrew Ringman and Frank Lewis developed the southern section in the early 1900s. There was a neighborhood around 107th Street that was nicknamed "Goose Island" by the Croatian residents.

* In 1902, the Grand Crossing Tack Company built a mill on the east bank of the Calumet River that was surrounded by flat prairie. It was sold to Interstate Iron and Steel in 1916. It then merged with Republic Steel in 1930. There were five thousand employees at the plant. LTV Steel bought the factory in 1984 and closed it in 2001.

* In 1937, the Steelworkers Union was just getting started. Republic Steel refused to sign a union contract. Half of the workers then went out on strike. On Memorial Day, the workers came to picket. They were marching across the prairie but were met by police who had been called in by management. The workers began shouting that they had the right to picket, and the police began firing into the crowd. Fifty people were shot, ten were killed and one hundred were beaten by clubs. It is known as the 1937 Memorial Day Massacre.

* The East Side has been filled with many Serbs, Croatians, Polish and Italians. Hispanics have been the majority since 1980.

FAVORITE THING ABOUT EAST SIDE

Living in the East Side as a child was equivalent to growing up in a small village: a parish church, a couple of parks, a huge tribe of kids and parents who were aware of just about everything that went on. Of course, we had the lakefront and Calumet Park with its great fieldhouse, ball diamonds and beach. A pretty close approximation of Norman Rockwell in the midst of steel mills and heavy industry.

Dan Mazar, lifelong resident

PLACE OF INTEREST

St. Simeon Mirotocivi Serbian Orthodox Church
3737 East 114th Street

This church was constructed in 1968 in the Byzantine architectural style and modeled after a Serbian monastery. It is one of the city's hidden gems. It has a gated entrance to its lovely landscaped grounds. The church is filled with frescos and gilded icons. Christmas for Serbians is on January 7 because they follow the old Julian calendar, which is thirteen days behind the more commonly used Gregorian calendar.

53. West Pullman

BOUNDARIES
N—115th Street
S—Little Calumet River
E—IC railroad tracks
W—Ashland/Halsted

NEIGHBORHOODS
West Pullman

HOW IT GOT ITS NAME
In 1891, the West Pullman Land Company bought the Old Morgan Farm. It developed the area and called it West Pullman. It is southwest of Pullman, but the company wanted that Pullman name included for marketing. The West Pullman Post Office was opened in 1892.

DID YOU KNOW?
* When the community area was formed in the 1920s, it included three villages. West Pullman had industry, working-class homes and a neighborhood called Stewart Ridge, with large grand houses for the wealthy. The Pullman corporate officers lived there. The town of Kensington was settled in 1850 in the northeast section of the area. It was often called "Bumtown" because of all its saloons. No alcohol

was permitted in Pullman, but there was plenty here! The town of Gano was west of Kensington. It was established in 1880 when the Pullman factory was being built.

* In 1894, the industrial district was built up in the section west of Halsted. Plano Manufacturing, Whitman & Barnes, Carter White Lead and several other companies had large plants here. The land company forged an agreement with

ICRR to use the tracks that ran across 121st Street for industry trains. The Metra now uses the tracks, with stops at State Street, Stewart Ridge and West Pullman at Halsted.

* The West Pullman Land Company built six hundred homes. Further development was stifled by the 1893 depression, the Pullman strike in 1894 and the economic downturn of 1903. The land company went bankrupt after these turbulent fifteen years.

* There had been a major Indian village at 127th Street. Newcomers first began settling here when the railroads arrived in 1852. Irishmen like Patrick Fitzgerald settled Kensington. Germans and Scandinavians were also early immigrant groups. Italians and eastern Europeans followed in 1880. The residents worked at factories in West Pullman, Pullman and Burnside until the Great Depression.

* After World War II, there was a boom. Companies like International Harvester, Dutch Boy Paints, Buddig Meats and Ingersoll came in to replace those that had failed.

* The industrial and population base of Chicago began a decline in the 1960s. The Interstate Highway System made transportation from the city outskirts to the city center possible. As the white residents left, African Americans moved in. The companies left, and brownfields remained. The unemployment rate in the area rose to 20 percent.

However, 50 percent of the population is working in white-collar jobs with high education attainment.

* Exelon and the Sun Power Company opened its plant here in 2010. It is the largest solar plant in the United States.

* When she died in 2003, Joan Kroc, the widow of McDonald's Ray Kroc, left $1.5 billion to the Salvation Army for centers in underserved areas. The gift made the new community center here possible.

FAVORITE THING ABOUT WEST PULLMAN
My favorite thing about West Pullman is the historic community connection.
Cheryl Hunt
Greater Roseland West Pullman Food Network

PLACE OF INTEREST
Foster House and Stables
12147 South Harvard

This home, designed by Frank Lloyd Wright, was built in 1900 on an open prairie with woods for Chicago attorney Stephen A. Foster. He was one of the officers in the West Pullman Land Company. His family used it as a summer home. The architecture of the house shows the influence of Wright's interest in the Japanese culture. Chicago Landmark status was granted in 1996.

54. Riverdale

BOUNDARIES
N—115th Street
S—138th Street
E—Bishop Ford Expressway
W—IC railroad tracks

NEIGHBORHOODS
Riverdale
Golden Gate
Eden Green
Altgeld-Murray Gardens

HOW IT GOT ITS NAME
George Dolton was the first settler here in 1835. J.C. Matthews moved nearby in 1836. Soon after becoming neighbors, they started a toll ferry service, and the area became known as Riverdale Crossing. The Riverdale Post Office wasn't established until 1873. The town of Dolton, Illinois, is named after the same George Dolton. Note that there is also a town called Riverdale, Illinois, west of Dolton.

DID YOU KNOW?
* David Perriman was another early settler who claimed land north of the river in 1837. Levi Osterhoudt opened a tavern close by in 1840. Levi became friends with George

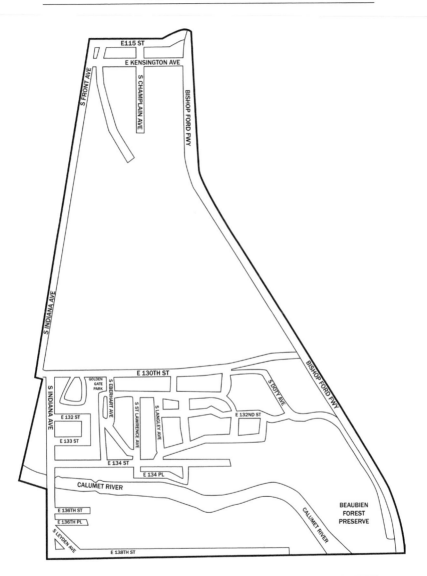

Dolton, and in 1842, they built Dolton's Bridge across the Little Calumet.

* The area around Chicago Thornton Road (now Indiana Avenue) at the bend in the river became known as Wildwood. James Bowen, from the Chicago Calumet Dock Company, built a mansion here. He was joined by other wealthy Chicagoans who built summer homes along the river.

* George Dolton sold some land to a Dutch immigrant named Jon Ton in 1849. Ton's farm, in the eastern area between 134th Street and the river, became an important stop on the Underground Railroad. Dolton and other abolitionists helped him hide slaves who were fleeing to Canada. There are plans to develop a visitors' center at the site.

* Most of the northern section of the area is industrial. The Pullman Company had a farm and brickyard here. The Calumet Paint Company was started in an abandoned church in 1880 and soon built a plant to serve the Pullman Company. In 1888, Sherwin-Williams purchased the company, and it became one of the largest paint factories in the country. It was closed in 1980 and demolished.

* Acme Steel came to the area in 1918 and constructed a large facility on the south side of the river. It went bankrupt in 2001 and was sold to International Steel Group, which merged with Mittal Steel in 2005.

* Before 1945, there was very little housing in the area. Altgeld Gardens was built for GIs returning from World War II. African American veterans and their families moved into the housing project. In 1954, the Murray Homes were constructed. Then, in 1968, one of the first black-owned town home and apartment complexes was built and called Eden Green.

* NBA basketball players Tim Hardaway, Terry Cummings and Cazzie Russell all grew up here. Sports journalist Scoop Jackson and psychologist Dr. Lloyd Bond were also residents.

FAVORITE THING ABOUT RIVERDALE

The Riverdale Community Area is a great neighborhood to learn social skills and to build on social equity!

Cheryl Johnson
People for Community Recovery

PLACE OF INTEREST

Flatfoot Lake at Beaubien Woods
13400 South Doty Avenue

Beaubien Woods is a 279-acre forest preserve in Cook County. Located near the Calumet River, it contains a mix of prairie, woodland and wetland habitats surrounding the lake. The preserve was named after two of Chicago's earliest settlers. Jean Baptiste Beaubien came to Chicago

in 1811. He had a general store on the grounds of Fort Dearborn. His brother, Mark Beaubien, of the Sauganash Hotel fame, arrived in 1826. Between them they had thirty-five children!

55. Hegewisch

BOUNDARIES
N—112th Street/130th Street
S—138th Street
E—Illinois/Indiana state line
W—Burley Avenue/Torrance Avenue/Bishop Ford

NEIGHBORHOODS
Hegewisch
Avalon Trails
Old Hegewisch
Arizona

HOW IT GOT ITS NAME
Adolph Hegewisch was president of U.S. Rolling Stock, a
company that made railroad freight cars. He bought land
for his rail yards in 1883. He then founded a village, named
after himself, as another attempt at an ideal company town
for his workers. By the way, locals pronounce it *heg-wish*, not
heg-a-vitch, as Adolph was called.

DID YOU KNOW?
* Early settlers in the 1840s included the Neubeister family.
They came to the shore of Wolf Lake and asked members
of the Indian village for permission to build there. (The last

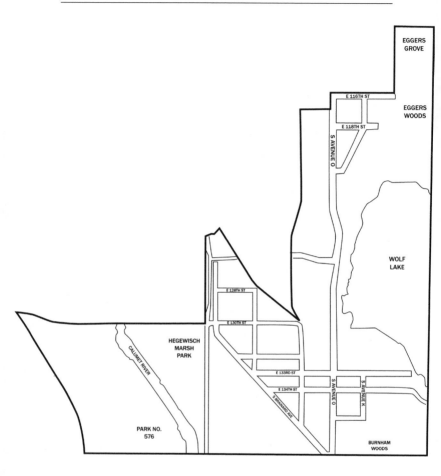

of the Illinois Pottawattomies left from here in 1847.) In 1927, their descendant, Joseph Neubeister, killed a bear to save the lives of two small children.

* The U.S. Rolling Stock Company was the main employer in the area. It became Western Steel Car Company in 1912. It was bought by Pressed Steel Car Company in 1926. The company made military tanks during World War II. In 1956, U.S. Steel began using the plant as a warehouse. It now houses several small steel-related businesses.

* Since 1980, there was a large landfill area west of the Calumet River. It was called Mount St. Hegewisch by the residents. It was the last landfill in the city. A moratorium on its expansion was enacted in 2004, and it was permanently closed in 2007.

* Hegewisch has several other "lasts." The last sawmill in the city, Calumet Harbor Lumber, is located here. The last horse-drawn fire engine was used here. The last trailer park in the city, Harbor Point Estates, was found here; the property was recently sold, and there are plans for a housing development.

* Hegewisch has been known as the "Mayberry of Chicago." It has a small-town atmosphere. The residential area is isolated by wetlands and industry. The residents are mostly of eastern European descent and, more recently, Mexican descent. A sense of community is felt among the pretty bungalows and frame houses.

* Wolf Lake has had its name for more than 150 years. It was a favorite vacation spot of Abraham Lincoln and his family. The

lake has been reduced in size and scarred by industrialization but remains a biodiverse ecosystem. It has been split in half by a railroad causeway at the Illinois-Indiana border. In 1946, it was dedicated as a conservation area.

* The Ford Calumet Environmental Center was scheduled for opening at Hegewisch Marsh in 2007, but financial difficulty postponed construction. Designed by Studio Gang, the building is to be built by salvaged steel and other recycled materials.

FAVORITE THING ABOUT HEGEWISCH

My favorite thing about Hegewisch is the diversity of its population. It is the melting pot of the Tenth Ward.

Patti Wojcikowski
Hegewisch Community Committee

Hegewisch has a small-town feel within a big city.

Brian Twardosz, president
Hegewisch Chamber of Commerce

PLACE OF INTEREST

Chicago Municipal Device
Located on Fire Station Wall
13359 South Burley

The word *device* was formerly used to mean emblem. Most Chicagoans just call it the "Y symbol." The "Y" represents

the Chicago River and its two branches. Sometimes the "Y" is shown upside down to indicate the reversal of the river flow. Look for it throughout the city on buildings, railings, bridges, fences and even lampposts.

56. Garfield Ridge

BOUNDARIES
N—Pershing/51st Street
S—59th Street
E—railroad tracks at Kenton
W—Harlem

NEIGHBORHOODS
Garfield Ridge
Vittum Park
Sleepy Hollow
LeClaire Courts

HOW IT GOT ITS NAME
Garfield Boulevard runs through the center of the community. It had been 55th Street but was renamed in honor of President James Garfield after his assassination in 1881. The "Ridge" part comes from the higher ground that formed the southern edge of Mud Lake. Do you remember Mud Lake in South Lawndale history? It extended down to 51st Street at an area known as Point of Oaks. Landfill from the I&M Canal and industry helped to dry the mushy, swampy Mud Lake.

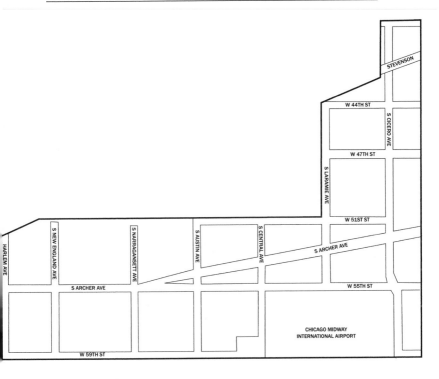

DID YOU KNOW?

* Colonel William B. Archer (street name) was the first I&M canal commissioner. He bought land here in 1835.

* The first resident was "Long" John Wentworth, the mayor of Chicago from 1857 to 1861. He bought lots and lots of land in 1853. He established farmland known as Summit Farm in 1857. In 1868, he retired from politics and settled into his mansion built on his country estate. Mr. Wentworth

died in 1888. His nephew, Moses Wentworth, then leased much of the land to a group of Dutch farmers who became the early settlers.

* The earliest neighborhood, developed in 1907, was Sleepy Hollow. It is located in the northeast corner of the area. Frederick Barlett bought land from Moses Wentworth in 1910 and developed Barlett Highlands, a fashionable gated community.

* The eastern part of the area was nicknamed Archer Limits because the Archer Avenue streetcar ended here. The western part was referred to as Summit, although it was unincorporated.

* In 1918, a Polish immigrant, Felix Bialon, opened a general store at Archer and Meade when the area was sparsely populated. He renamed it Midwest Department Store when the area began growing. It was a neighborhood fixture until 1990.

* Chicago Meadows Golf Course was established in 1919 near Laramie and Archer. It later was called Laramie Golf Course and then closed in 1934.

* Vittum Park was developed in 1947. It honors Harriett Vittum, who was a prominent social reformer. She was administrator of the Northwestern University Settlement

House for forty years. The Settlement House was started in 1891 in Noble Square and continues to provide services today.

* LeClaire Hearst Park was named because of nearby LeClaire Courts and Hearst Magnate School. Antoine LeClaire (street name) was a French fur trader who first came to Chicago in 1800 and frequently conducted business in this area. He went on to found Davenport, Iowa. Phoebe Hearst, mother of William Randolph Hearst, started the Parent-Teacher Association in 1897.

FAVORITE THING ABOUT GARFIELD RIDGE

The different pockets of mini-neighborhoods, each couple of blocks being distinct little neighborhoods, but they come together during the many parades and community functions.

Rob Bitunjac, president
Clear-Ridge Historical Society

PLACE OF INTEREST

Midway Airport
5700 South Cicero

Originally the Chicago Air Park, this was built in 1923 for use by air mail carriers. The city opened the Chicago Municipal Airport at the expanded site in 1927. From 1932 to 1962, it earned the title of the "World's Busiest Airport." In 1949, the name was changed to Midway Airport in honor of the World War II battle of the Midway. The airport expanded

and built a new terminal in 2003. The airport holds the Battle of Midway Memorial. It includes *America*, a nine-foot-tall bronze statue by Gary Weisman of a World War II soldier. An actual airplane hangs from the ceiling. The aircraft, similar to those used in the war, was recovered from Lake Michigan in 1991, forty-seven years after it crashed in a training session. As part of the Chicago Public Art Program, a suspended sculpture of a bird in flight, designed by Ralph Helmick, is composed of 2,500 small cast-metal airplanes. Local artist Karl Wirsum created a large mural made of glass panels that depicts children's fascination with flight.

57. Archer Heights

BOUNDARIES
N—Stevenson Expressway
S—CTA Orange Line tracks/53rd Street
E—Corwith Yards railroad tracks at Central Park Avenue
W—railroad tracks at Knox

NEIGHBORHOODS
Archer Heights

HOW IT GOT ITS NAME
Archer Avenue is a major thoroughfare in the area. The "Heights" part comes from the ridge that marked the southern edge of Mud Lake. A subdivision named Archer Heights was built in the area in 1912.

DID YOU KNOW?
* The area had only a few farms and scattered housing until 1900. Patrick Murphy owned much of the land in the southern part of the area. Unfortunately, after he died, his heirs did not pay the taxes and lost the property. Frederick Barlett Company then bought up the land and subdivided it into lots to sell. Horse-drawn streetcars came down Archer in 1896, but the area did not have water, electricity, paved roads or shops. Sales were not brisk.

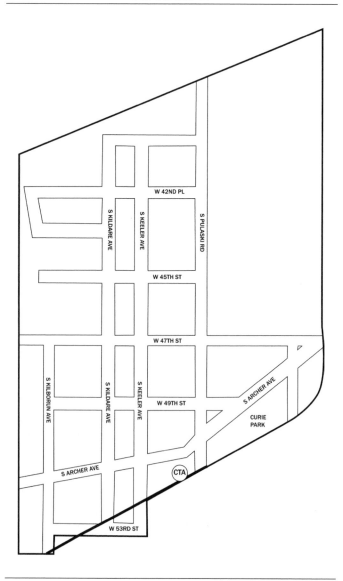

* Other companies began developing the area in 1912, and public amenities were acquired. The area was called the Archer Road District and sometimes Bungalow Belt. Most of the northern section was owned by railroads and held for industrialization.

* Many Polish immigrants began to move into the neighborhood. Archer Heights became a Polish enclave. Evidence of the Polish influence is still found today. It is home to the national headquarters of the Polish Highlanders Alliance. Its chalet-type building includes a restaurant and a banquet hall. The Polish Book Discussion Club meets regularly at the library. Curie Park and Marie Sklodowska Curie High School honor the Polish scientist who pioneered research of radiaton. The Society of Polish Folk Artists is also found here.

* Much commercial growth occurred in the 1930s. Railroad yards and industrial districts covered most of the area.

* The Archer Heights Civic Association was established in 1938. It is the oldest neighborhood organization in the southwest side and remains very active today.

* After World War II, more homes were built in the southwest section. Archer Heights has been a stable working-class community. As the Polish residents have aged or moved away, the community area has had a growing Hispanic population in recent years.

* The Greater Chicago Food Depository is located on Ann Lurie Place. It distributes food to 650 food pantries, shelters or soup kitchens in Chicago. The street was named after the philanthropist who made a major donation to the food bank.

* Look for Bobak's Sausage at the Taste of Chicago. It has been located in Archer Heights since 1967. It even has its own retail store. Bobak's is called "Chicago's Sausageologists" and wishes everyone "Peace, Love and Sausage" on its logo. The Taste, our very own outdoor food festival, has been held every summer since 1980 in beautiful Grant Park.

Favorite Thing about Archer Heights

Archer Heights is a very active international community. We have a good housing stock and convenient access to transportation.

Thomas Baliga
Archer Heights Civic Association

Place of Interest

Archer Heights Library
5055 South Archer

The library was built in 2000 to replace the branch that had been located in a small storefront. It contains a large colorful mural by Brian Sikes, associate professor at the School of the Art Institute of Chicago. Completed in

2003, it is entitled *Object Lessons: Matter, Energy, Time.* Laura Mosquera, who has a large mural installed at the Chicago Avenue Red Line stop, also has artwork displayed here.

58. Brighton Park

BOUNDARIES

N—Stevenson Expressway

S— railroad tracks at 49th Street

E—Campbell/Western Avenue

W—Corwith Yards railroad tracks at Central Park Avenue

NEIGHBORHOODS

Brighton Park

HOW IT GOT ITS NAME

Henry Seymour bought land here in 1835. He developed a small village called Brighton in 1840. Because of hopes to become a livestock trading center, it was named after the cattle market in the Brighton neighborhood of Boston, Massachusetts.

DID YOU KNOW?

* Joseph McCaffery was known as the "Father of Brighton Park." He came to Chicago in 1849 and helped to incorporate the town of Brighton Park in 1851. He built the Blue Island Plank Road (now Western Avenue) and went on to become the president of the Brighton Cotton Mill, which started in 1871.

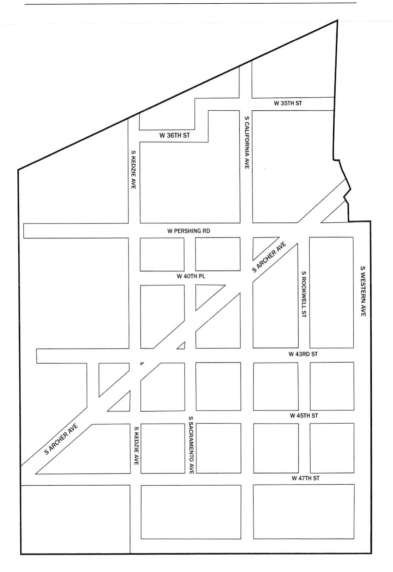

* In 1857, there was a stockyard built near the two livestock herding routes of Blue Island Plank Road and the old portage trail (now Archer Avenue). The Brighton Hotel was built nearby. The Union Stockyards were completed in 1865, and the Brighton Park stockyard was forced to close.

* Thomas Kelly came to Chicago in 1864 and started a grocery store in Brighton Park. He was named the superintendent of the Brighton Cotton Mill in 1876. In 1878, he sold his store to John and Matthew Larney. They had come to Chicago as teenagers from Cavan County, Ireland. Thomas Kelly was married to Ann McCahill, who was also from Cavan County. The Larney brothers added a saloon to the store, and Larney Hall remained here for decades.

* Matthew Larney became the first Brighton Park postmaster in 1873. The post office was to be named Factoryville, but that name was already being used in Illinois. So they stuck with the classier-sounding Brighton.

* The Alton Railroad arrived in 1875 and led to the construction of a roundhouse and repair shop. The Santa Fe Railroad came in 1887 and developed the Corwith Yards, which remain today. Germans and Irish settled here to work at the railroads.

* In 1886, lightning struck the warehouse of Laflin and Rand Explosives Company. The explosion made a twenty-

foot-deep crater and damaged property for miles around. Laflin Rand and the nearby DuPont Powder Company together made two-thirds of the explosives and gunpowder in the country.

* Manufacturing districts were established in 1905. French Canadians, Poles, Lithuanians and Italians worked in these industrial parks. In 1930, the area was 37 percent Polish.

* Crane Plumbing Company opened a large plant in 1915. It closed in 1977, and the loss of jobs caused many people to move away. Latinos moved in and are now 85 percent of the area population. Calmeca Academy was opened in 2010 with a Dual Language program. The population has increased in the last decade, but unfortunately the poverty rate has also increased.

* In 1979, the Polish Pope John Paul II came to Brighton Park to visit his countrymen and celebrate Mass at the Polish Five Holy Martyrs Church. A portion of 43rd Street is named after him. It was the first time a pope had ever visited Chicago.

* Brighton Park is one of six community areas to participate in the Play Streets program. Each warm season, streets are temporarily closed to traffic to allow residents to take part in organized fitness activities to promote a healthy lifestyle and to combat obesity.

FAVORITE THING ABOUT BRIGHTON PARK

I grew up in Brighton Park—graduating from Burroughs Elementary and Kelly High School, going to "the Hut" before it was actually called the Hut and grabbing a slice at Falco's pizza after school. Even after all these years, my favorite thing about Brighton Park has to be all the familiar and friendly faces I see every day. Sure, the taquerias are delicious, but it's the hardworking families of Brighton Park that make it into the place I remember so fondly.

Marcos Ceniceros
Brighton Park Neighborhood Council

PLACE OF INTEREST

DuPont-Whitehouse House
3558 West Artesian

This house was built in 1875 by the DuPont Explosives Company for Junot Whitehouse, the superintendent of the gunpowder plant. It was later the home of Joseph McCaffery. The Chicago Landmark status came in 1996. Renovation of the residence is in progress.

59. McKinley Park

Boundaries
N—Stevenson Expressway
S—Pershing Road
E—Chicago River South Branch Fork
W—railroad tracks at Campbell

Neighborhoods
McKinley Park

How It Got Its Name
In 1901, President William McKinley was assassinated. The South Parks Commission was getting ready to open a neighborhood park and immediately decided to name it after him. McKinley Park was opened in 1903. It was the first of the new local parks developed to provide a green space for recreation and community services in the midst of urban overcrowded housing. McKinley Park was tremendously successful and became a model for parks across the country. The beautiful lagoon is still treasured. A seasonal skating rink is another distinction.

Did You Know?
* In 1836, Irish workers on the I&M Canal began occupying empty land in the area. In 1840, farmers and speculators began buying the land and told the Irish squatters that their

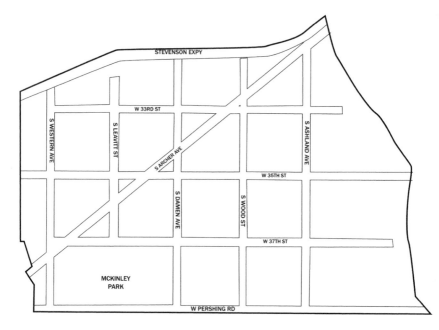

time was up. Many houses were built on stilts because of floods in the spring and poor drainage of the area. It was nicknamed Ducktown.

* The town of Canalport was planned in this community area, across the river fork from the future Bridgeport. It was never developed. Bridgeport beat the competition.

* "Long" John Wentworth opened the Brighton Trotting Park racetrack in 1855. It was located at the present site of McKinley Park. It was closed in 1877.

* The South Fork of the South Branch of the Chicago River has been called Bubbly Creek—not in an affectionate way. The waste from the meatpacking factories drained into the waterway, and it became a gassy, thick and foamy mess. A photo from 1911 shows a chicken standing on the cruddy top of the water. Alas, the river fork is still polluted today.

* In 1865, Union Rolling steel mill was built at Archer and Ashland. It was failing in 1883 and bought by Illinois Steel Company and closed in 1896 to move down to South Chicago.

* After the Great Fire of 1871, eleven new plants and twenty-seven brickyards opened in this community area to help rebuild the city.

* In 1890, the neighborhood of Mount Pleasant was built for the Irish workers on the Chicago Sanitary and Ship Canal and at the steel mill.

* From 1902 to 1908, speculators bought up all of the remaining land in the area. Industrial Parks were built in the northern section and along the river fork. Now warehouses on Iron Street are becoming lofts. New condos are revitalizing the area. McKinley Park is a melting pot of different cultures.

* A popular neighborhood haunt is Lindy's and Gertie's on Archer Road. The original Lindy's Chili was started here in

1929. Gertie's Ice Cream opened in nearby Gage Park in 1901. Both businesses were bought and combined in 1974. The result has been a crowd-pleasing destination, with six other locations.

* In 2008, the Polish Sts. Peter and Paul Church, the German St. Maurice Church and the Irish Our Lady of Good Counsel Church were all consolidated into Blessed Sacrament Parish.

FAVORITE THING ABOUT MCKINLEY PARK

I love to walk through the neighborhood and see all the families enjoying each other—in the parks or on their front stoop. The family-oriented atmosphere is my favorite thing.

Sister Eunice Drazba
Aquinas Literacy Center

PLACE OF INTEREST

Statue of President William McKinley
Western and Ashland

The statue was installed at the entrance to the park in 1905. The country was going through an economic recession at the time when it was commissioned. Sculptor Charles Mulligan came up with a creative solution to the tight budget. He acquired a universally scorned bronze statue of Christopher Columbus that had stood on the lakefront. Mulligan melted and recast the statue into the likeness of President McKinley.

60. Bridgeport

BOUNDARIES
N—Chicago River South Branch
S—Pershing
E—railroad tracks at Stewart
W—Chicago River South Branch Fork

NEIGHBORHOODS
Bridgeport

HOW IT GOT ITS NAME
The town was platted by the I&M Canal Commissioners in 1836. They named it Bridgeport because of the bridge at the canal lock, where cargo needed to be transferred, and the area acted as a port. The neighborhood formally became Bridgeport in 1863 when it was annexed into the city of Chicago.

DID YOU KNOW?
* The area was first called Leigh's Place (sometimes written as "Lee's Place") when James Leigh had a farm here. In 1816, his cabin became a fur trading post, and the area was called Hardscrabble. Chief Alexander Robinson also had a cabin in Hardscrabble before he opened his tavern at Wolf's Point. François LaFramboise came in 1817 to settle

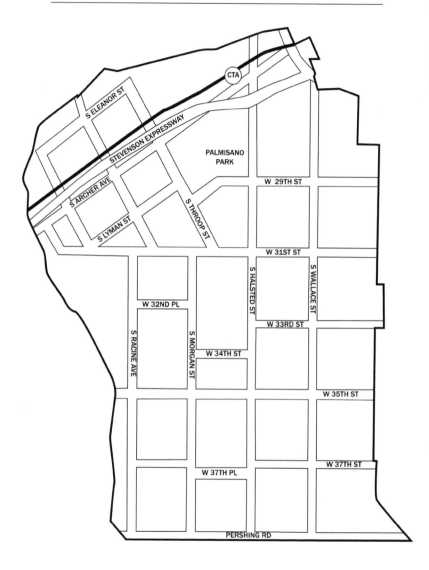

here. In 1827, Russell Heacock built a cabin here and a tavern called Heacock's Point.

* The Illinois & Michigan Canal was authorized in 1827 to form a waterway to connect the Great Lakes with the Mississippi River system. The federal government gave land to the State of Illinois for its construction. The canal began at the Chicago River at Bridgeport and extended ninety-six miles to the Illinois River. Work began in 1836, but the canal wasn't completed until 1848. Work was interrupted from 1841 to 1845 during an economic depression. The state was broke. Workers were paid with "canal scrip" that they could use to buy land. Most of the laborers were Irish immigrants who were fleeing the potato famine. They built shanties and frame cottages along the river. The area was called "Cabbage Gardens." The workers built the ninety-six-mile-long canal while battling malaria, cholera, dysentery, mosquitos and snakes. Thousands died. Any traces of the canal have disappeared.

* Railroads came to Chicago in full force during the 1850s, and the need for the canal had diminished greatly by 1866. Use of the canal did continue until 1900, but it had become severely polluted by industrial dumping and human waste. The drinking water supply from Lake Michigan became contaminated. The Chicago Sanitary and Shipping Canal was built from 1892 to 1900 to replace the I&M Canal, in order to provide a deeper

channel with a stronger current. This diverted lake water into the canal and reversed the flow of the Chicago River. The pollution problem was sent downstate.

* When the canal was built, Bridgeport was predominantly Irish. Since then, a portion of the area that is east of Halsted, called Hamburg, has been Irish. The "Lithuanian Downtown" was formed around Lituanica and 33rd Street. The German neighborhood was called Dashiel. The Poles had their New National Auditorium, which served as a wedding hall. The Croatians had "Little Dalmatia" along Wentworth. Czechs and Italians also had their own enclaves. Bridgeport has become even more diverse over the past several decades.

* Five of Chicago's mayors have been from Bridgeport: Edward Kelly, Martin Kennelly, Richard J. Daley ("the Boss"), Michael Bilandic and Richard M. Daley. Bridgeport was represented in city hall for all but ten years from 1933 to 2011. Schaller's Pump Saloon, opened in 1881, was considered the real headquarters for the Democratic machine.

* Filbert's Old Time Root Beer has been made in Bridgeport for eighty-five years. George Filbert began making his own draft-style root beer in 1926 during prohibition. He delivered it in half-barrels.

FAVORITE THING ABOUT BRIDGEPORT

Bridgeport is rich in history, never forgetting of the deep-rooted immigrant experience of diverse cultures. There is a small-town vibe where everyone knows each other, so despite the lingering old guard, there is a deep sense of community!

<div align="right">

Kristina Tendilla
Benton House

</div>

PLACE OF INTEREST

Palmisano Park
2700 South Halsted

In 1836, Illinois Stone and Lime Company opened a quarry at this site to cut stone needed for the Chicago Harbor. A few years later, Marcus Stearns took over and renamed it Stearn's Quarry. The giant hole in the ground was operated until 1970. Then it became a landfill nicknamed Mount Bridgeport. It was transformed into a beautiful park designed by Earnest Wong in 2009. There are terraces and walkways leading down to the lovely pond.

61. New City

Boundaries
N—Pershing Road
S—Garfield Boulevard
E—railroad tracks at Stewart
W—Western Avenue/railroad tracks

Neighborhoods
New City
Back of the Yards
Canaryville

How It Got Its Name
The village of New City was an affluent residential section southwest of the stockyards. Skilled workers lived in this development south of 51st Street in more comfortable housing than the unskilled workers, who lived in Packingtown near the packinghouses.

Did You Know?
* In 1865, eight different livestock centers in the city combined to form the Union Stockyards. Armour, Swift, Morris and Libby soon joined them in the 425-acre complex. Factories to manufacture items such as soap, glue and fertilizer, from the slaughterhouse byproducts,

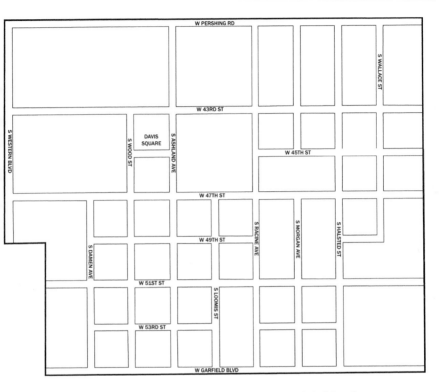

were built west of the yards. The area west of Ashland was known as Packingtown.

*The Hough House Hotel was built in 1865 and renamed Transit House Hotel in 1869. It burned down in 1912 and was replaced by the Stockyard Inn. The Saddle and Sirloin Club was opened in the Records Building in 1903. Fire destroyed it and the Stockyard Inn in 1934,

and they were quickly rebuilt. Both were closed in 1971 with the stockyard.

* The Dexter Park racetrack opened near the Inn in about 1875 and was replaced in 1885 by the Dexter Pavilion, a grandstand for showing livestock. It was also destroyed in the 1934 fire and was replaced by the International Amphitheater. The amphitheater became host to many conventions and various events such as the circus, ice shows and concerts. It closed in 1999.

* Packingtown became known as "Back of the Yards." Cheap cottages and boardinghouses were built here for the workers. Life here and in the slaughterhouses was dramatized by Upton Sinclair in his novel *The Jungle.* He wrote about the low wages of unskilled workers, hard working conditions and poor health environment. Irish, German and eastern European immigrants settled in the congested neighborhood. Churches, institutions and a sense of camaraderie made it bearable. The University of Chicago opened a settlement house. The workers who went on strike in 1894 and 1904 were easily replaced by the many unemployed desperate for work. After the unions got the right to organize in 1935, conditions improved. Joe Meegan and Saul Alinsky organized the residents in 1939 to become leaders for change. Chicago became known as the birthplace of community organizing.

* Ashland Avenue, along the stockyards, became known as "Whiskey Row." Each ethnic group had its own taverns. Workers would stop in for lunch and a nip after work.

* Canaryville is east of Halsted. It was sometimes called the "Front of the Yards." The area was predominantly Irish. In spite of the stench that was emitted from the slaughterhouses, Gustavus Swift lived here from 1875 until he moved to Kenwood in 1898. Father Maurice Dorney started St. Gabriel's parish in 1880, and he was known as "King of the Yards." The *Chicago Tribune* called him a troublemaker because he crusaded for the workers, but he was respected by their employers at the same time.

* After the stockyards closed in 1971, the Stockyards Industrial Park was developed. New City has experienced positive growth.

Favorite Thing about New City
The people and how they stick together as a community. They celebrate life.
Sister Angie Kolacinski
Holy Cross Immaculate Heart of Mary Parish

Place of Interest
Union Stockyard Gate
Exchange and South Peoria

The Gate was built in 1875 and was designed by John Root. This is the last remnant of the 106 years of history

at this site—a reminder of why poet Carl Sandburg called Chicago the "Hog Butcher for the World." It became a Chicago Landmark in 1972. Nearby is a memorial honoring twenty-one firefighters who died in the horrific Stockyard Fire of 1910.

62. West Elsdon

Boundaries

N—railroad tracks/53rd Street

S—59th Street

E—railroad tracks at Central Park Avenue

W—railroad tracks at Kenton

Neighborhoods

West Elsdon

How It Got Its Name

It was west of the town called Elsdon in what is now Gage Park. Elsdon, named after a village in England, was a small railroad worker's settlement built in 1890 next to the Elsdon Train Station at 51st Street and Central Park Avenue.

Did You Know?

* The setting was swampy and had no city amenities. Only a few German farmers and Irish railroad workers lived here. There were only sixteen homes in the area in 1889 when it was annexed to the city. In 1920, the area was drained; electricity, water and paved roads arrived. Nearby Industrial Parks attracted eastern European workers, and the population bloomed.

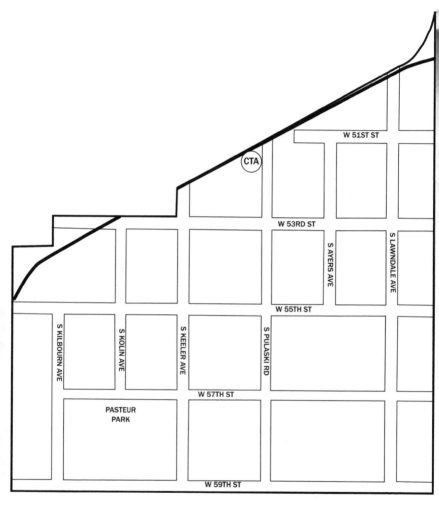

CTA

W 51ST ST

W 53RD ST

W 55TH ST

W 57TH ST

W 59TH ST

S AVERS AVE

S LAWNDALE AVE

S KILBOURN AVE

S KOLIN AVE

S KEELER AVE

S PULASKI RD

PASTEUR
PARK

* Early settlers were lured to the area by developers, who baited them with two housing lots for the price of one and a free three-year pass on the railway. Sounds fishy. But the area remained sparsely populated until 1938. The post–World War II era brought the most development.

* The area is 90 percent residential. It was settled by eastern Europeans who moved into the many brick bungalows. As they retire, the homes are being bought by young Hispanic families. Pulaski Avenue is the commercial and retail heart of the community.

* The "K" streets extend down to this neighborhood. It is occasionally called "K Town" by the locals. These streets reflect the diversity of Chicago. Karlov is named after a Hungarian town, Kolin is named after a Czech town, Kolmar is named after a German town, Kildare is named after an Irish county and Kenneth is named after Scottish kings.

* The West Elsdon Civic Association was founded during World War II and is still active today. In 1946, the Airport Homes housing complex was built to provide temporary housing to returning veterans. The civic association members demonstrated to keep African American vets from moving in with white vets. They continued to oppose public housing in white middle-class neighborhoods until the 1980s.

* The CTA Orange Line did not come to the neighborhood until 1993. This access to transportation has made this quiet community more attractive to home buyers. Airline employees rent the apartments of the western section. But most of homes are bungalows with well-tended lawns and pretty flowers. It is a quiet neighborhood in spite of its proximity to Midway Airport because of the way the runways are angled.

* Mass at St. Turibius Church is said in Spanish, Polish and English—more of that Chicago diversity. Its motto is "We are One Family." The parish was founded in 1927. It is ministered by Augustinian priests.

* The Polish National Catholic Church is located in West Elsdon. In 1895, Catholic Polish immigrants in Chicago were disgruntled with the Roman Catholic Church for not providing Polish priests and for not recognizing their culture. They left Catholicism and started an independent parish. This Christian denomination now has 127 parishes in the United States and Canada.

FAVORITE THING ABOUT WEST ELSDON

You can walk anywhere within the neighborhood—from church, parks, ice cream parlors, grocery stores [and the] *pharmacy—and still wave hello to your neighbors. You can easily exit the city via Midway Airport or travel toward the city on the Midway Orange*

Line. The multiple CTA and PACE buses can take you locally or to the near suburbs. We have it all locally and worldwide.

Bernadette Byrnes
West Elsdon Community

PLACE OF INTEREST
Chicago Fire Soccer Club Field
5825 South Kostner

Adjacent to Pasteur Park, this field was opened in 2011 as part of the city's "Take the Field" program to provide turf fields in the parks located in underserved areas. It is sponsored by the Chicago Fire soccer team. The Fire started as a major-league soccer team in 1998. They played in Soldier Field until 2006. The team now calls Toyota Park home.

63. Gage Park

BOUNDARIES
N—railroad tracks at 49th Street
S—59th Street
E—railroad tracks at Leavitt
W—railroad tracks at Central Park Avenue

NEIGHBORHOODS
Gage Park

HOW IT GOT ITS NAME
Businessman and attorney George W. Gage died in 1875 while serving on the South Park Commission. The other board members decided to name a planned park in his honor.

DID YOU KNOW?
* When Gage Park was annexed to the city in 1889, there were only about thirty cottages in the area. The settlement of Elsdon was in the northwest corner of the area near the Elsdon train station. Tremont Ridge settlement was located near the Tremont train station at 57th and Leavitt.

* Although the land for Gage Park was in a prime location at the end of Garfield Boulevard, the park was not developed until 1903 after the residents pleaded for

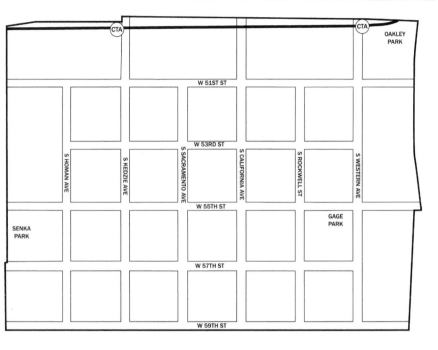

more facilities. The fieldhouse wasn't built until 1926 after the residents again pleaded for more. The fieldhouse auditorium contains a mural done by Tom Lea, a nationally known artist from Texas who had attended the School of the Art Institute of Chicago.

* The trolley service extended down Western and Kedzie in 1897 and spurred some growth. After the park was completed, even more residents arrived. These early homeowners were Catholic eastern Europeans and Irish.

As in the other Chicago communities, each nationality group built its own church.

* In 1922, Ben Bohac, a Czech American, organized one of the largest banks in Illinois. The Talman Home Federal Savings and Loan was located at 51st and Talman. It merged with LaSalle Bank in 1992.

* Senka Park was named for Duke Senka, a longtime park district employee. The park was created in 1971 on an abandoned rail yard. It has a walking trail that meanders for more than a mile. It is home to one of the park district's "Movies in the Park" programs. Since 2000, 128 outdoor parks have featured free current and classic movies shown on huge screens.

* In 1972, Gage Park High School became integrated despite protests. The school is now 80 percent Hispanic. In 2010, the students in a civics class did not believe that Martin Luther King Jr. had marched just a few blocks away. They thought that "there should be a sign or something." This triggered a project to acquire oral histories, photos and videos of the 1966 Chicago Freedom Movement. Their collection is housed in a kiosk at nearby Marquette Park.

* The UNO charter school system has an ambitious master plan for the vacant land (previously industrial) on 51st

Street. The elementary school has been opened as a soccer academy. Architect Juan Moreno has created an exciting "not your run-of-the-mill" educational building. The future projects include a high school, a soccer stadium, a new civic center and a public plaza.

* Gage Park is part of the Bungalow Belt. The housing also consists of ranch- and Cape Cod–style homes, town houses and two- or three-flats. Although mostly Hispanic, a number of Middle Eastern and Lithuanian residents have also moved here. It is a tight-knit community where people look out for one another.

FAVORITE THING ABOUT GAGE PARK

Gage Park is a very generous community. There are many cultural events held in the area. I really appreciate the young life.

Jose Ovalle, director
Mexican Folk Dance Company

PLACE OF INTEREST

Lithuanian Jesuit Youth Center
5620 South Claremont

This facility was built in 1975. Jesuit priests from Lithuania first came to the United States in 1930 to serve immigrants from their country. The center has extensive archives, as well as an auditorium and classrooms to teach youth of Lithuanian descent. There is a chapel

and a Jesuit residence next door. Several memorial sculptures were installed in 1971. Look for the sculpture of a Lithuanian freedom fighter.

64. Clearing

NEIGHBORHOODS
Clearing West
Chrysler Village
Clearing East

HOW IT GOT ITS NAME
A railroad freight clearing yard is a location where outgoing trains are made up and incoming trains are broken down. In 1890, railroad president Alpheus B. Stickney bought land from "Long" John Wentworth near Harlem Avenue. He had tracks laid out to form a mile-long ring called Stickney's Circle to use as a clearing yard. The settlement of Clearing formed nearby.

DID YOU KNOW?
* The first settler was John Simpson, who purchased land for farming in 1842. The first little schoolhouse was built in 1860 for the children of the few German farmers in the area.

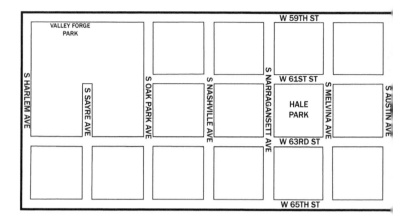

* Henry Porter bought Stickney's Circle in 1898 for use by the Chicago Union Transfer Company. Around this time, there were only about ten houses in the community. In 1907, Henry Porter encouraged companies to come to develop the Clearing Industrial District. Argo Corn Products was the first to build a plant here.

* With the industry came residential growth. By 1911, Clearing was big enough to be incorporated into a village. George Hill's Hardware Store, Buckmeier's Tavern and Al Marshall's Place were early businesses.

* The street 63rd Place was called Silk Stocking Boulevard because the railroad and factory officials lived there; 64th Place,

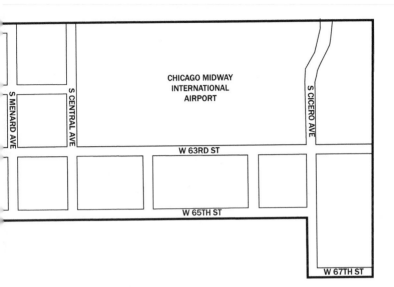

however, was called Moonshine Alley because the workmen who lived there were known to be making their own liquor.

* In 1912, the Clearing baseball team played at Question Mark Stadium at Central and Hale (now 62nd Street).

* In 1915, annexation to the city of Chicago was approved by the residents. The southern half of Midway Airport extends into the community area. At the completion of the airport in 1927, there were five thousand people living in Clearing. Most were Italian and Polish. Population increased greatly after World War II, as bungalows galore were built.

* A tornado hit here at 62nd and Austin in 1921. The Chicago area has had ninety-two significant tornadoes from 1855 to 2010. The last time one hit downtown was in 1876. Beware: skyscrapers do not avert tornadoes.

* Chrysler Village was a neighborhood in the eastern section of the area south of Midway Airport. Brick single-family homes, duplexes and town homes were built around Lawler Park. They were constructed in 1943 during World War II to house the workers at the nearby Dodge/Chrysler Defense Plant.

* The State Bank of Clearing, built in 1913, was replaced in 1959 with a building designed by architect Harry Weese. The bank closed and has since stood empty. Preservation Chicago put it on the 2013 endangered building list.

* Clearing has been experiencing resurgence since the revitalization of Midway Airport. The new terminal opened in 2004, and more businesses have been coming to the area.

FAVORITE THING ABOUT CLEARING

Its long and colorful history and how that history defines many aspects of the community to this day, specifically the rail yards and airport.

Rob Bitunjac
Clear-Ridge Historical Society

PLACE OF INTEREST

Old Clearing Town Hall
5649 West 63rd Street

The building has "Town Hall 1912" engraved high up on a wall. It was converted into condos in 2004.

65. West Lawn

Boundaries
N—59th Street
S—77th Street
E—railroad tracks at Central Park Avenue
W—railroad tracks at Kenton/Cicero Avenue

Neighborhoods
West Lawn
Ford City

How It Got Its Name
In 1877, the developer of Chicago Lawn, nicknamed "the Lawn," also owned land in the eastern portion of this community area. It was divided from Chicago Lawn by the railroad tracks, and the settlement here became known as West Lawn.

Did You Know?
* Development was slow because the water from surrounding higher ground flowed into the area to make it marshy. The land was finally drained, and construction commenced in 1910. It became another part of the Bungalow Belt.

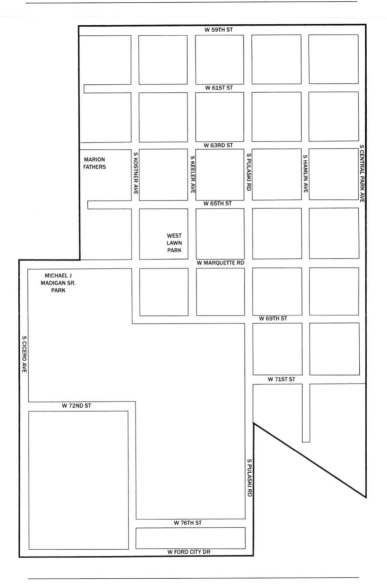

* There was a brickyard located in the northwest portion of the area in 1890. It was soon abandoned, and a large pond was left behind. The pond was used as a swimming hole and ice skating rink until it was filled in 1910.

* Few immigrants settled here. Most of the residents bought their second home here after moving up the economic ladder.

* Streets were paved in the western portion of the area in 1930. The Great Depression curtailed development, and the community remained vacant until after World War II. Rows of affordable single-family homes were built. The population decreased during the late twentieth century mostly just because of the older residents—there were more deaths than births. The population has increased again and has become mostly Latino.

* During World War II, in 1942, the Chrysler/Dodge Company built a defense plant to manufacture engines for B-29 bombers. The buildings were sold to the Tucker car factory in 1946. Ford Aircrafts Engines owned it from 1955 to 1959. It built engines for B-24 Liberators during the Korean War. Tootsie Rolls are now made in one of the buildings. The rest of the area became Ford City Mall in 1965. I never knew how the mall got its name!

* The Balzekas Museum of Lithuanian Culture is located in West Lawn. Stanley Balzekas opened the museum in a two-flat next to his car dealership in 1966. The museum outgrew its space and moved into the old Von Solbrig Hospital building in 1986. It contains the largest collection of Lithuanian artifacts outside Lithuania, as well as a library and gift shop.

* The Marian Fathers came from Lithuania in 1913 and built a monastery here that was closed in 2003. The building is now used for retreats. Since the 1960s, the priests had granted use of the adjoining land as a little-league baseball field. It was sold to the park district in 2003 and is now formally called Park No. 528. Everyone else calls it Marian Fathers Park.

* The *Draugas* newspaper has been headquartered next to the monastery since 1916. It is the largest Lithuanian-language paper in the world and is published three days a week.

FAVORITE THING ABOUT WEST LAWN
It is very friendly and makes everyone feel welcome. I like the strong ethnic identity.

Amanda Castro
Zacatacos Restaurant

Place of Interest

National Archives Chicago Center
7358 South Pulaski

The center is located next to Daley College. If you are creating a family tree, you can make an appointment to research its records. The staff holds educational workshops, hosts field trips and provides additional genealogy resources.

66. Chicago Lawn

BOUNDARIES
N—59th Street
S—railroad tracks at 75th Street
E—railroad tracks at Bell Street
W—railroad tracks at Central Park Avenue

NEIGHBORHOODS
Chicago Lawn
Marquette Park
Lithuanian Plaza

HOW IT GOT ITS NAME
The village of Chicago Lawn was named by its founder,
John Frederick Eberhart, in 1871. The town was located in
the northern part of this community area.

DID YOU KNOW?
* The first building here was the Chicago Lawn train
depot, built in 1876. Mr. Eberhart paid the train
company to extend here, and the station was built at 63rd
and Central Park. Five years later, there were nine houses
in the little village. Mr. Eberhart, the "Father of Chicago
Lawn," built his own house on 64th Street near Homan,
and it still stands today.

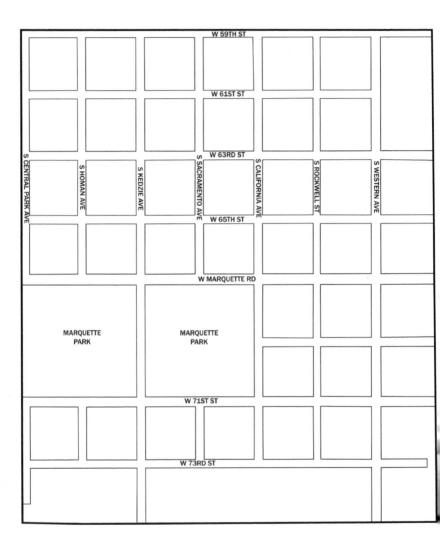

* In 1880, Western Avenue was just a dirt trail. Pryor's General Store sat alone at 64th Street at the halfway point between Blue Island and the city center. It served as a stop for the travelers on their way. Amos Cavender's grocery store was built in 1882 north of 63rd Street.

* In the late 1890s, Chicago Lawn became more developed. The horse-drawn trolley arrived in 1890, and the population grew. Julius Wessel constructed a block-long building in 1910. An 1875 map shows a planned community called Avondale south of the park, but it was never developed. This southern section wasn't settled until after the electric streetcars came this far southwest in 1900.

* Marquette Park was planned in 1905 by the Olmsted brothers. Because of drainage problems, development was slow. In 1913, the golf course, lagoon and concert grove were completed.

* "Hetty Green's Cabbage Patch" was empty prairie owned by the eccentric millionaire from New York. She refused to sell for needed development until 1911 after haggling with the pastor of St. Rita of Cascia Church. Her property on the eastern portion of the area became Marquette Manor, named after the park. In 1917, developer William Brittigan built and sold bungalows here.

* Many Lithuanians lived in the area, which became known as the Lithuanian Gold Coast. The Lithuanian Sisters of St. Casimir came here in 1911 and built their motherhouse. They started the St. Casimir Academy school for girls that year. It is now Maria High School. The sisters opened Holy Cross Hospital in 1928. Most of the Lithuanians moved to Lemont, Illinois, but the nuns remain.

* The National Biscuit Company opened a huge bakery here in 1941—it is more popularly known today as Nabisco, makers of Chips Ahoy! and Oreos.

* The first Giordano's pizza opened here in 1974 at a little storefront located at 63rd and California. Oh, Chicago pizza! In the late 1800s, immigrants from the Naples region of Italy came to Chicago. Thin-crust cheese pizza was served in the backroom of saloons; there were no pizzerias. In 1943, Ike Sewell and Ric Ricardo opened Pizzeria Uno, serving a new style of pizza with a deeper crust. Adolpho Rudy Malnati Sr. was their employee at the time and has always maintained that it was his idea. His son, Lou Malnati, opened his own deep-dish pizza restaurant in 1971. Rudy Malnalti Jr. opened Pizano's in 1991. Gino's East opened in 1966 as the second deep-dish pizzeria in Chicago. Giordano's, owned by brothers Efren and Joseph Boglio, created stuffed pizza based on their mother's recipe for an Italian Easter pie. There is a difference between deep dish and stuffed.

Deep-dish pizza is made with a biscuit-like crust cooked in a high-sided pizza pan. Cheese is added; sausage or other favorite ingredients can be added as well. It is then topped with tomato sauce. Stuffed pizza has a flakier crust; it is filled with tons of mozzarella. A second thin crust is layered over it, and then it is covered with tomato sauce. Both are called Chicago pizza. Either way, it is definitely better than New York pizza.

Favorite Thing about Chicago Lawn

I love Chicago Lawn because it is a beautiful amalgam of black, Latino and Arab nationalities. For over forty-two years, the Arab Community Center and the Arab American Action Network have been a part of the social fabric of Chicago Lawn, and we have a rich and proud history of struggling with our neighbors for racial, social and economic justice.

Hatem Abudayyeh, director
Arab American Action Network

Place of Interest

Lithuanian Monument
Marquette Park
S. California and Marquette Road

This monument honors Steponas Darius and Stasys Girenas, two Lithuanian American pilots who died in a 1933 record-setting transatlantic flight from New York to Lithuania. They were just four hundred miles from their

destination. They had both been fighter pilots for the United States during World War I. Dedicated in 1935, the monument is a sleek, polished granite formation with a bronze globe that shows the flight path.

67. West Englewood

BOUNDARIES
N—Garfield Boulevard
S—75th Street
E—Racine Avenue
W—railroad tracks at Bell Street

NEIGHBORHOODS
West Englewood

HOW IT GOT ITS NAME
Early settler and realtor Henry Lewis named the Englewood community in 1868. This area west of the railroad station became known as Englewood-on-the-Hill. When trolley service arrived in 1890, residents began calling it West Englewood.

DID YOU KNOW?
* The Drexel family of Philadelphia, of Drexel Boulevard fame, owned land west of Ashland between 63rd Street and Marquette Road. A subdivision called Drexel Estates was developed there in the 1860s. It was absorbed by the adjoining South Lynne settlement in 1870. The area was annexed to the city in 1889.

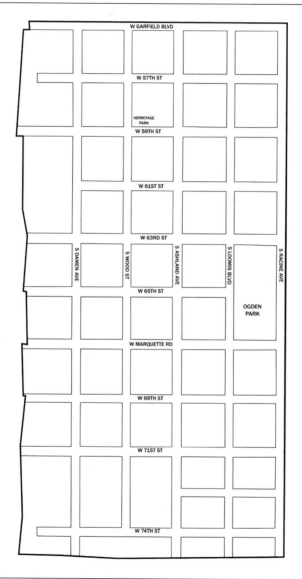

* The earliest settlers, in the 1840s, were Swedish and German farmers. In 1908, Swedish immigrants built the Messiah Church. J.P. Jensen built a dry goods store at 63rd and Ashland. There was a small community of African Americans at 63rd and Loomis. The "L" service came in 1907, and many Italian families moved here. The terminus of the CTA Green Line Englewood Branch is here at 63rd and Ashland.

* The first movie and performance theater was the 1912 Hippodrome. It became the Atlas Theater in 1918, the West Englewood Theater in 1920 and then the Ogden Theater in 1936. Bob Hope came to Chicago in 1928 to break into vaudeville. His first professional assignment was to emcee the show at the West Englewood Theater.

* The racial makeup of the area changed in the 1960s. At the same time, the aging buildings began to deteriorate. From 1980 to 2010, the population of West Englewood dropped by 50 percent with black flight—the out-migration of inner-city African Americans to suburbs with newer home construction.

* The West Englewood Tigers is a baseball team for kids from five to twelve years olds. The organization recognizes that "sport involvement has a positive relationship with academic achievement." Its goal is that every athlete excels academically and earns an athletic scholarship to college.

They practice on the eight baseball fields at Ogden Park. The park was opened in 1905. It is one of the 134 parks in the city and has one of the eighty fieldhouses. The fieldhouse was extensively remodeled in 1972. The park became a major regional park in 1998 when a carousel, a water feature and an outdoor stage were added.

* The Windy City Hoops program was recently introduced at Ogden Park. Beginning in 2013, the free year-round basketball league is offered in ten city parks for boys and girls in low-income neighborhoods. National Basketball Association Hall of Famer Isiah Thomas was instrumental in starting the program. He said that "as a child, growing up in Chicago, basketball was a way that I could enjoy myself, make friends, stay safe and obtain the education I needed to succeed in life…I see kids who want an opportunity."

* A food desert is defined as a neighborhood where fresh fruit, vegetables and other healthful foods are lacking. Such districts tend to be filled with "quickie marts" where processed foods and foods high in sugar and fats are handy. Such areas have higher rates of obesity and poor health. The Walmart Market and Walgreens Food Mart opened to help remedy the problem.

FAVORITE THING ABOUT WEST ENGLEWOOD

I love my community because my community loves me. We were able to raise our children in a place that is full of peace, joy and happiness.

Clara Kirk
Clara's House
West Englewood United

PLACE OF INTEREST

Lindblom Math and Science Academy
6130 South Wolcott

This school was built in 1919. It is named after Robert Lindblom, who immigrated to Chicago from Sweden in 1867. He served on the board of education. His name was chosen to reflect the Swedish American ethnic identity at that time. This beautiful and historic school was rehabilitated in 2003 and was approved as a Chicago Landmark in 2010. It is a selective enrollment school, with the reputation as one of the top college prep schools in Illinois.

68. Englewood

BOUNDARIES
N—Garfield Boulevard
S—75th Street
E—railroad tracks/irregular border
W—Racine Avenue

NEIGHBORHOODS
Englewood
Hamilton Park

HOW IT GOT ITS NAME
The area was first settled in 1852 and called the Junction Grove because of the Chicago Junction railroad station at 63rd and LaSalle. Many railroad lines joined here. Some of the settlers were from Englewood, New Jersey. In 1868, merchant Henry Lewis suggested changing the name to Englewood to improve the image of the area. However, the nearby woods were soon cut down.

DID YOU KNOW?
* In 1868, L.W. Beck donated land to build the Cook County Normal School, the forerunner of Chicago State University. It seems more a bribe than a donation. Beck proceeded to develop the area's first subdivision around it.

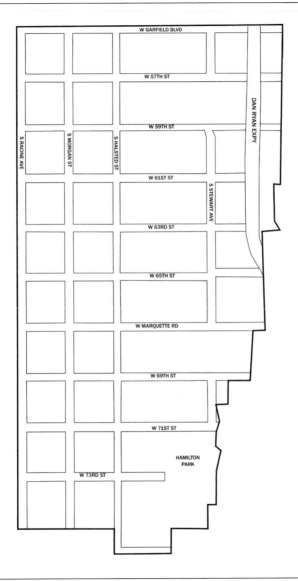

Early neighborhoods were Normalville, Linden Grove and Eggleston.

* The population grew after the Great Fire of 1871 because of the easy railroad access. Another growth surge occurred in anticipation of the Columbian Exposition of 1893. Swedish, German and Irish workers settled here.

* J.B. Lanyon owned the Harness and Turf Goods store. In 1886, he opened the Lanyon Opera House. Artwork for the Columbian Expo was produced at a workshop there.

* Herman Mudgett (aka Dr. H.H. Holmes) had a hotel at 63rd and Wallace in 1894. He was the serial killer immortalized in the book *Devil in the White City.* Shortly after his arrest, the Holmes Castle Hotel burned to the ground. There were rumors of his ghost wandering the neighborhood.

* In 1901, the huge, ornate Becker Ryan department store was built at 63rd and Halsted. Sears bought it in 1929 and tore it down to rebuild in 1933. Wieboldt's Department Store opened nearby in 1930. Wieboldt's started in 1883 and had ten stores in Chicago until they all closed in 1986. The intersection of 63rd and Halsted was the second-busiest retail district in the city. There are now few buildings left. The Art Deco–style Chicago City Bank and Trust building was constructed in 1929 and still stands. The new Kennedy King College was built on nearby vacant lots in 2007.

* In 1905, seven Canadian nuns came to open St. Bernard's Hotel Dieu (House of God) to provide healthcare to the area. It grew into St. Bernard's Hospital, which is still in business.

* When industry and jobs moved out, white workers went with them. African Americans moved in. Blacks were 11 percent of the population in 1950, 69 percent in 1960 and 98 percent in 1970. Because of poverty, many couldn't afford to maintain the homes as they aged and deteriorated. Half of the housing units have been torn down.

* Since the 1980s, there has been concern regarding drugs, gangs, the lack of youth activities, inadequate housing and the need for job training. Urban renewal projects have been announced by the city in the past but never materialized. Organizations such as Teamwork Englewood, Community Development Corporation, Resident Association of Greater Englewood (RAGE) and Englewood Employment Initiative have a quality-of-life plan and envision a brighter future.

FAVORITE THING ABOUT ENGLEWOOD

My favorite things are Kusanya Café, Mile Square Health Center and Kennedy-King City College, with its radio and TV stations and the Sikia Restaurant.

Rosalind Moore, director
Teamwork Englewood

My favorite thing is economic development and how it is improving the community. I also appreciate the new Community Garden and RAGE.

Rashanah Baldwin, manager

Englewood Portal

PLACE OF INTEREST

Kelly Library
6157 South Normal

This is the second-oldest branch library in Chicago. Named for businessman and library benefactor Hiram Kelly, the library was built in 1911 and underwent extensive restoration in 1989. Four outstanding artworks, including Jacob Lawrence's *Schomberg Library*, are housed in the library.

69. Greater Grand Crossing

BOUNDARIES
N—63rd Street/South Chicago Avenue/67th Street
S—79th Street
E—railroad tracks angled from Kenwood
W—railroad tracks/irregular border

NEIGHBORHOODS
Greater Grand Crossing
Park Manor
Grand Crossing
Winneconna Parkway

HOW IT GOT ITS NAME
Paul Cornell bought land here in 1855. He did not offer lots for sale until 1870. He originally called the village Cornell, but the name already existed for another Illinois town. He then chose Grand Crossing to reflect the train intersection in the middle of his development.

DID YOU KNOW?
* There were four other villages in the community area. Brookline, Park Manor, Cummorn and Brookdale were absorbed into Greater Grand Crossing.

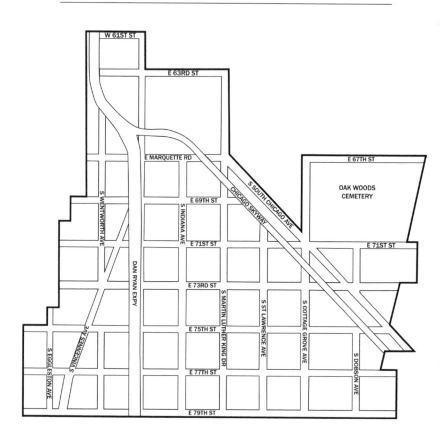

* The Ten Mile House tavern was built in 1847 at Vincennes and 79th. It was also known as Schorling's Road House. Farmers would bring produce to the city in horse-drawn carts. There was a system of inns located every ten miles where people could rest. The inn also served as the Cummorn Post Office.

* In 1853, a historic train wreck occurred where the tracks intersected at 75th and South Chicago Avenue. Late at night, a Michigan Southern train collided with an Illinois Central train that was running without regulation headlights. Eighteen people were killed, and forty were injured. Following the crash, all trains had to come to a complete stop before proceeding through the intersection.

* In 1870, Paul Cornell built the Cornell Watch Factory on a curving lot at 76th and Greenwood. The Chicago Tack Company was established by Orrin Bassett in 1986 at 75th and Woodlawn.

* Irish, English and Germans were the early residents in the area. Swedes and Italians soon joined them. Al Capone lived with his family at 72nd and Prairie from 1923 until he was forced out of town in 1928.

* The Winneconna Parkway neighborhood was originally known as Cummorn. The streets loop around the lovely and peaceful Auburn Park. The lagoon is a remnant of the original wetlands.

* Oak Woods Cemetery was established in 1853. The first burials took place in 1860. The wooded 183 acres contain four small lakes. When the modern St. Lawrence Seaway was completed in 1959, one of the first ships to

pass through brought one hundred tons of marble to construct the Tower of Memories. Many famous people were buried here: physicist Enrico Fermi, gangster Jake Guzik, Olympic athlete Jesse Owens, Mayor Harold Washington, attorney Clarence Darrow, baseball owner Bill Veeck, magazine founder John Johnson, baseball player Cap Anson and others.

* Gary Comer, founder of Land's End clothing company, grew up in Greater Grand Crossing. His foundation opened the Gary Comer Youth Center in 2006 and funded the Gary Comer College Prep in 2008.

* Shani Davis, Olympic speedskating champion, spent his early years in Greater Grand Crossing. He learned to roller skate when he was two years old, and then, when he was six years old, he switched to ice skating and joined the Evanston Speedskating Club. At ten, he moved with his family to Rogers Park to be closer the Evanston rink.

FAVORITE THING ABOUT GREATER GRAND CROSSING
Greater Grand Crossing is an embracing area; 75th Street is full of entrepreneurs. Life is sweet for me here.

Stephanie Hart
Brown Sugar Bakery

PLACE OF INTEREST

Confederate Mound
Oak Woods Cemetery
1035 East 67ᵗʰ Street

There were about six thousand Confederate soldiers who died while prisoners at Camp Douglas. They were originally buried at the Chicago City Cemetery but were exhumed in 1872 when the cemetery became Lincoln Park. They were buried together here in a mass grave, which remained unmarked until 1895, when ex-Confederate soldiers donated the monument.

70. Ashburn

BOUNDARIES

N—railroad tracks at 75th Street/77th Street
S—87th Street at city limits
E—railroad tracks at Leavitt/Hamilton
W—Kostner/Cicero

NEIGHBORHOODS

Ashburn	Parkview
Scottsdale	Crestline
Beverly View	Wrightwood
Marycrest	

HOW IT GOT ITS NAME

The first train station here was called Wabash Junction at the intersection of the Wabash Railway and Great Trunk Railroad. The name was changed to Clarksdale in 1892. In 1904, when Wabash Railroad administrators realized that there was already a Clarksdale in Illinois, they changed the settlement name. It has been reported that the name Ashburn was chosen because the area had been a dumping ground for ashes collected from Chicago's furnaces.

DID YOU KNOW?

* The first settlement was in Clarksdale along the railroad at 83rd and Central Park Avenue. Dutch, Irish and Swedish workers built thirty homes.

* Chicago's first airport was called Ashburn Flying Field. It opened in 1916 as a training field for pilots. During World War I, it also served as a training camp for the U.S. Army Signals Corps, which was responsible for military communications. In 1923, Emil "Matty" Laird began to build biplanes there. The airport was closed in 1939. The neighborhood of Scottsdale was established in 1950 on the site of the old airfield.

* The Beverly Country Club was established in 1908. It was built outside the community because Beverly was a "dry" area, and the members wanted to have cocktails handy. Part of the golf course extends into Ashburn. It is next to the Dan Ryan Woods. A section of Evergreen Cemetery also sneaks up into the area.

* Real growth of the area did not occur until the 1950s. The area between Scottsdale and Wrightwood is often just called "Bogan" because of Bogan High School. Southsiders also have a tendency to identify their neighborhood by their parish, so you might hear Wrightwood referred to as the St. Thomas More area or simply "Tommy More."

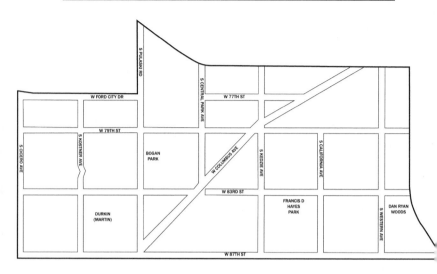

* The residents that arrived in the '50s were mostly Irish, German, Polish and Italian. In the 1980s, the African American population began increasing. The community worked to minimalize racial tension. Ashburn has often been cited for successful neighborhood integration.

* The Marycrest neighborhood was recently built in 1995 around 85th and Kedzie. It was constructed on an unused portion of the Evergreen Cemetery.

* The Sarah E. Goode Academy, opened in 2012, is one of the U.S. STEM schools (Science, Technology, Engineering and Math). The idea is to prepare students for the workforce of the future. Sarah Goode was born a slave

in 1850. She came to Chicago after the Civil War and was the first African American woman in the country to receive a patent—for a unique cabinet that she designed and sold in her furniture store. The school name was picked from suggestions submitted by residents.

Favorite Thing about Ashburn

The finest city service representatives are acting as the eyes and ears of their blocks. Ashburn is a great place to work, shop, play, do business, raise a family and worship.

Lona Lane, alderman

Place of Interest

Major Taylor Trail Mural
1030 West 111th Street

The six-mile-long Major Taylor bike trail begins in this area in Dan Ryan Woods. Marshall "Major" Taylor was a legendary African American professional cyclist who set the world record for the one-mile track in 1889. Bicycle racing was the most popular sport at the time. He came to Chicago when he was twelve years old and lived in Bronzeville. He died penniless at Cook County Hospital in 1932 and was buried in an unmarked grave in Glenwood, Illinois. In 1948, Frank Schwinn, of bicycle fame, had a gravestone placed to honor him.

71. Auburn Gresham

BOUNDARIES
N—railroad tracks at 75th Street
S—railroad tracks at 89th Street/91st Street
E—railroad tracks at Eggleston
W—railroad tracks at Leavitt

NEIGHBORHOODS
Auburn Gresham
Gresham

HOW IT GOT ITS NAME
The Auburn settlement developed in 1872 around the railroad station at 79th and Wallace. The source of the name Auburn is unknown, but there was a famous poem called "Sweet Auburn," "the loveliest village on the plain." Gresham was first called South Englewood. This settlement developed around the railroad station at 89th and Halsted. Walter Gresham, from Indiana, was the U.S. secretary of state until he died in 1895. In about 1905, the railroad renamed the station in his honor.

DID YOU KNOW?
* Dutch farmers were the first settlers in 1840. Irish railroad workers came to settle in 1850 when the first tracks were

laid. William Ogden developed most of the area. Streetcars extended to the area in 1893, and the population increased.

* In 1910, a steady stream of development began after more streetcars came. Auburn Gresham is listed as a Bungalow Historic District. The Irish remained, and the area took on a *slainte!* atmosphere.

* The Highland Theater was built in 1926 at 79th and Ashland and is now a church and conference center. Riley's Trick Shop opened in 1937 and stocked things like

whoopee cushions and joy buzzers. Hanley's House of Happiness was a popular tavern. Barnett's Five and Dime was a favorite variety store.

* The city's first St. Patrick's Day parade was held along 79th Street from 1953 to 1960. It was called the Southtown Parade. Mayor Daley moved it downtown and renamed it the Chicago St. Patrick's Parade.

* Ethnic succession took place from 1960 to 1970. The area is now a primarily middle-class black neighborhood. Although most of the housing remains in good condition, many businesses moved out, and the commercial strip deteriorated. The city has begun to put a large reflective red "X" on vacant buildings to warn first responders that they are structurally unsafe.

* This area has had resurgence over the last decade. New retail and residential development is taking place. Community leaders Father Michael Pfleger of St. Sabina, Deborah Moore of Neighborhood Housing Services and Terry Peterson of Chicago Housing Authority have had an impact on its revitalization. The residents have banded together to work for improvement.

* The beautiful SOS Children's Village opened in 2004. It provides homes for children and their foster parents. Siblings can remain together. The children don't "age out" and have

to leave the system at eighteen years old; the village continues assistance with education, employment and housing.

* Catholic Charities opened the St. Leo Campus on Halsted Street in 2007. The complex includes the St. Leo Residence for homeless veterans, the John Paul II Residence for persons with physical disabilities, a Department of Veterans Affairs (VA) clinic and the Veterans Garden.

FAVORITE THING ABOUT AUBURN GRESHAM

Auburn Gresham is a Community Rich with History and pregnant with Possibility. It is one of the Jewels of Chicago that I am proud to call Home.
Father Michael Pfleger, pastor
St. Sabina Faith Community

PLACE OF INTEREST
St. Sabina Church
1210 West 78th Street

This parish was formed in 1916 when the first Mass was held in a Racine Avenue storefront. The church was built in 1933. The racial makeup of the parish changed in the 1960s, and the pastor at that time welcomed African Americans to the neighborhood, unlike many other churches in the surrounding neighborhoods. Since 1981, the pastor, Father Michael Pfleger, has led efforts to revitalize the area. In 2011, the parish created a memorial wall called *Youth Not Forgotten* to honor children lost to violence. Numerous social service programs are provided by the parish.

72. Beverly

BOUNDARIES
N—87th Street
S—107th Street
E—Beverly Avenue
W—Western/California/railroad tracks at Sacramento

NEIGHBORHOODS
Beverly
West Beverly
East Beverly

HOW IT GOT ITS NAME
It was first called Beverly Hills in 1889. It is said that early resident Alice French advocated for the village to be named after her Beverly, Massachusetts childhood home. Since the area was located on the Blue Island Ridge, the highest elevation in the city, the "Hills" part was added. It was not named for Beverly Hills, California, which was founded in 1907.

DID YOU KNOW?
* The first settler was DeWitt Lane. In 1834, he built a log cabin when this area was called North Blue Island Ridge. He was joined by Norman Rexford, who built a tavern. However,

they both left in 1836. There were only five other houses of English settlers. John Blackstone bought lots of land in the area and built his estate, the Blackstone House, in 1839.

* The Rock Island Railroad and the Panhandle Line were built in 1852 but did not offer commuter services. The Panhandle Line came south along Beverly Avenue. The Rock Island Line came down through Washington Heights along Vincennes. The area around 103rd Street at the eastern border of Beverly, where the lines intersected, was informally called "the Crossing." In 1865, the Panhandle Line began offering passenger service at 91st, 95th and 103rd. To keep in competition, the Rock Island Line built the "Dummy Line," which went west from 97th and Vincennes and curved south through the middle of Beverly. They opened stations at Prospect Avenue, Oak Street (99th) and Tracy Avenue (103rd).

* In 1874, this area was part of the town of Washington Heights. The settlements of Longwood around 95th Street, Walden around 99th Street and Tracy around 103rd Street were absorbed.

* The rail lines were reconfigured in 1889 to establish the stops at 91st, 95th, 99th, 103rd and 107th. These stations are now used by Metra. This area separated from Washington Heights in 1889 and was renamed Beverly Hills. The convenience of all these stations spurred growth.

* Baers General Store opened in 1887 and operated until 1954. Thomas Downey opened the Washington House Hotel at 105th Street and Vincennes in 1880. John Schneider bought it in 1889.

* John H. Vanderpoel was a Dutch-born artist who lived in Beverly and was an instructor at Chicago's School of the Art Institute from 1880 to 1910. Georgia O'Keefe said that he "was one of the few real teachers that I have known." The Vanderpoel Memorial Art Gallery is housed in the Ridge Park Fieldhouse.

* Beverly became a settlement for upper-income English Protestant residents. Now there is a mix of Protestants and Catholics; a mix of grand Tudor-, Colonial- and Victorian-style homes, along with more modest bungalows; and a mix of African Americans and whites. The diversity in parts of Chicago is a wonderful thing.

* Walter Burley Griffin Place has been a Landmark District since 1981. Walter Griffin was the architect who designed seven of the Prairie-style homes here. He was a co-worker of Frank Lloyd Wright's. He met architect Marion Mahoney at the Oak Park studio, and they were later married.

FAVORITE THING ABOUT BEVERLY

Beverly is Chicago's most lovely neighborhood. The hilly terrain, the lovely houses and the tree-lined streets all make it a real city treasure.

Matt Walsh
Beverly Area Planning Association

PLACE OF INTEREST

Givins Castle
10244 South Longwood Drive

Real estate developer Robert Givins had this house built in 1887 to impress his fiancée. It was designed to copy an Irish castle. Since 1942, it has been the home of the Beverly Unitarian Church.

73. Washington Heights

HOW IT GOT ITS NAME

The Blue Island Land Company bought up land here in 1869, where the Rock Island and Panhandle Lines crossed. The Washington Heights Post Office was started that same year. The village of Washington Heights was incorporated in 1874. I think we can presume that it was named after the first U.S. president.

DID YOU KNOW?

* In 1836, Jefferson Gardner built a tavern in the area. William Wilcox began to operate it in 1844. There were also a few farmers in the vicinity until 1860. Prairie schooners would travel along the Vincennes Trail carrying cargo from Indiana to downtown Chicago. They would camp on

William Wilcox's farm because it was known to have good-tasting well water. There were several other saloons along the trail. Since Beverly was dry, these watering holes were very popular.

* The original Washington Heights was settled in 1860 at about 103rd and Vincennes by Irish, Germans and American-born citizens. The small village of Fernwood was located to the east and settled in 1880 by Irish and American-born. Brainerd was located between Racine and Ashland from 87th to 91st Street and was also settled in 1880. All three towns were annexed to the city of Chicago together in 1891.

* The first public school opened in 1874. For the prior two years, Mr. J.A. Wadhams taught the children in a small wood-frame building. He became the first principal.

* Brainerd was named after Frank Brainerd, one of the founders of the Rock Island Railroad. Before annexation, 91st Street was named Brainerd Street. Brainerd Park is located on 91st Street. There is still a Metra station and public library named after the original town.

* The Chicago Bridge and Iron Works was opened at 105th Street and Throop in 1889. It has grown to be an international conglomerate, but it is no longer located in Chicago, no longer builds bridges and no longer makes

iron. It is now based in Texas and does projects for oil and gas companies.

* The old site of the ironworks will become a development for single-family homes. The initial plan was stalled and fell apart due to finances after only about twenty-five houses were built. An alderman's wife was in charge of selling the homes and received much TIF money. There couldn't have been anything unscrupulous going on, could there? No, not in Chicago politics! A new developer has stepped in.

* Most of the housing was built between 1920 and 1940. Predominately Irish, German and Swedes moved in. The population transitioned to 98 percent African American between 1950 and 1970. It remains primarily middle class.

* Interstate 57 opened in 1967. It cut through the area and displaced many longtime residents. It is the only Chicago expressway without a nickname. In 2012, a section of I-57, between Exits 339 and 358, was designated as the Tuskegee Airmen Memorial Trail. The Tuskegee Airmen were the first African American military aviation crew in the U.S. Armed Forces. They were based in Tuskegee, Alabama, and 992 pilots were trained there from 1941 to 1946; 450 pilots served overseas in World War II, with an outstanding collective war record. Although they returned to again face racism, they paved the way for full integration in the military.

FAVORITE THING ABOUT WASHINGTON HEIGHTS

The people here are very friendly. There are a lot of business opportunities here, but Washington Heights needs more services to improve the spirit of the community.

Diara Brooks
Scoops Hair Mechanics Barber and Beauty

PLACE OF INTEREST

Woodson Regional Library
9525 South Halsted

This library was built in 1975 and named to honor Dr. Carter Woodson, the father of the study of African American history and culture. A shining star within the library is the suspended sculpture *Jacob's Ladder*, designed by Richard Hunt. He is a southside native who attended the School of the Art Institute of Chicago.

74. Mount Greenwood

BOUNDARIES
N—99th Street/103rd Street
S—115th Street
E—railroad tracks at Sacramento
W—Pulaski/Cicero

NEIGHBORHOODS
Mount Greenwood
Mount Greenwood Heights
Talley's Corner

HOW IT GOT ITS NAME
In 1877, George Waite received a land grant to develop a cemetery. He gave it the name of Mount Greenwood because it was a wooded area along the ridge.

DID YOU KNOW?
* The first settlers were Dutch and German farmers, who were alone on the plain in 1860. They must have been independent souls. Most of the Germans were on the north side.

* This area was once called the Seven Holy Tombs because of the cemeteries in the vicinity. St. Casimir Lithuanian

Cemetery is the only one within its borders. Mount Greenwood Cemetery sits in unincorporated territory.

* After the cemeteries were established, many taverns and restaurants opened to help restore the mourners before

their long carriage ride back to the city. James "Yank" Cunningham ran a popular saloon.

* Protestant temperance groups wanted the area to be "dry" like Morgan Park and Beverly. Residents voted to be incorporated as the town of Mount Greenwood in 1907 to be free of the abstainers' grip. The village chose to be annexed to Chicago in 1927. However, it did not receive city services like sewers and paved streets until 1936. Residential development could then begin, and many new homes were built until 1960.

* The "Battle of the Ditch" occurred in 1916. There was a drainage ditch that ran along Mount Greenwood Cemetery. The residents were concerned that its polluted water was a health hazard. They obtained a court order to have it filled, but the cemetery ignored the ruling. The residents then proceeded to fill it in themselves. That's Chicago determination!

* Saint Xavier University was founded in the Loop by the Sisters of Mercy in 1846. They moved to Douglas in 1873 after the Great Fire. In 1956, they came to settle in Mount Greenwood. Mother McCauley High School was built next door. It is named after Catherine McCauley who founded the Sisters of Mercy in Ireland. Brother Rice High School has also been located next door since 1956. It is named after Edmund Ignatius Rice, who founded the Christian Brothers in Ireland.

* The Talley's Corner neighborhood was named after Mary Talley, who died in 2003 at eighty-nine years old. She was born on a Pottawattomie reservation in Kansas and came to Chicago in 1921. She was a founding member of Queen of Martyrs Parish and a Christ Hospital nurse who was held in such high esteem that the neighborhood adopted her name.

* The community area is home to many Chicago firemen, police and other civil servants. It is known as a peaceful residential area. John Powers wrote three books about growing up in Mount Greenwood. Did you ever hear of *Do Patent Leather Shoes Really Reflect Up?*

FAVORITE THING ABOUT MOUNT GREENWOOD
Mount Greenwood calls itself a "Village of Good Neighbors." They are working to advance the welfare and social justice of the community.
Andrew Knoell, teacher
Brother Rice High School

PLACE OF INTEREST
Chicago High School for Agricultural Studies
3857 West 111th Street

Pete and Angie Ouwenga had rented land here and started operating their farm in 1948. The land later reverted back to the school district, and the school was built in 1985. The city's last surviving farm is part of the campus. The institution is a Chicago Public Magnet School, with more than six hundred students.

75. Morgan Park

BOUNDARIES
N—107th
S—115th/119th
E—Halsted/Ashland
W—California/railroad tracks at Sacramento

NEIGHBORHOODS
Morgan Park
Kennedy Park
West Morgan Park
Beverly Woods

HOW IT GOT ITS NAME
In 1844, Thomas Morgan bought land along the Blue Island Ridge from John Blackstone. The property ran all the way from 91st Street to 119th Street. The Blackstone House, located in Beverly at 92nd and Pleasant Street in an area called Campbells Woods, was renamed Upwood by Morgan. In 1869, his heirs sold the section south of 107th Street to a land company. It became the village of Morgan Park. It was officially incorporated as Morgan Park, Illinois, in 1882. Morgan Avenue later became 111th Street.

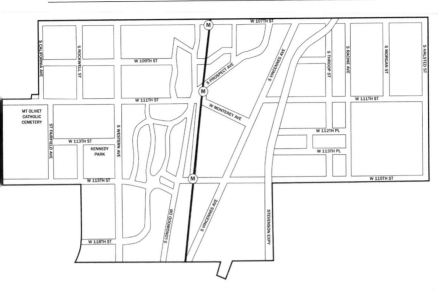

DID YOU KNOW?

* The Blue Island Land Company built stately, upscale homes with large lots on curving streets. The plan excluded any businesses or industry. The village became Protestant and alcohol-free. The land company was backed by executives of the Rock Island Railroad, and they made sure that the commuter line extended down into the neighborhood.

* The land company donated property for academic establishments to entice more residents. The Mount Vernon Military Academy was built in 1873 on a ridge overlooking "Horse Thief Hollow." It was renamed Morgan Park Military Academy in 1877. From 1892 to 1906, it was affiliated with the University of Chicago as a

teacher training school. It is still operating as Morgan Park Academy and is proud of its diversity and strong academics.

* The Chicago Female College was founded by Gilbert Thayer in 1875. It remained in Morgan Park until 1890. His daughter, Julia Thayer, continued the college in Givins Castle in 1895 until it became part of the Cook County Normal School.

* The Baptist Theological Union first started at the old University of Chicago in Douglas in 1868. The land company was able to lure it to Morgan Park in 1877. It left in 1892 to become part of the University of Chicago Divinity School in Hyde Park. The buildings of both the Female College and the Baptist Theological Union became part of Morgan Park Academy.

* The Correspondence School of Hebrew was started here in 1880 by William Rainey Harper. It was renamed American Institute of Hebrew in 1883. Harper went on to become the first president of the University of Chicago in 1892, and the headquarters of the institute went with him. The institute became part of the School of Divinity in 1905.

* In 1920, Irish and black citizens began moving in. They were resisted and restricted to the area east of Vincennes. Now the area is diverse and stable.

* In 1979, two Morgan Park residents were reminiscing about the old St. Patrick's Parade on 79th Street. Missing the

neighborhood feel of it, they began their own little parade with just children marching—"the wee folks of Washtenaw and Talman." Well, it grew and grew and grew until it became the notable Southside St. Pat's Parade on Western Avenue.

* The Walgreen family mansion was located on Longwood Drive. It was donated to the Mercy Home for Girls in 1987 and became part of its complex.

FAVORITE THING ABOUT MORGAN PARK

Morgan Park is distinguished by its diversity of fine homes, renowned architecture, yards and trees. The local churches, institutions and businesses give the community roots. The glacial ridge gives it a unique geographical distinction. We are known as the "Village in the City."

*Edris Hoover, lifelong resident
president, Ridge Historical Society*

PLACE OF INTEREST

*Walker Library
11071 South Hoyne*

This library was built in 1880 as a gift to the community by real estate developer George Walker. Mr. Walker advocated for the educational facilities that were established in the area. The library was administered by the University of Chicago from 1894 to 1904, when it returned to the village. It was fully renovated in 1995.

76. O'Hare

BOUNDARIES
N—irregular border
S—irregular border
E—Cumberland
W—York Road

NEIGHBORHOODS
O'Hare
Schorsch Forest View

HOW IT GOT ITS NAME
This area was named in honor of Lieutenant Commander Edward "Butch" O'Hare. He was a young navy pilot from Chicago who died in 1943 during combat in World War II. He had been awarded the Congressional Medal of Honor in 1942 for saving an aircraft carrier by shooting down enemy planes.

DID YOU KNOW?
* German immigrants settled here in 1840 to establish orchard farms. There were also twenty-four homes, two general stores and lumberyards. The railroad named the village Orchard Place in 1854.

* In 1942, the War Department purchased Orchard Place. It built a huge Douglas aircraft plant here. A special depot stored captured enemy planes and rare experimental planes. The planes were sent to the Smithsonian after the war. The airfield here was called Orchard Place/Douglas Field. That is why the airport identification letters are ORD.

* Merrill C. Meigs was chairman of the board that selected the site. He became an aviation consultant to the U.S. War Board. In 1948, Meigs Field was built on Northerly Island to provide an airport close to downtown. It disappeared in the middle of the night in 2003. Mayor Daley wanted parkland.

* The production of aircraft ceased in 1945, and the land was transferred to the City of Chicago. The airport was renamed simply Orchard Field. In 1949, the name Chicago O'Hare International Airport was chosen, and the development began. It opened to commercial air traffic in 1955.

* The airport was annexed to the city in 1956. Land around Foster Avenue was included to make it merge with the city. The Kennedy Expressway connected it to downtown in 1960. The Blue Line "L" extended to the airport in 1983.

* O'Hare trivia: A skeleton of a brachiosaurus is displayed in Terminal 1 courtesy of the Field Museum. A replica of "Butch" O'Hare's fighter plane hangs in Terminal 2. The

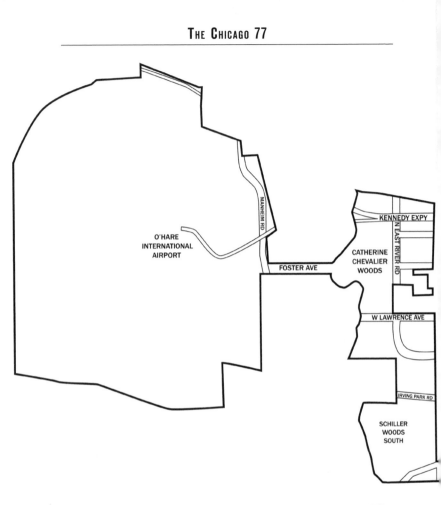

UIC Medical Center has an outpost in Terminal 2. The Chicago Historical Society has a shop in Terminal 3.

* Have you noticed that there is not a Terminal 4? International flights moved through the original Terminal

4. When the new International Terminal was built, it was decided to call it Terminal 5 to avoid confusion. The Terminal 4 name will be used again in future expansion.

* Many Chicago restaurants welcome travelers at the airport. You can get a taste of the Billy Goat Tavern, Berghoff's, Lou Mitchell's, Goose Island Brewery Deli, O'Brien's and Tortas Frontera. Of course, there is also Chicago pizza— Uno's, Gino's East and Connie's are represented.

* Catch a glimpse of the airport in many movies. You can find it in scenes in *Home Alone*, *Risky Business*, *Planes Trains and Automobiles* and *My Best Friend's Wedding*.

FAVORITE THING ABOUT O'HARE

In every direction and in myriad ways, the constantly active environment that is O'Hare is fascinating. Technology, architecture, meteorology and humanity stream together into the machine of one of the world's busiest transportation hubs. Each component is in a state of constant interaction and adaptation to the ebb and flow of traffic, weather and demand. Rarely does one find a place so dynamic and engaging on so many different levels. Watch the airplanes, the people and the hustle. See the excitement, the tension, the perseverance. In every direction, night and day: yes, fascinating.

Bill Zangs, pilot
United Airlines

PLACE OF INTEREST

O'Hare Terminal 1
10000 West O'Hare

In 1984, the terminal was designed by Jahn Helmut, who was also the architect for the James R Thompson Illinois State Building. The lower walkway is illuminated by a kinetic installation of neon lights called *Sky's the Limit*, executed by Michael Hayden in 1987.

77. Edgewater

Boundaries

N—Devon Avenue
S—Foster Avenue
E—Lake Michigan
W—Ravenswood Avenue

Neighborhoods

Edgewater
Andersonville
Magnolia Glen
Lakewood Balmoral

Bryn Mawr Historic District
Edgewater Glen
Edgewater Beach

How It Got Its Name

The name Edgewater was first used in 1885 by John Lewis Cochran. From 1885 to 1893, he bought and developed land in the area. He built mansions along the lakeshore and provided amenities such as streetlamps before his clients moved in. The Edgewater Historical Society uses the same typeface that was used in his newspaper ads. He persuaded the railroad to establish a train stop and named the station Bryn Mawr because he had grown up in the Philadelphia area. He built smaller houses to the west.

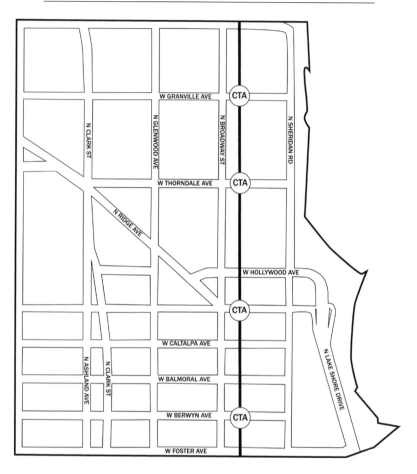

DID YOU KNOW?

* The first settler in the area was Nicholas Kransz, who came from Luxembourg in 1848. His farm was located where Senn High School now stands. He built the Seven

Mile House stagecoach stop at Ridge and Clark, where the trails intersected. Other farmers joined him in the area, and Edgewater became known as the "Celery Capital of the Midwest."

* In 1849, Nicholas Kransz married Margaret Faber, also from Luxembourg. They had five children. His daughter Anna married Bernard Weber. Bernard went into business with Anna's brother Henry. In 1890, the Kransz and Weber Company subdivided the farm and constructed fifty homes. Other landowners began to subdivide their property at about the same time.

* Another early farmer was John Anderson. He mapped out a small village and called it Andersonville. The Andersonville school was built in 1855. After the Great Fire of 1871, many Swedish immigrants moved up into Andersonville.

* The Saddle and Cycle Club is a private country club that opened in 1895 on Foster Avenue. The clubhouse was built in 1899, when the lake was still at its doorstep. They had horse stables, a three-hole golf course, a boathouse and a pier. This posh club is still active today.

* Many residents were skilled in building and design and improved the area to attract more Swedes. Between 1895 and 1940, they created 140 buildings along Clark Street. The entire street was dominated by Swedish shops. The

exodus to the suburbs of the 1950s changed the character of the neighborhood, but you can still find a few Swedish restaurants and stores. The Swedish American Museum is located here, and the Swedish tradition of observing the summer solstice is celebrated at the annual Midsommarfest.

* Sheridan Road wasn't completed until 1880 due to the irregular shape of the shoreline. Apartment buildings were built to the west after the electric trolley arrived in 1891. In the 1950s, the lakefront mansions were razed, and the building of the high-rise canyon began.

* The Gethsemane Garden Center was originally a bar and restaurant called Winandy Saloon. The building was completed in 1897 next to the Hanson Greenhouse. It became a Veterans of Foreign Wars (VFW) post after World War II. In 1977, Regas Chefas restored the historic façade and opened a great shop filled with plants and flowers.

* The Fireside Inn has been a restaurant and saloon since 1905. It started as a place of respite for the mourners from Rosehill Cemetery. The original owner, Peter Eberhardt, ran it until 1943. In 1989, it was revitalized and expanded.

FAVORITE THING ABOUT EDGEWATER

Since Edgewater was developed as a suburb of Chicago in the late 1880s, it has always felt like its own town within the city. The

residents work together to beautify and care for their homes, blocks, streets and parks...and, of course, there is Lake Michigan!

Thom Greene, co-founder
Edgewater Historical Society

Best of Chicago! Non-wealthy people can still live almost in luxury in Edgewater, with the lake as our backyard and the Red Line moving us where we need to go. Swimming and evening picnics when the mercury rises past ninety, or skiing and iceberg watching when it dips below negative twenty-five, make life vibrant in this immigrant-rich, thrift store–friendly, delicious-coffee neighborhood.

Erica Meiners, resident

PLACE OF INTEREST

Edgewater Beach Apartments
5555 North Sheridan Road

The lavish pink Edgewater Beach Hotel was built in 1916. An addition opened in 1924. The apartment building was built one block to the north in 1929. The Beach Walk, where all the big bands played, and the Marine Dining Room were wildly popular with locals and visitors from around the world. After it lost its beach, when Lake Shore Drive was built, the hotel began to go downhill and was torn down in 1970. The apartment building, the only section that still stands, became a co-op building in 1949.

Annexations and Additions to the City of Chicago

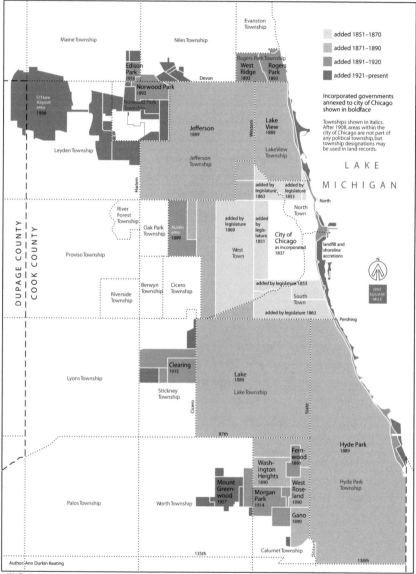

Maine Township

Niles Township

Evanston Township

added 1851–1870
added 1871–1890
added 1891–1920
added 1921–present

Incorporated governments annexed to city of Chicago shown in boldface

Townships shown in italics. After 1908, areas within the city of Chicago are not part of any political township, but township designations may be used in land records.

Edison Park 1910

Norwood Park 1893

Norwood Park Township

Devon

Rogers Park Township

West Ridge 1893

Rogers Park 1893

O'Hare Airport area 1956

Leyden Township

Jefferson 1889

Jefferson Township

Western

Lake View 1889

LakeView Township

L A K E

M I C H I G A N

added by legislature 1863

added by legislature 1853

North

River Forest Township

DUPAGE COUNTY

COOK COUNTY

Oak Park Township

Austin area 1899

added by legislature 1869

added by legislature 1851

North Town

City of Chicago as incorporated 1837

landfill and shoreline accretions

N

ONE SQUARE MILE

Proviso Township

West Town

added by legislature 1853

Berwyn Township

Cicero Township

Riverside Township

South Town

added by legislature 1863

Pershing

Lyons Township

Clearing 1915

Stickney Township

Cicero

Lake 1889

Lake Township

State

87th

Hyde Park 1889

Fern-wood 1891

Washington Heights 1890

West Roseland 1890

Hyde Park Township

Mount Greenwood 1927

Morgan Park 1914

Gano 1890

Palos Township

Worth Township

135th

Calumet Township

138th

Author: Ann Durkin Keating

© 2004 The Newberry Library

RESOURCES

Andreas, Alfred. *History of Chicago*. New York: Arno Press, 1884.

———. *History of Cook County*. Chicago: self-published, 1884.

Bachrach, Julia. *City in a Garden*. Chicago: University of Chicago Press, 2012.

Bull, Alfred. *The Township of Jefferson, Ill*. Chicago: self-published, 1911.

Chicago Fact Book Consortium. *Local Community Fact Book*. Chicago: University of Chicago Press, 1960–90.

Danckers, Ulrich, and Jane Meredith. *Early Chicago*. Chicago: Early Chicago Inc. (self-published), 1999.

Drake, St. Clair, and Horace Cayton. *Black Metropolis*. Chicago: University of Chicago Press, 1945.

Drury, John. *Old Chicago Houses*. Chicago: Chicago Daily News, 1941.

Grossman, James, Ann Durkin Keating and Janice Reiff, eds. *Encyclopedia of Chicago*. Chicago: University of Chicago Press, 2004.

Hayner, Don, and Tom McNamee. *Streetwise Chicago*. Chicago: Loyola University Press, 1988.

Holland, Robert. *Chicago in Maps*. New York: Rizzoli, 2005.

Holli, Melvin, and Peter Jones, eds. *Ethnic Chicago*. Grand Rapids, MI: WB Erdmans Publishing Company, 1994.

Karlen, Harvey. *Chicago Crabgrass Communities*. Chicago: Collectors Club of Chicago, 1992.

Keating, Ann Durkin, ed. *Chicago Neighborhoods and Suburbs*. Chicago: University of Chicago Press, 2008.

Mayer, Harold and Richard Wade. *Growth of a Metropolis*. Chicago: University of Chicago Press, 1969.

Miller, Donald. *City of the Century*. New York: Simon & Schuster, 1996.

Neu, Denese. *Chicago by the Pint: A Craft Beer History of the Windy City*. Charleston, SC: The History Press, 2011.

Pacyga, Dominic. *Chicago: A Biography*. Chicago: University of Chicago Press, 2009.

Pacyga, Dominic, and Ellen Skerrett. *Chicago: City of Neighborhoods*. Chicago: Loyola University Press, 1986.

Schoon, Kenneth. *Calumet Beginnings*. Bloomington: Indiana University Press, 2003.

University of Chicago Maps Collection. University of Chicago Library, Chicago, Illinois.

Wilkerson, Isabel. *The Warmth of Other Suns*. New York: Random House, 2010.